3-

THE MEDIEVAL ART OF LOVE

OBJECTS AND SUBJECTS OF DESIRE

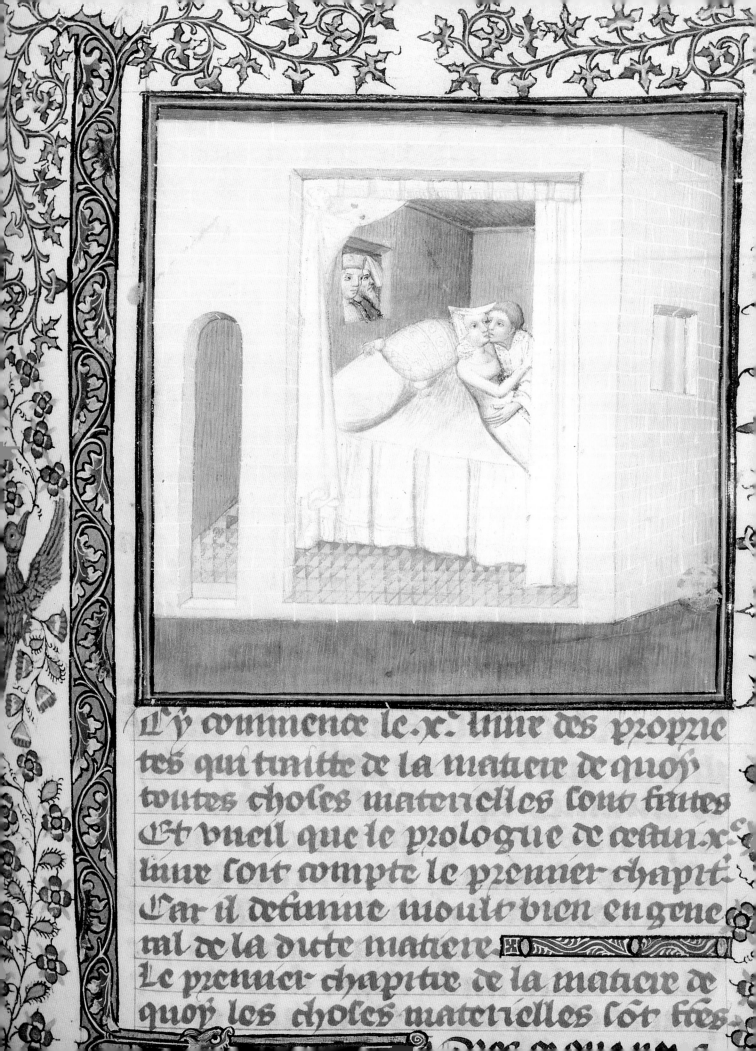

Cy commence le .x. liure des proprie
tes qui tmitte de la matiere de quoy
toutes choses matericlles sont faites
Et vucil que le prologue de cestui .x.
liure soit compte le premier chapitre
Car il deffinne moult bien en gene
ral de la dicte matiere.
Le premier chapitre de la matiere de
quoy les choses matericlles sont tres

THE MEDIEVAL
ART OF LOVE

OBJECTS AND SUBJECTS

OF DESIRE

MICHAEL CAMILLE

HARRY N. ABRAMS, INC., PUBLISHERS

ACKNOWLEDGMENTS

This book could not have been completed without the input of many students, friends, and colleagues, but I especially want to thank Carla Dunham, Kathryn Duys, Nancy Gardner, Malcolm Jones, and Paul Williamson for their help. Susan Bolsom-Morris and Kara Hattersley-Smith brought its text and images to life and I dedicate it to S.M. "de tout mon coeur" (to borrow a device from one of the beautiful objects reproduced here) and by a lovely coincidence on St. Valentine's day, in Paris!

Frontispiece: "How Material Things are Made," from Bartholomeus Anglicus, *Livres des Propiétez des Choses*, Paris, c. 1400. Wolfenbüttel, Herzog-August-Bibliothek.

Page 6: Hieronymous Bosch, *Inside the Bubble of Love*, detail of *The Garden of Earthy Delights*, c. 1510. Madrid, Prado.

Editor Kara Hattersley-Smith. Design Cara Gallardo, Area. Picture Editor Susan Bolsom-Morris

Library of Congress Cataloging-in-Publication Data
Camille, Michael.
 The medieval art of love : objects and subjects of desire /
Michael Camille.
 p. cm.
 Includes bibliographical references (p.) and index.
 ISBN 0-8109-1544-8
 1. Love in art. 2. Art, Medieval. I. Title
N8220.c36 1998
704.9'493067'0902–DC21 98-17485

Printed and bound in Italy

Harry N. Abrams, Inc.
100 Fifth Avenue
New York, N.Y. 10011
www.abramsbooks.com

Contents

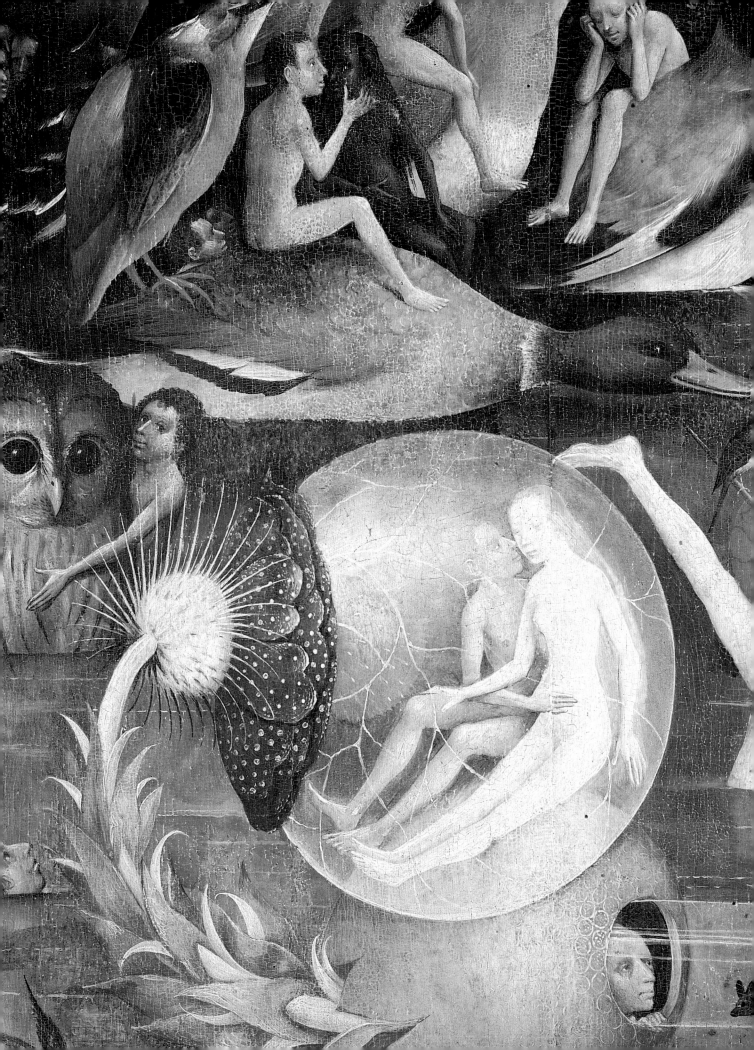

PREFACE

An "art" is a skill or practical knowledge and my title, *The Medieval Art of Love*, is meant to evoke exactly this sense of something learned, as well as the famous amatory guidebooks of the past, the *Ars Amatoria* by the Roman poet Ovid and the *De Amore* written by the twelfth-century cleric Andreas Capellanus, which has been translated as *The Art of Courtly Love*. But the term "art" should also suggest to modern readers the particular power of pictorial, rather than verbal signs in the manufacture of desire. Especially in books such as this one, meant for a general audience, works of medieval art are too often reproduced as if they were simply "illustrations" of historical reality. These "images of medieval life" are presented uncritically as reflections of literary texts or concepts rather than as objects in their own right. They become part of the vast reservoir of media images circulating the globe, which appear today on things as diverse as computer screens, greetings cards, calendars, and cups and saucers. Here I hope to treat these works not as images but as powerful things in their own right, made for particular purposes, rituals, and moments in time. Often given by men to women, but also sometimes by women to men, these sumptuous objects did not reflect so much as embody medieval amatory experience. They might mark a couple's status or legitimate their marriage as well as providing them with elaborate fantasies of sexual control, submission, and desire.

Desire had the same paradoxical meaning in the Middle Ages that it has today – a longing for some object that can never be satisfied. Once satisfied, desire dies, so the pleasure of desire lies in its perpetual deferral. According to the French scholar of medieval love and marriage Georges Duby, "the historian cannot measure the role of desire" but this was exactly the project of his compatriot, the philosopher Michel Foucault, whose great unfinished work, *The History of Sexuality* (1976), attempted to assess, in his own words, "the practices by which individuals were led to focus their attention on themselves, to decipher, recognize, and acknowledge themselves as subjects of desire." As an art historian I am less interested in measuring desire than in understanding its role in the creation of objects and subjects. These terms, as described in the subtitle of this book, can be seen on one level as simply the splendid "objects" or things reproduced here and their "subjects" or subject-matter. But the word *subject* has two more meanings that are relevant here. One can be *subject* in the sense of under the control and domination of another, or one can be a subject in the sense of a self-possessed mind. In psychoanalysis this latter sense of the term subject is often used to contrast with *object*, implying a capacity for internal self-motivation and will in contrast to the mute passivity of the external thing. These two senses of the word subject were available to the lover in the Middle Ages, allowing him to present himself as both subject to his lady and at the same time the creator of his own sensational and long-suffering subjectivity. The object, by contrast, was where he projected his desire, on to the beautiful, empty, and isolated beloved, the distant, static, and unattainable body of the woman who became increasingly identified with the work of art.

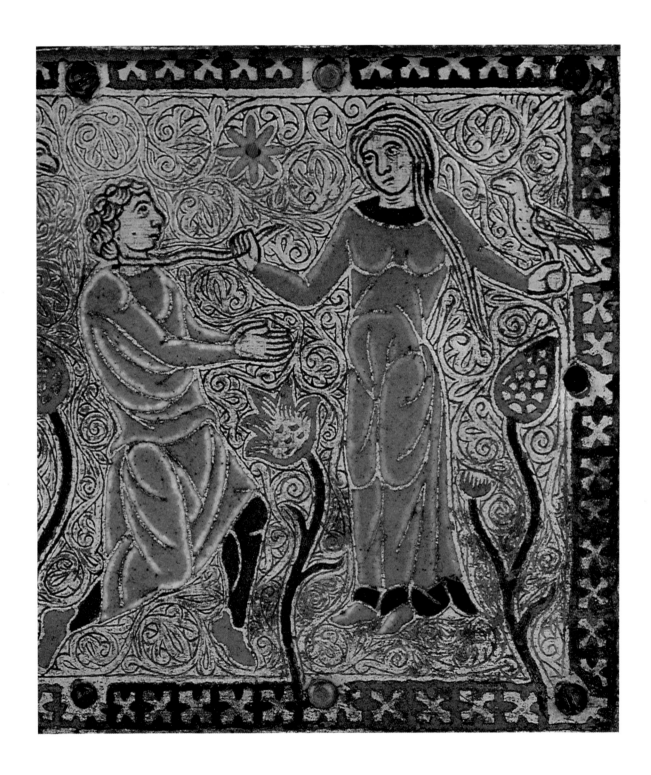

1. The lover captured by his lady (detail of fig. 4, p. 11).

LOVE'S LOST RELICS

One of the most haunting of the short Lays by the earliest-known French woman poet, Marie de France, written at the twelfth-century Plantagenet court of Henry II, is called *Laüstic* or "The Nightingale." It narrates the love-affair between a young wife and her next-door neighbor. The two were able to gaze at each other and even converse from their respective windows in the middle of the night, but they were unable, in Marie's words, to "take their pleasure with each other, for the lady was closely guarded." One day the suspicious husband asks why it is that his wife leaves their bed and where she goes. She replies that she rises to listen to the sweet but melancholy song of a nearby nightingale, which, she says, "brings me great pleasure. I take such delight in it and desire it so much that I can get no sleep at all." After having his servants snare the bird, the angry husband takes it, still living, into his wife's chamber where he breaks its little neck and throws its corpse directly at her, "so that the front of her tunic was bespattered with blood, just on her breast." These intimations of a Christlike sacrifice continue in the closing lines of the poem, which describe the creation of a beautifully wrought object by the two thwarted lovers, an object that symbolizes their never-consummated communion. The lady makes the first layer, carefully wrapping the nightingale's corpse "in a piece of samite [a rich silk fabric], embroidered in gold and covered in designs." A servant then takes it to the young knight who "had a small vessel prepared, not of iron or steel, but of pure gold with fine stones, very precious and valuable. On it he carefully placed a lid and put the nightingale in it. Then he had the casket sealed and carried it with him at all times." Like the precious pseudo-reliquary of the nightingale described in Marie's poem, the luxurious objects discussed and reproduced in this book are memorials and embodiments of love.

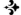

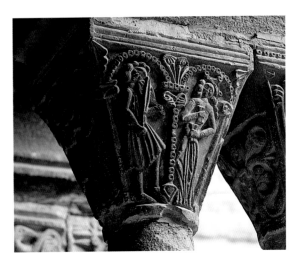

2. A troubadour and a female dancer.
Limestone capital, c. 1230. Cloister of the monastery
of Santa Maria de l'Estany, Spain.

THE TROUBADOUR'S PASSION

A small twelfth-century Limoges enamel casket glitters as sumptuously as any reliquary chasse in a church treasury (figs. 1 and 4). Speckled pools of turquoise, green, and white enamel are set against an incised flower-patterned ground of gold, techniques that were first developed by metalworkers in the South of France. But what is performed here is not the Passion of Christ or the Saints but a different kind of more pleasurable suffering. It represents not the relationship between man and his ineffable God but that between man and his unapproachable lady. On the left a male musician accompanies a female dancer, a pairing that sometimes appears in contemporary ecclesiastical contexts, such as monastic cloister carvings, as examples of the dangerous vices of the outside world (fig. 2). But on the casket this dance expresses not damnation of the body but that *joi* or "joy" of the noble

gladness of youth that was first celebrated by the South French poets who many argue "invented" modern love, the troubadours. A contemporary and much larger painted wooden coffer contains, on one of its ends, the same pairing of music and dance (fig. 3). Similar tight and revealing fashions, perhaps influenced, like the songs of the troubadours themselves, by traditions from Moorish Spain, expose the legs and breasts of both musician and dancer in ways that would have appeared highly suggestive to twelfth-century viewers. The musician's robe split at the hip was one of the singular vices of male vanity, which along with being clean-shaven and using mirrors, was specifically cited by the Prior of Vigeois in 1184. Men were criticized for effeminacy in this period, not because they wanted to become like women but because they wanted to attract them. This clerical outrage responds to a widespread transformation in twelfth-century culture – first in the South of

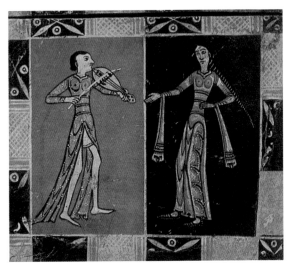

3. A troubadour and a female dancer. Casket,
c. 1180 (detail). Painted wood, 8¼ x 2" (21 x 5.1 cm).
Vannes, Cathedral Treasury.

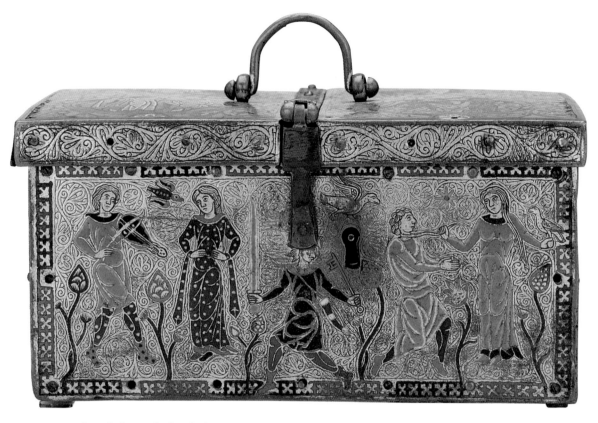

4. A troubadour and a female dancer, a figure holding a sword and a key, and a lover captured by his lady.
Casket, c. 1180. Limoges enamel, 8¹/₂ x 3¹/₂" (21.2 x 9.1 cm). London, British Museum.

France and then spreading to the courts of the North – to which this chest, which some scholars attribute to the Southern *Pays d'oc* and others to the Northern *Pays d'oil*, testifies.

The Limousin troubadour Bernart de Ventadorn (c. 1145–80) sang of wanting to become a bird, so that he "might fly through the air and land deep in her house," which explains the bird flying between the musician and dancer on the Limoges casket, which also represents the poet's voice of longing. The bird that flies toward the sun on the other side of the lock recalls another bird described by Bernart – the lark that flies toward the thing that will cause its death.

The lady on the right of the casket carries a falcon on her wrist, yet another winged sign of the lover's desire, this time totally in her control. With her other hand she holds a young man around the neck by the long leather halter by which the falcon was secured to its owner's wrist (see fig.1). This man is hers. His kneeling posture together with his clasped hands indicate his submission. Another song by Bernart de Ventadorn describes how "Since I am her liege subject wherever I find myself, to the point that I pledge myself to her, head bowed in absolute submission: and hands clasped, I surrender myself to her pleasure, and I wish to remain at her feet

until she, as a sign of mercy, admits me where she undresses." These metaphors of the rapture of capture are used by Andreas Capellanus in his famous Latin treatise *De Amore*, written in the 1180s at the court of Countess Marie of Champagne. Andreas, who was a chaplain, that is, a cleric, describes the etymology of the word love, *amor*, from the verb *amo*, to catch or be caught, "for the lover is caught in the bonds of desire and longs to catch another on his hook [*hamo*]." In the enamel, too, the lover is likewise both the hunter and the hunted, both master and slave of his own desire.

In the South of France, where this casket was produced, the term *fin'amors* described a fictional form of love in which the lady could be referred to as *mi dons* – "my lord." The lover's pose on the casket recalls the gesture of homage with which a vassal signaled his submission, by kneeling and placing his hands together between those of his lord, the *immixtio manuum*. The woman here is thus adopting the position of a powerful man in the feudal hierarchy. Seals, which were used in chivalric society as actual signs of personal power, sometimes depict this gesture and a few even depict a knight paying homage to a lady (fig. 5). This would have provided its owner with a self-image of his knightly service, with implications of his being "civilized" through his devotion to an ideal. By investing his mistress with the power of judgment and control over his desire, the man was simultaneously elevating his own sub-

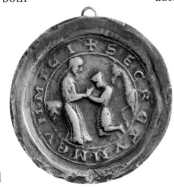

5. A kneeling knight pays homage to his lady. Seal of Gérard de St. Aubert, 1199. Paris, Archives Nationales.

jectivity and negating that of the lady, whose desire is ignored.

This seal would have been used to ratify land transactions, and the Limoges casket too has to be placed in the context of medieval property relations, and not just considered as the medieval equivalent of a lady's jewel-box. The property that passed through men and which constituted their inalienable inheritance was land, known in legal terms as an immovable possession. By contrast "movable" property, considered to be less valuable, was usually stored in chests. What passed through women were these very "movables," synonymous with the dowry provided by the bride's family at marriage – clothes, jewels, and objects like the Limoges casket. The ideology of *fin'amors* tends to describe the direction of the gift as always going from male to female, just as all the action on the casket, the gaze of the male lovers and the birds of love, all flow in her direction. But the flow of the dowry, the direction of actual goods and money, would have gone the other way. Marriage was a form of gift exchange, in which men bound themselves to each other in kinship bonds using the circulating currency of women as conduits of exchange. Men also often gave gifts to one another. Scholars of the troubadour lyric have shown how, despite their fictive address to a woman, these poems could be addressed just as easily to powerful lords, making them part of the power-play between men, celebrating masculine status. The Limoges cas-

ket with its enameled roundels of warriors on the lid, as well as its troubadour subjects on the front panel, might also just as easily have been a gift to a noble lord from his vassal, in which the male giver was equating his own position, *vis-à-vis* his lord, with that of a lover subject and bound to his lady. It is not so much a record of personal relationship as a public statement about power.

Before we leave this fascinating object, it is important to note that directly under the clasp that opens the little box – the point of danger – is one more character. Dressed in black he holds up a sword toward the dancing couple and a key toward the couple on the right. Is he perhaps favoring their feudally sanctioned relationship over the passionate dance on the other side? His is the only figure to break out of the frame with his two differently colored shoes, a sign, like his shaggy hair, of his duplicity. This figure too can be found in troubadour poems as the antithesis to the noble lover, as one of those gossiping and spying courtiers known as the *lauzengiers* who threaten to separate the lovers and who are rivals for the lady's attention. As well as his horn, an emblem of those who guard entryways like city gates, this scraggy fellow holds up a key to the actual keyhole of the casket as guardian of its contents. The lover's lack of access to his lady's body is literally embodied in the box itself whose opening is so jealously guarded. This work was also structured to keep its secrets, like that genre of troubadour poetry known as *trobar clos* or "closed poetry" that was admired for the hidden allusions and complexity of its language.

Many of the themes to be treated in detail in the rest of this book are present on this casket. They take us through all the stages traditionally associated with love, from initial looking (*visus*) to speaking (*alloquium*), touching (*contactus*), kissing (*oscula*), to the final consummation of the sexual act (*factum*). The first chapter deals with the importance of vision in the theory and practice of love. This is vividly presented in the Limoges casket in the lady's eyes toward which the first blue bird of desire flies, gazes that bind these four people into two pairs. Whether caskets such as this one were gendered objects, associated with women or men, is a question to which I will return in Chapter Two, which addresses the important notion of gift-giving in a wider range of medieval objects. The scenes on the casket are set in a garden filled with buds, only one of which bursts into flower, before the kneeling man on the right, as if responding to his desire. The time and place of nature so fundamental to the art of love will be the subject of Chapter Three. Still concerned with the natural world, the use of animals associated with the hunt, such as the falcon perched on the lady's arm here, will be explored in various contexts in Chapter Four, which will also examine other signs that were deployed to represent the developing physical relationship between lovers. The troubadour's ultimate goal was physical union with his lady. Only hinted at in the Limoges box, in the proximity of key and keyhole, this theme will be discussed in the fifth, climactic chapter. What happens after passion is spent – detumescence and decline – as well as the three things that were thought by theorists to cause love's decay – marriage, old age, and death – are not part of the twelfth-century casket since they develop into fully fledged themes in art only in the later Middle Ages. These ominous events

will be the subjects of the final chapter, which is intentionally short and literally anticlimactic.

Most of the visual images in this book are objects of Gothic art, dating from the thirteenth to the early fifteenth century. But in the rest of this Introduction I want to look at a few more examples of those rare objects that have survived from the twelfth century, when the Romanesque style was still current. I will not attempt to present yet another theory for the origins of this new language of love, which has been ascribed to influences as diverse as Islamic love poetry, Cathar heresy, the revival of Ovidian classical ideas, and increasing devotion to the Virgin Mary. The phrase "Courtly Love" itself was not used in the Middle Ages. First coined by the French medievalist Gaston Paris in 1883, there has been much scholarly debate as to whether "Courtly Love" ever existed as an actual social phenomenon or whether it was just a fiction of

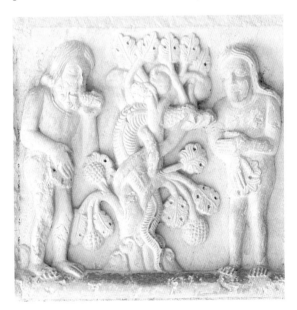

6. *Temptation of Adam and Eve*. Limestone capital, c. 1150. Cloister of Girona Cathedral.

the poets, so I shall avoid the term. The medieval art of love was first invented by the troubadours in the *langue d'oc* of Southern France, a culture that was almost totally destroyed during the Albigensian Crusade early in the thirteenth century. It was spread to Northern France and England by the *trouvères* using the *langue d'oil* and then to the *Minnesänger* – those who sang of love in German. Historians tend to describe this revolutionary change in relations between men and women as an ideology that developed in response to real social and economic change, such as the Church's increasing need to control courtship and marriage. Literary scholars see it rather as a more self-contained poetic fantasy and as the crucial beginnings of modern lyrical subjectivity. I see no problem in accepting this new discourse of love as both reality and fantasy, in the sense that what people imagine and shape into images is part of the structure of their actual lives and not just the reflection of some text or ideology outside it. It is precisely this unreality of the love experience that gives the visual arts such an important role in its historical fabrication.

ADAM'S SHAME

The most frequently depicted couple in medieval art do not gaze at each other with deep-felt longing but with abject shame. Adam and Eve, the first man and woman, are represented not only in Bibles in the twelfth century but also on church portals and townhouses. Adam is usually placed on the left and Eve on the right of the spectator in monumental Romanesque examples (fig. 6). While Eve is on the right side from the external viewer's point of

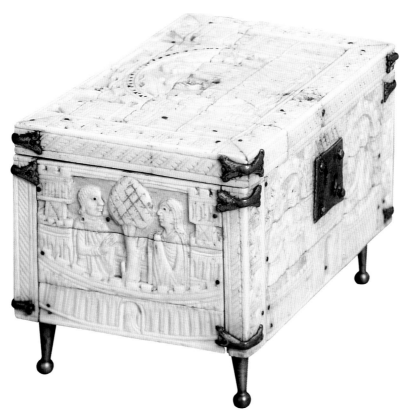

7. Tristram and Isolde under the tree. "Forrer" casket made in Cologne, 1180–1200.
Bone, 3¼ x 4½" (8.4 x 11.5 cm). London, British Museum.

view, she is of course on the sinister, left side from the devil's or God's point of view, just as the damned are pushed into Hell on God's left hand on the great carved tympana of twelfth-century churches such as Autun Cathedral and the abbey of La Madeleine at Vézelay. Likewise most lovers are forced endlessly to replay these primal positions of "our first parents," as people called them.

For St. Augustine this first sin was a rehearsal for the three stages of all sin, which is committed by suggestion, pleasure, and consent. The devil (the serpent) first makes the suggestion, the flesh (Eve) delights in it, and the spirit (Adam) consents. As the first of "love's slaves" Adam gave in to a woman and he is often shown eating the forbidden fruit, sinning through his mouth, indicating his sexual appetite. Eve had first given in to the desires of her eyes in seeing that the forbidden tree was "fair to the eyes and delightful to behold" and she is often shown grasping for the fruit with her hand. Significantly, Adam and Eve cover their genitals, which in the case of Adam are no longer under his control. For this disobedience they are driven from the garden into the harsh world where the human race can continue only through the relentless cycle of lustful sex,

painful birth, and dreadful death, a cycle in which love has no place.

Unlike Adam and Eve, who are trapped under the all-seeing gaze of God, courtly lovers depend upon secrecy, on not being seen. On the short side of a small bone casket carved in Cologne around 1200 stands another couple beneath a tree, the man again on the left and the woman on the right from our external viewpoint, hemmed in by a garden wall (fig. 7). This is not Eden and these are not our first parents but Tristram and Isolde, whose tragic tale is told on all five sides of this little object. The adventures of the young knight and his love for Isolde, his uncle Mark's wife, exist in various literary versions in the twelfth century, notably that by the poet of the Plantagenet court, Thomas. But none of the written versions exactly fits the subjects found on this casket, suggesting that oral versions of the story were just as likely to be fashioned into courtly receptacles as written manuscript sources. Whereas the Edenic couple are naked and ashamed, these two are fully clothed and resplendent. Whereas Adam is bearded, a key sign of masculinity in medieval culture, the young Tristram is clean-shaven, as are most male lovers in medieval art. Here it is not the woman who makes the gesture of delight and possession with her outstretched hand but the desiring Tristram. On the other end of the box King Mark and his Queen are shown in the same garden setting, but joining hands as the married couple. Here, by contrast, the illicit lovers do not touch, a separation that emphasizes the *dolor* mixed with the *joi* that is the hallmark of their thwarted love. Every couple in medieval art re-enacts the

first couple's loss of innocence and yet at the same time defies the inherited curse of sex and death, through the sheer energy of their deceitful desire.

The Bayeux Tapestry interrupts the great epic narrative of the conquest of England in 1066 by William, Duke of Normandy, with an enigmatic scene labeled "where a cleric and Aelfgyva ... ," as if teasing the viewer to fill in the story of the scandal whose exact details have been lost to posterity (fig. 8). The "chin-chucking" is not an intimate gesture of affection here but a breaking of boundaries. In the marginal scene below a naked man with an enormous erection extends his arm in the same way as the cleric above, making a clear association between male sexuality and violence. The woman is represented and named as the possession that has been unlawfully "taken" by the unnamed clerk. Her name sits in the center of her "house," suggesting the subversion of her clan and the crime against male property that constituted rape in this period. He is merely a type – a cleric who has violated his vows. Only a century later clerics would be in the forefront of developing poetic ideas of love and in poetic debates between two ladies about the relative merits of knights or clerics as lovers. It is clerics who nearly always win favor, since they are described as refined in manners, wealthy, and generous in giving gifts, compared to rough, brutish military men. Indeed it was a widespread belief that a knight could learn good manners and the art of love from a cleric. In the Bayeux Tapestry, however, created before the culture of idealizing love had developed in the cathedral schools and courts of Europe, this cleric is breaking social and sacred

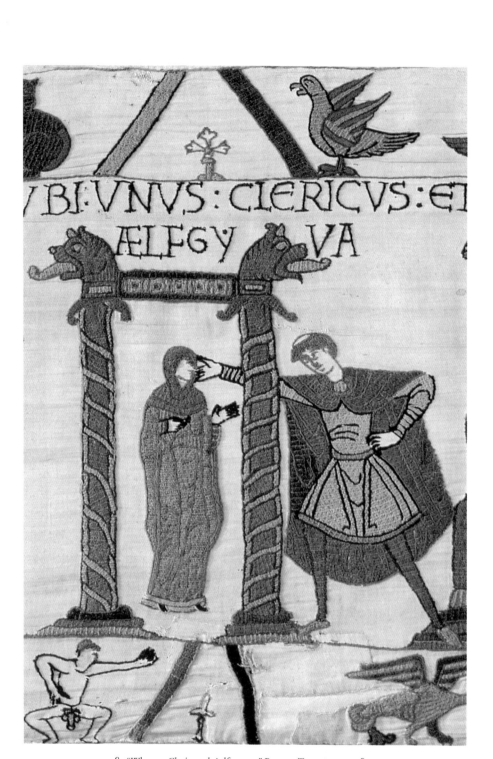

8. *"Where a Cleric and Aelfgyva ..."* Bayeux Tapestry, c. 1080.
Wool embroidered on linen, 1'9" x 226' (0.53 x 68.8 m).
Bayeux, Musée de la Tapisserie.

9. *"Where a Lady with a Dog and a Man with a Falcon ..."* Embroidered purse, 1170–90. Silk threads on linen, 2'1½" x 2'9" (10 x 13 cm). Chelles, Musée Municipal Alfred-Bonno (Seine-et-Marne).

but for a woman, who stands here on the right of the couple as if to deny any hint of Eve's sinister position as temptress. Whereas Aelfgyva's shrouded body is enclosed within an architectural frame protected by two snarling dragonheads, suggestive of the way in which real women's spaces were circumscribed in this period, the lady on the purse floats free, displaying her body and looking out at us with piercing eyes. Dangling by its delicate strings from a lady's belt, here is one of the few medieval objects that speaks from a first-person subject position, identified with its wearer's body, holding the purse strings as well as controlling the bonds of desire that leash in and control her noble lover. They also control her own body since the purse, with its opening and closing drawstring, was a common metaphor for the vulva in many European vernaculars.

boundaries. For all its celebration of masculine power and epic treachery, the tapestry is in fact an embroidery, probably designed by men but actually woven by women. Whether nuns or noblewomen, its creators lived lives as tightly enclosed as the shamed lady Aelfgyva whom they wove within her silken prison.

A century later a purse was embroidered in a similar technique, depicting a couple whose relationship is being celebrated rather than censured (fig. 9). The man has the falcon on his wrist as a sign both of his nobility and his role as the hunter in the encounter. But the lady has a dog on a long leash, which jumps up at him, representing her capacity to control the male's baser, animal passions. It was not only made by

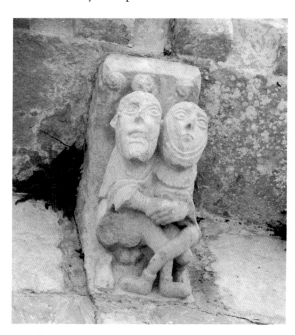

10. God sees the shameful couple "caught in the act." Apse corbel, Church of Cénac, Dordogne.

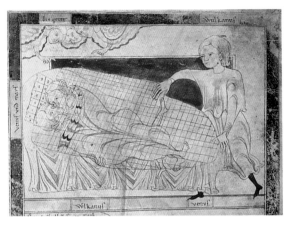

11. The gods see Mars and Venus making love
under the net of Vulcan, from Heinrich von Veldeke's
Eneide, Regensburg, c. 1215. Berlin Staatsbibliothek,
MS germ. fol. 282, fol. 39r.

The survival rate of such superb objects of medieval secular culture, compared with embroidered liturgical copes, candlesticks, and crosses kept in church and cathedral treasuries, is very small, which is one of the explanations why we tend to look at medieval art with the eyes of bishops rather than lovers. Secular caskets and embroideries that did survive, like the previous example, did so only because they were later appropriated by the Church as precious containers for sacred relics. The shame that tainted every body with the sin of Adam and Eve is so ubiquitous in Romanesque art that we sometimes forget that an alternative but mostly lost realm of imagery existed alongside it. In public contexts, in church paintings and sculpture, the joining of two people's bodies always has something animal about it, as in the corbel sculpture on the apse of the little church of Cénac in the Dordogne (fig. 10). This couple, like their first parents before God in the garden, stare embarrassedly upward, for they have been "caught in

the act." The eternal entwining of their knobbly knees in stone may refer to a popular story, much repeated by preachers of the period in their sermons, about a man and a woman who had sex in a church and were thus punished for their pollution of the sacred space by remaining stuck together like dogs for a whole year. Placed next to the biting mouth of Hell that awaits them, the couple on the corbel is yet another depiction of public humiliation and shame, a warning image to the community.

In the unique illustrated codex of Heinrich von Veldeke's retelling of Virgil's *Aeneid* is another image of a man and a woman caught *in flagrante delicto* (fig. 11). The classical lovers Mars and Venus are here trapped in the net of jealous Vulcan and exposed to the view of the other gods. In the sphere of private images, such as this manuscript, what goes on in bed can be celebrated as a marvelously melding form of mutual absorption in the other. Wiggling toes and pounding thighs delineate the very corporeal desires of these deities, whose bodies are simultaneously covered and revealed by Vulcan's magical net. Significantly, the artist has not distinguished the male from the female in terms of their bodily structure, which is near-identical, but only in terms of their position. From above the other gods look down, but according to the Middle-High German text opposite their gaze is more voyeuristic than censorious: "Hearing Vulcan's complaint, they thought it wrong for themto be lying so close to each other. But there were some gods present who would gladly have been captured beside lady Venus under such circumstances."

12. Pyramus and Thisbe joined in death. Fragment of a carved tympanum from the church of Saint-Géry-au-Mont-des-Boeufs, Cambrai, c. 1180. 2'6¹/₄" x 2'1¹/₂" (77 x 65 cm). Musée de Cambrai.

Although the medieval art of love was produced in opposition to the Church's teachings, religious art was itself influenced by secular forms, even if they are presented as exemplars of what to avoid. That sex equals death is brilliantly represented in one of the rare church tympana from the twelfth century to depict a classical love myth as an exemplar of sin, the story of Pyramus and Thisbe, who meet their deaths when Thisbe, wrongly believing her beloved to have been killed by a lion, commits suicide and Pyramus then impales himself on the same sword (fig. 12). Striking details, such as the youth's tender touch of his beloved's hair with a large clumsy hand, make this joined pair, who have almost indistinguishable bodies, a moving and unusual work. Their gory mutual impalement takes place under the leaves of the mulberry bush, their own Tree of Life, which in the story is stained dark red with their blood and was probably, like most sculpture, originally brightly painted this color. In Ovid's telling of the story to which this sculpture seems indebted, Pyramus and Thisbe had much sorrow in love, which was at first sweet but then became

13. A couple joined on the handle and back of a mirror case, Swabia, c. 1150. Bronze gilt, h. 3¹/₂" (8.8 cm). Frankfurt, Museum für Kunsthandwerk.

bitter to them, like the fruit of the trees in love's garden. The fact that they do not face one another may be a visual indictment of their love as being perverted, since this sculpture decorated a church. A face peers down at them from out of the foliage above, both evocative of God's all-seeing gaze but also of the secret that is so crucial to the excitement of love. This is of course the myth of all lovers – that they are unseen – which is always undermined by their being made into images and thus into objects, not of God's but of our gaze.

Someone is also watching the couple who are welded together under the bedclothes in a mid-twelfth-century bronze-gilt mirror case from Germany (fig. 13). But rather than a deity or the jealous husband, this watcher is urging the lovers to further heights of sensual pleasure by accompanying their performance with his own on the harp. The artist had probably seen ancient mirrors of this type, ut the inclusion of the harpist here recalls the legend of Tristram and Isolde as well as the accepted belief that music was "the food of love." Roused by the contemplation of

physical beauty (which is caught in the mirror's glass-side), the lover desires not just to gaze on his beloved but also to hold her, to touch and play her like an instrument. The amorphous faces of the couple blend in a kiss that is repeated in the handle, which is formed of a full-length embrace. As we shall see in Chapter Two, mirrors – which are among the most numerous luxury objects to survive from the Middle Ages – were the catoptic containers of love's secrets and, as emblems of enticement and enchantment, more closely associated with women than men. As a precursor of the later Parisian ivory mirrors with their more allusive erotics, this brasher bronze mirror invites the grasp of the person using it and celebrates the contact of flesh with flesh.

Although in this Introduction I have been contrasting sacred and secular images of lovers, I do not want to put the power of the Church and its institutional and spiritual control on one side and the secular world of the courts with their political and idealizing rituals on the other. One of the things I want to emphasize in this book is that on all levels, from the political down to the psychological, the sacred and profane overlapped, shared languages, subjectivities, and even, as we shall see, identical visual codes. The same artists who illuminated the *Roman de la Rose* one day would be back to the usual Bibles and Psalters the next. The maker of the Swabian mirror also probably made bronze candlesticks for the altar, which would never, unlike that object, be touched by women's hands. Audiences likewise overlapped, and it has been argued that the new language of love would never have developed in the twelfth cen-

tury had it not been for radical shifts in spirituality, most notably among Cistercian monks such as the twelfth-century reformer Bernard of Clairvaux (1090–1153), who while castigating courtly excess and fashion on the one hand, at the same time structured his own relationship with God in terms of the intimate and erotic engagement of a lover with his beloved.

THE BRIDE'S LONGING

"O that you would kiss me with the kisses of your mouth: for thy breasts are sweeter than wine. Smelling sweet of the best ointments ... Behold thou art fair O my love, behold thou art fair, thy eyes are as those of doves ... I am the flower of the field and the lily of the valleys." These words open the most "erotic" of all biblical books, the Song of Songs. The "you" addressed here is the longed-for Bridegroom and the "I" is the plaintive voice of the Bride whose lyrical languishing has echoed through Western culture for more than two millennia. In most twelfth-century Bibles the letter "O" of the word "kiss" (*Osculetur*) shows this union. The bed on which the kissing couple on the Hamburg mirror consummate their passion can be seen in an initial in a manuscript of Bede's commentary on the Song of Songs made in the monastery of St. Albans in early twelfth-century England (fig. 14). This was created by a great monastic artist who also, in the second decade of the twelfth century, painted a famous Psalter, now in Hildesheim, for Christina of Markyate. Christina had escaped from an arranged marriage planned for her by her parents not by eloping with a young lover, but by having herself

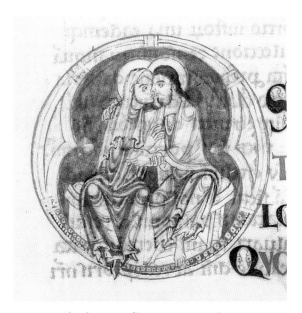

14. The closeness of lovers. *Sponsus* and *Sponsa*
representing Christ and the Church in Bede's commentary
on the Song of Songs, from St. Albans, c. 1130.
Cambridge, Kings College, MS 19, fol. 21v.

walled-up in a cell at the abbey of St. Albans to live the reclusive life of an anchoress, married only to Christ. For the nobility this was as radical an act of social renunciation as any sexual affair, since it also prevented the lucrative political and economic gains that came with betrothal. The bride in the Bede manuscript, however, was a focus of identification not only for nuns like Christina but also for monks. Because the female Bride is the "voice" of the Song she is in the subject position on the left, which is the position of the (usually) male subject viewing his female object, as in the troubadour images we have seen. Bede, like most monastic commentators, interpreted this longed-for Bridegroom as Christ and his Bride as both the Virgin Mary and the Church. A less institutional and more personal interpretation

was that of the Cistercian St. Bernard, whose mystical interpretation of this union saw it representing the soul's thirst for God. The face of the Bridegroom/Christ overlaps that of his Bride, as does his halo, suggesting her obliteration by the object of her desire. This loss of self was the mystic's goal but not that of the courtly lover, who sought to foreground himself and never to take second place. God could not be presented as so passive an object as the beloved lady, so here he is painted in active embrace.

Twelfth-century images of orthodox religious texts such as this one are animated by far more physical and sensual intimacy than secular art of the same period. This is because the sacred image could be seen as a *figura* or "figure" pointing to a signifier beyond in a higher realm and not as an end in itself. By contrast, the two earthly lovers painted between the lines of a Latin poem in the manuscript known as the *Carmina Burana* do not touch each other (fig. 15). This famous German collection of 228 poems, many of them love lyrics, represents the flourishing learned culture of the French schools of the twelfth century and the greatest single anthology of medieval Latin poetry to have survived. Such collections were often described as *florilegia* or collections of flowers. Here the man is about to hand to the lady wearing a long belt a bunch of roses and lilies, emblematic of his gift of love, and the poem or song he has made for her. The scribe left only a long rectangular space in which to fit two figures, whose standing and lying positions are suggestive. Although this image is embedded in a masculine, clerical Latin discourse, it is one that is radically different from that of the enclosed monk who feared female pollution. Longing for

tympanum cum lyra. Do er zu der linden chom dixi se/
deamus. div minne twanch sere den man ludum faciam.
Er graif mir anden wizen lip. non absq; timore. er sprah
ich mache dich ein wip dulcis es cum ore. Er war mir
uf daz hemdelin. corpe detecta. er rante mir in daz pur
gelin cuspide erecta. Er nam den chocher unde den bogen
bene uenabatur. der selbe hete mich betrogen ludus copleat'.
Suscipe flos florem quia flos designat amorem.

Illo de flore nimio sum captus amore.

Hunc florem flora dulcissima semper odora.

Nam uelud aurora fiet tua forma decora.

Florem flora uide quem dum uideas michi ride.

Flore florement tua nox cantus phylomene.

O caela del flore rubeo flos convenit ori.

Flos inpictura non est flos imo figura.

Qui pingit florem non pingit floris odorem.

union, it represents the carnal rather than the spiritual, the physical body over its spiritual *figura*. The nine-line Latin poem that starts on the line above begins: "Flower, pluck my flower, because a flower stands for love." The "subject" voice of the poem is that of the man who implores his love to accept his gift, physically to interact with her senses: "Smell the flower, sweetest Flora, ever fragrant!" he implores, "Look upon the flower Flora! When you see it smile at me! Speak kindly to the flower! Your voice is the song of the nightingale. Give kisses to the flower! A flower suits a red-rose mouth."

This Latin lover contrasts the *forma* or external beauty of the flower with a more fraught word – *figura*. It is this visual term that brings a bitter and melancholy note to this sweet-smelling song in the final couplet and which also incidentally explains why this is one of the few poems in the *Carmina Burana* manuscript to have received an illustration. Pleasure is always charged with the possibility of danger and its goal is ultimately unattainable. An image of Christ is, of course, not Christ himself, as the theologians insisted, but a sign that can lead the pious beholder toward an apprehension of his divinity. In this way the "flower of the field"

and the kiss of the Bridegroom described in the Song of Songs are visible and experiential signs that can transport the devout to a higher realm of interpenetration with divine things, through the region of similitudes. But no such security in sacred signification exists for the persona of the lover in this poem in the *Carmina Burana*. Yearning for the sign to become substance, in the last two lines at the bottom of this page he admits that, like this picture, his desire – and ultimately his beloved – are illusory:

> A flower in a picture is not a flower,
> just a figure;
> whoever paints a flower, paints not the
> fragrance of a flower.

This is the most important irony of the medieval art of love on both the verbal and visual registers. For the lover the image seems to be on the one hand just an empty illusion, an always-elusive object of desire, but on the other this very emptiness serves as an indispensable prop in the construction of that desire. Without the image love could not exist.

15. The distance between lovers: the poem "Suspice, flos, florem," from *Carmina Burana*, ?c. 1230. Munich, Bayerische Staatsbibliothek, MS Clm. 4660, fol. 72r.

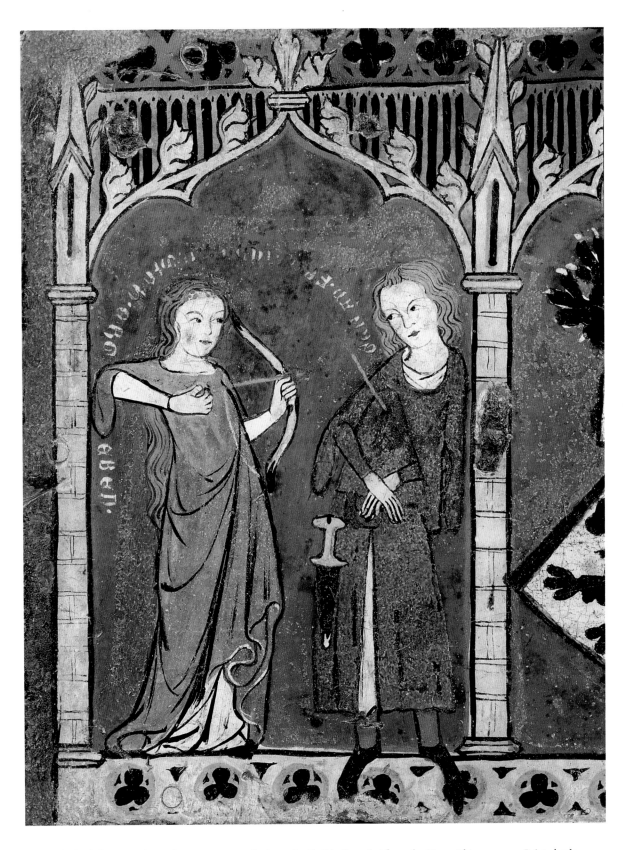

16. The lady (Frau Minne) shoots an arrow at the lover. Inside lid of a casket from the Upper Rhine, c. 1320. Painted oak, 4^1/$_4$ x 10^9/$_{16}$ x 4" (1.67 x 4.2 x 1.66 cm). New York, The Cloisters Collection, The Metropolitan Museum of Art.

CHAPTER ONE

LOVE'S LOOKS

Love is a certain inborn suffering derived from the sight
of and excessive meditation upon the beauty of the opposite sex.
Andreas Capellanus

So strong was the belief that sight stimulated amorous desire that Andreas Capellanus could argue that blind people were incapable of experiencing it. "Love at first sight" is vividly represented in the frontispiece miniature in a Parisian manuscript containing the collected works of Guillaume de Machaut (1300–77), who was the greatest composer-poet of the fourteenth century (fig. 18). Looking at his beloved is the only consolation of the lover in this poem, *Le*

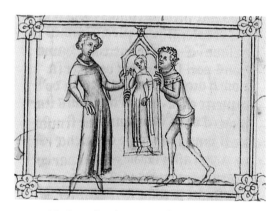

17. The lover fixes his gaze on his lady's portrait, from Guillaume de Machaut's *Le Livre du Voir-Dit*, Paris, c. 1370-77. Paris, Bibliothèque Nationale, MS fr. 1584, fol. 235v.

Remède de Fortune, who looks upon "the beautiful proportions, simple and modest without irregularity, of her lovely body." In the miniature the older poet's lover persona stands on the left in rapt contemplation of the lady, who does not return his gaze but points back with her hand, aware that she is being looked at. She stands behind a literal barrier, a horizontal beam that blocks the way in front of her. Access to her is only visual. It is exactly this inaccessibility that makes the poet long for her even more, just as a

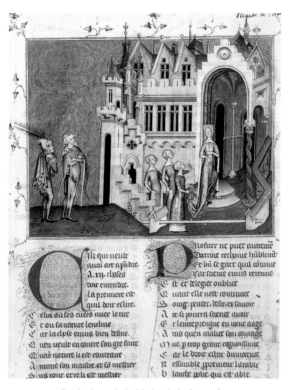

18. The lover beholds his lady from afar,
from Guillaume de Machaut's *Le Remède de Fortune*,
Paris, c. 1350-55. Paris, Bibliothèque Nationale,
MS fr. 1586, fol. 23.

something of the slow, fetishistic lingering over the white moments of flesh, especially the neck and face. The new tight costumes that became fashionable in the mid-fourteenth century exposed more of the lady's shoulders and waist. The building with fantastically wrought turrets and finely carved windows also monumentalizes the lady by framing her. Just as our eyes can follow the crenelations and penetrate the shadowy vaulted space within, the woman's body is presented as a complex and subtle surface to be perceived with sophisticated taste. The architecture actually combines motifs evocative of female confinement – the towers and donjons of a castle – with the more open civility of an urban "hotel," or even the new Louvre palace being built by Charles V at this period. For Machaut love is not only stimulated by looking, it works like art and architecture: "Love, by her skill caused my Lady's great beauty to carry away my heart when I first saw her."

HE LOOKS AT HER

In medieval optics the eye was not the passive camera that it is today but an active lantern. The new "intromission" theory, adopted by thirteenth-century scholastics under the influence of Aristotelian and Arabic science, described the eye as receiving rays from external objects. This theory, however, never totally replaced the older Platonic notion that the eye itself sent out beacon-like rays toward its object, and some philosophers, such as Roger Bacon, combined the two notions. In a period when the evil eye was commonplace and when pregnant women were urged not even to look at pictures of mis-

twentieth-century French literary lover, Roland Barthes, describes in his *Lover's Discourse* (1977): "Here then, at last, is the definition of the image: that from which I am excluded."

It is precisely this distance between viewer and object that allows the male poet's eyes literally to touch his lady, since vision was often thought to work by physical rays that actually emanated from the viewer toward the object. Describing the beloved object from head to toe was a poetic convention used by numerous poets, including Machaut, that was not available to artists who had to show the body all at once. But the artist here has managed to suggest

shapen monsters lest their fetus mimic their distorted form, looking was an act charged with danger as well as pleasure. The eyes were linked in Aristotelian theory directly to the locus of feeling in the body – the heart. Andreas Capellanus was careful to describe the inner psychological effect of love in these medico-scientific terms: "For when a man sees some woman fit for love and shaped according to his taste, he begins at once to lust after her in his heart; then the more he thinks about her, the more he burns with love, until he comes to a fuller meditation."

This relationship between outer looking and inner thinking is vividly expressed in a unique manuscript of a thirteenth-century poem, the *Roman de la Poire* or "Romance of the Pear,"

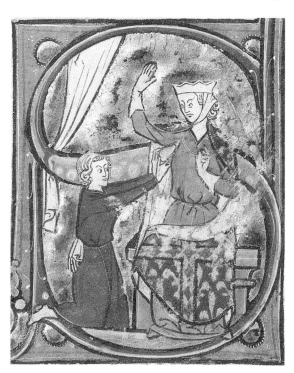

19. Sweet Looks offers the lady the poet's heart, from *Le Roman de la Poire*, Paris, c. 1260–70. Paris, Bibliothèque Nationale, MS fr. 1584, fol. 41v.

which makes the lover's gaze into an actual character, Douz Regart or Sweet Looks (fig. 19). Within the curve of a golden "S" he is pictured kneeling before the lady and offering her the lover's heart. The glove in his belt signals his messenger's status. It is interesting that the poet and artist did not represent the lover kneeling before the lady directly but only through this visual intermediary. The initial "S" opens a short lyric refrain sung by Sweet Looks, the fifth of sixteen that are sung by various characters, such as Beauty and Nobility. These run through the manuscript and together spell out, in acrostic form, the name of the lady, annes, the lover/poet tibaut, and amors. This triangulation, which makes love a relationship between not just two persons but between them and a third, Love himself, is played out throughout this book.

The *Roman de la Poire* is one of the earliest Gothic picture cycles devoted exclusively to *fin'amours* and it has been called a "Psalter of love" because its visual structure, with a prefatory picture cycle as well as large historiated initials embedded in the text itself, is modeled upon manuscripts of those sacred songs of praise. To compare it with an actual Psalter of the same period, made for King Louis IX of France, is instructive (fig. 20). Here in the opening initial to Psalm 1, "Blessed is the man who walks not in the counsel of the ungodly," two different kinds of look are contrasted in the figure of the biblical king David as exemplars for the royal reader of the improper and proper use of the eyes. In the top half of the letter David looks down on an improper object – the naked body of Bathsheba with whom he fell in love when he saw her bathing – while below he kneels looking up to the

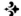

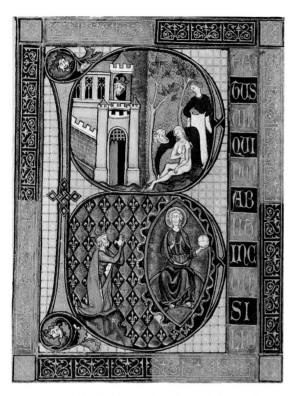

20. David looks down on the naked Bathsheba and
up to God, from the Psalter of St. Louis, Paris, c. 1250–60.
Paris, Bibliothèque Nationale, MS fr. 2186, fol. 85v.

proper object of contemplation – God. Whereas
King David in the Psalter page seems to have a
direct vision of God, albeit separated in a heaven-
ly mandorla, suggestive of a disembodied and
mystical mode of vision, the lover in the *Roman
de la Poire* gains access to his lady only at one
remove, through a personified representation of
the most important of his bodily senses – sight.

This visual distance or gap between the lover
and his beloved is a crucial component of love's
ennobling rapture. In a rare illustrated manu-
script of troubadour songs the images in the
lower margins are cued to the relevant words of
the text above by little signs, such as that of four
dots next to the first figure on the left, who is

shown weeping and which is cued to the word
"eyes" in the text (fig. 21). This poem by the trou-
badour Foulqet de Marseille complains of the
suffering caused by his eyes, which not only see
but also weep. To his right is the Love, personi-
fied as a crowned seraph, with six wings and
three faces. Next we see the lover attempting to
embrace the lady but she resists. In the middle
Love reappears flapping its wings and the poet
flees from Love toward the lady, who in turn
flees him. This illustrates the paradoxical situa-
tion described in the poem: "I flee that which
pursues me and pursue that which flees me."
The dark blue of the lady's robe and the wings of
the seraphic Love help suggest that the lover
flees and pursues the same thing. This manu-
script represents one of the most carefully
worked-out attempts to analyze love in visual as
well as verbal terms and to show the psycholog-
ical complexity of the lover's situation as both
pleasure and pain, attraction and repulsion.

But the lover's separation from his lady does
not mean separation from her image. Another
of Guillaume de Machaut's poems, *Le Livre du
Voir-Dit*, which means "true story," has been
described as an autobiographical account of the
ageing poet's relationship with a real woman,
much younger than himself. He conducts a
whole love affair via an image of his fifteen-year-
old beloved, Toute Belle. She sends him her
three-dimensional portrait, which he worships
as if it were an idol of the goddess Venus. The
image even seems to transform before his eyes,
its dress turning green for inconstancy when he
suspects his young friend of being unfaithful.
When Toute Belle suddenly stops writing, the
despondent poet locks her image in a coffer but

is then plagued by dreams of the statue calling out to him from its prison that she has done nothing wrong. Rejuvenated by another amorous missive, he once more orders a servant to unlock the coffer and bring her *ymage* to him, which he finds sweetly smiling and no longer green. A delicately drawn grisaille miniature in a manuscript made in Machaut's lifetime depicts this moment (see fig. 17). Here the image is a painting rather than a statuette, of a young lady posed full length. The poet is drawn touching the frame as if to emphasize its status as an impenetrable image, only a simulacrum of the longed-for object. This scene is a perfect expression of the way in which images were crucial to the structuring of desire, not merely reflecting but enabling the process of love to continue. We know that Machaut's royal patrons actually utilized pictures in making choices about their politically motivated marriage-matches.

According to chroniclers, the thirteen-year-old king Charles VI was given the choice between three painted portraits of princesses: "He saw three and he chose the most beautiful," deciding upon Isabeau of Bavaria in 1385.

One of a series of model-book drawings on prepared boxwood panels made in Paris at the end of the fourteenth century depicts what I believe may be the first "face-to-face" meeting of this couple, in Amiens on 14 July 1385. On the left of one sheet a profile of a pouting boy stares rather self-consciously while a beautiful girl wearing a garland looks demurely down (fig. 22). The distinct physiognomies of the two faces are close to those public sculpted portraits of the King and Queen that still exist at Poitiers and on their tombs at St. Denis. But here we are far from state portraiture. This is an intense personal moment for the young people involved, but one that was nonetheless viewed by many eye-

21. The fleeting object of the lover's gaze, from a *Chansonnier*, Padua, c. 1280. New York, Pierpont Morgan Library, MS 819, fol. 56r.

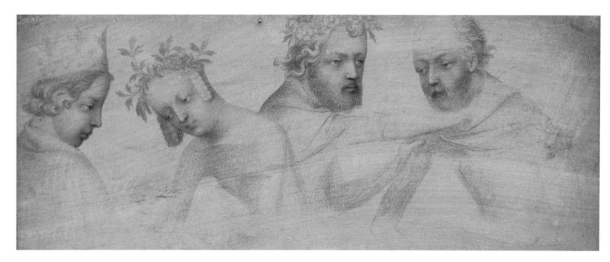

22. Charles VI first beholds Isabeau of Bavaria, and a mysterious male couple. Model-book made in Paris, c. 1390. Silverpoint on bookwood panels prepared with gesso, 5 x 6³/₄" (13 x 17 cm). New York, Pierpont Morgan Library, MS M. 346, fol. 2v.

witnesses. According to the chronicler Froissart, Isabeau bowed to her new lord and he himself bent down toward her so that their faces came close. "With this look," wrote Froissart, "pleasure and love met in his heart for he had seen beauty and youth and he had a great desire to see it and to have it." This moment was not "drawn from life" of course, but is a fantasy reconstructed by a court painter, perhaps Jaquemart de Hesdin, some years after the events. Even more intriguing is the embrace of two men on the same panel. The younger of the two, like the queen, wears a garland and places his hand inside the hood of the other. Scandals surrounded the Parisian court at this time, especially the figure of Charles's brother the Duke of Orleans described by chroniclers as enormously seductive to both women and men, and who, before his murder in 1407, was reputed to have had an affair with Queen Isabeau. The model-book does not contain a series of standard types but girls tweaking the noses of wildmen and other dis-

turbing dalliances. If this particular leaf contains, as I suggest, the "loves" of Charles VI and his infamous brother, it was surely not meant to be made public, but was kept in a closed box of precious drawings that artists such as Jacquemart increasingly guarded as their private property. In 1398 this very artist was accused of stealing such models from other artists.

Just as our own contemporary fashion industry presents eroticized images for the consumption of a predominantly female audience, many of the images reproduced in this book that objectify women's bodies as objects of desire do not preclude their being enjoyed by women as well as men. Able to look at other women and images of other women more easily than those of the opposite sex, the courtly lady was caught in something of the same self-spectacularization that haunts our own consumer society. This can be seen in an Italian twelve-sided birth tray, known as a *desco da parto* (fig. 23). This image seems at first to reverse the male logic of the gaze and to

empower the female object. The famed lovers of fable and antiquity, identifiable from inscriptions on their clothing as Achilles, Tristram, Lancelot, Samson, Paris, and Troilus, are painted kneeling in a lush garden and staring up at the naked goddess Venus who floats above them in a mandorla, just like that in which the Virgin Mary is usually assumed to heaven. This dark-winged Venus has subdued the earthly warriors of love in the verdant meadow below, whose fruits also bear the mark of her generative influence on nature, through the power of her pudenda. The golden sight-lines do not go from male subject to female object, but following the pictorial convention by which the rays of heavenly bodies like the sun shine *down* upon the earth, the beams that emanate from Venus's vagina strike the faces of the kneeling lovers below. The contemporary Italian poet Boccaccio had written: "Venus urges on whatever in nature is slothful to continue and increase itself. Therefore carnal pleasure in man may be approved." But this apparent potency of the object of desire turns out here to be illusory once we realize what this image was made *for*. This birth tray was made to function in the ritu-

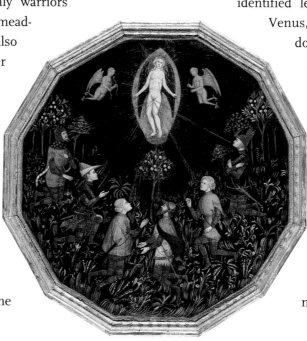

23. *Venus Venerated by Six Legendary Lovers.*
Birth tray made in Florence, c. 1400. Tempera on wood, diam. 20" (51 cm). Paris, Musée du Louvre.

als following childbirth. For the husband who would have had this object made as a gift to his wife for presenting him with offspring (preferably male), the image of the celestial and venereal Venus simultaneously ennobled his own lower appetites and celebrated his wife's productive capacities. Lying on her back during her confinement, the first recipient of this tray might have identified less positively with this Venus, who appears pinned-down and vulnerable in her triumph.

We should not be afraid of reading "against the grain" of the iconography where a particular context warrants it, as is the case here. What looks like a straightforward representation of the power of women over men turns out to articulate just the opposite when we look at it from the point of view of its user. The idea that a picture articulates a particular subject-position was not very developed in more traditional medieval religious narrative. There the whole point was to present the events pictured as historical truth happening from no individual point of view, except perhaps for God's. But often in objects of secular art the direction of the gaze's power is obvious. It is also important to remember that

images and things do not only embody a particular viewpoint but were meant to be used and viewed by a particular kind of body. The question we must keep asking of these fragments of glances and signs of stares is whose desire is being represented? The answer, with a few fascinating exceptions, most often turns out to be that of the male poet, knight, cleric, or artist. Students of medieval literature and history have long understood the deprecation of the feminine and the male narcissism that is inherent in the medieval art of love. But art historians have been less able to see, in their more material manifestations of desire, the cracks and distortions in what many still consider to be an idealizing mirror held up to medieval life. The elegant gestures and subtle symbols structuring these representations of courtly couples serve not to articulate the harmony between a man and a woman, so much as to highlight the coercive manipulation that forever splits them apart, opposing masculine and feminine within the image as irreconcilable sites and sights of difference.

24. Lavinia falls in love with Aeneas from a tower, from Heinrich von Veldeke's *Eneide*, Regensburg, c. 1215. Berlin, Staatsbibliothek, MS germ. fol. 282, fol. 66r.

SHE LOOKS AT HIM

There are a few examples of love-at-first-sight affecting a female subject in medieval art. One striking example is a half-page picture in the illustrated Middle-High German version of the *Aeneid* by Heinrich von Veldeke (fig. 24). Here a talented artist, working with only the rather limited pictorial repertoire he had inherited for depicting the lives of saints, strove to represent the new psychological interiority of love. According to the text opposite this half-page miniature, "Lavinia was up in the tower. She looked down from a window and saw Aeneas, who was below. She gazed intently at him above all. There where she was standing in her chamber Love struck her with his dart. Now she had fallen into the snares of love; whether she wishes it or not, she must love." The following pages illustrate her curled up in agony as "she began to perspire, then to shiver, then to tremble. Often she swooned and quaked. She sobbed and quivered. Her heart failed; she heaved and gasped and gaped." At the first instance of looking Lavinia is mute. The speech scroll that serves to represent extreme emotion throughout this manuscript is not shown here. That her feelings are all turned inward is also suggested by the position of her head in the arched window of the tower. Even though she is supposed to regard Aeneas from a high tower it is interesting that the artist has kept his head above hers and makes his return gaze just as strong. He is not content to be looked at but must look in return and, unlike the dumbstruck Lavinia, his long pointing finger suggests his speech. Earlier in the same

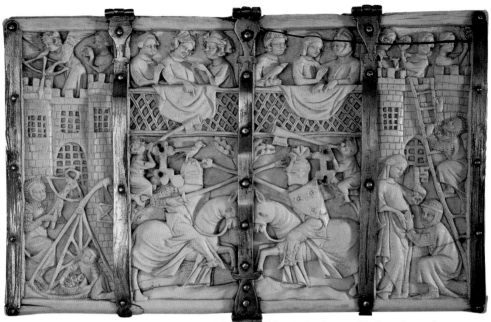

25. Ladies watch knights jousting, and the siege of the Castle of Love. Lid of a casket made
in Paris, c. 1320. Ivory, 10¹/₄ x 6³/₄" (26.2 x 17 cm). London, British Museum.

manuscript the artist had represented the excessive and uncourtly love of Dido for the same man as leading to her suicide. Here, by contrast, the noble and uplifting quality of Lavinia's love is emphasized.

The *Ménagier de Paris*, which was written around 1394 by a Parisian husband for the instruction of his fifteen-year-old wife, stated: "If you are walking out go with your head straight forward, your eyelids low and fixed, and to look straight before you down to the ground at twelve yards without turning your eyes on man or woman, to the right or to the left or staring upward or moving your eyes from one place to another, or laughing or stopping to talk to anyone in the streets." Recent feminist theory has emphasized, quite rightly, the cultural predominance of a scopic regime in which women tend always to be the objects of the male gaze. But

women too could look for themselves and certainly in literary works, as well as in a few visual images, we witness the female viewing the male and an eroticization of the male body. But by contrast to that of the female, which is always presented as naked (like Venus in the birth tray), as open to the gaze, the male body is all surface, a carapace or hard shell surrounded by and protected by armor and heraldry that announces its strength and impenetrability. Whereas Lavinia beholds Aeneas from the opening of the tower – a building type that, as we shall see, is often used to represent the vulnerable female body – he is shown as a mounted knight entering the city, an image of armed invulnerable action.

Two ladies centrally positioned as the preeminent spectators look down on knights jousting from the lists on the lid of an ivory casket (fig. 25). Many churchmen criticized tourna-

ments not just as idle games that diverted warriors from the battle against the infidel but also because they effeminized males by making them the decorated objects of female desire. In the siege of the Castle of Love represented on either end of the lid it seems that knights in armor have indeed been softened. One jouster is wearing a helm in the shape of a bird, the other's shield is emblazoned with three roses, erotic signs that absorb the gaze of the spectators. Actual tournaments served, like this fantasy one, to construct male social identity. Although in some parodic marginal images ladies enter the lists themselves to joust with their loves, the proper position for the lady within this ritual of chivalry was as the inspirational sign, the knight bearing her favor or gage and fighting to win her love as the prize. In Gottfried von Strassburg's *Tristan* (c. 1210) the women of King Mark's court enjoy Riwalin's jousting from the same distant but admiring position as those watching in the ivory. Whereas, as we saw, the male gaze tends to linger over, penetrate, and even to undress the static form of the female body, the look of these ladies is more social and collective in its admiration of the male body in action:

> Look! the youth is a fortunate man: how wonderfully everything he does suits him! How perfect his body is! How his legs, worthy of an emperor, move in and out together! How firmly his shield remains glued to its spot at all times! How the spear becomes his hand! How all his clothes look good on him! How he carries his head and hair! How gracious

are all his movements! How excellent he is! Fortunate is the woman who will have lasting joy from him!

In the same way as the language here, the visual forms of the ivory present the male bodies in combat in terms of symmetry and geometrical patterns created by the interaction of the knight and his armor. Whereas it is always the flesh that announces the female as an object of the gaze, for the male object it is this impenetrable carapace of chivalry.

One of the functions of images of knights in medieval society was to demarcate the position, role, and appearance of men as distinct from women. But sometimes the knight did not just carry an item of his lady's wardrobe, her garter or veil, as a gage but wore them in a kind of cross-dressing. This incorporation of feminine excess served to pre-empt and deflect any criticism of the knight's emasculation. In one striking example a great German knight not only wears his lady's favor, he becomes her (fig. 26). This is Ulrich von Liechtenstein, who has a crowned Venus crest on his helmet – a reference to the main narrative of the *Frauendienst* in which the poet, disguised as Venus, emerges from the sea at Venice to undertake a knightly expedition. What looks like one of the most conventional of the 137 full-page portraits of love poets in the Manesse Codex, in a hierarchical arrangement according to their supposed social station, turns out to be a much more playful interpenetration of male and female signs. Venus on the helmet holds her attributes, the arrow of love and the firebrand of passion. In the spectacle of war it was the resplendent male strung with symbols

26. Ulrich von Liechtenstein with his Venus helm, from the Manesse Codex, Zürich,
c. 1300. Heidelberg, Universitätsbibliothek, Cod. pal. Germ. 848, fol. 237r.

such as this that struck all onlookers as an object of desire. Love-gifts could be given to men by men: for example, after a battle at Calais in 1350 King Edward III gave the prize of a chaplet of pearls to a French knight Eustace de Ribemont, whom the English had taken prisoner, for being the best warrior on the field and begged him to wear it "for love of me." Armor, which served to protect the knight on the battlefield and at tour-naments, became not only elaborately fashioned and the focus of the metalworker's art, but sym-bolic of the male body itself.

The only male body in medieval art that is truly naked and open to the gaze of male and female desire is that of Christ. In a manuscript made for a nun who saw herself as the bride or *Sponsa* of Christ in the Song of Songs, one opening shows how violently this other love-longing could be

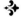

27. The *Sponsa*'s mystical vision of Christ's wound, from the *Rothschild Canticles*, western Flanders,
c. 1320. New Haven, Yale University Beinecke Library, MS 404, fols 18v–19r.

visualized (fig. 27). Here the bride is ready to thrust a lance, like that of the centurion Longinus at the crucifixion, into the side of her beloved across the page; he looks back toward her and points at the gaping wound in his side. She points to her eye with her left hand as if to emphasize the erotic ocularity of this penetration. These two pages are based on the Song of Songs (chapter 4, verse 9): "Thou hast wounded my heart, my sister, my spouse," a violent expression of the other meaning of passion – pain as well as ecstatic love, in which Christ took on the role of the beloved bridegroom. His elegantly elongated body, hanging between the pillar of the flagellation and

nailed by one hand to the wood of the cross, is unusually and audaciously totally naked, turning coquettishly to hide his sex but revealing large swelling thighs. Only by becoming a female body was it possible for God to become the focus of an eroticized gaze. The woman who owned this little volume, probably a nun in a Flemish or German convent at the turn of the fourteenth century, was positioned to construct her own visions of mystical union with Christ, empowered to construct her own desire in a way that her courtly counterpart never could be. Christ's finger returns to his own wound, in relentless self-exposure, making this not a reciprocal circuit of desire, but, like all mys-

tical images, one that is radically inverting of normal patterns. The gaze still only goes in one direction, toward the female Christ from the male-female's phallic spear. Just as Christ's feminization allows him to become an object of desire (for male as well as female devotion) here the woman's masculine role as bearer of the phallus is what makes her vision possible.

WHO LOOKS AT THEM?

Issues of gender are also important in the earliest representations of Love as a power beyond the human, an abstract force existing outside the lovers themselves. The God of Love is not blind in medieval art. Rather, he has all the bold, apotropaic power of an icon of Christ, staring out at us, the readers of the manuscript, and ready to shoot his next arrow in the very first full-page image in the *Roman de la Poire* (fig. 28). As Erwin Panofsky charted in a famous essay, the blind Cupid of classical mythology – with all the associations of ignorance and darkness – was replaced in the Middle Ages by a deity who is, like God, all-seeing. From his central position, usually in a tree, like a serpent in the Tree of Life

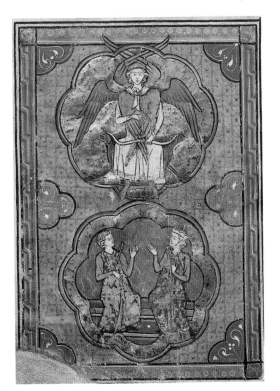

28. The God of Love shoots arrows at the two lovers, from *Le Roman de la Poire*, Paris, c. 1260–70. Paris, Bibliothèque Nationale, MS fr. 2186, fol. 1 v.

in courtly disguise, he watches the lovers as the ultimate voyeur. Ovid had long before invented the metaphor of Cupid's arrow which starts their suffering with its sting of pleasure and pain, but it was the thirteenth-century poet Guillaume de Lorris who more audaciously likened the God of Love to "an angel descended straight from heaven." This was in the first part of the *Roman de la Rose* where we read how "When love saw me approach he did not threaten me, but shot me with the arrow that was made of neither iron nor steel, so that the point entered my heart through my eye." These two organs, eyes and heart, are in play in the *Poire* miniature too, where the God of Love shoots arrows at the two lovers into their hearts, but they also look at one another, as if suddenly seeing the beauty of the other at the very same moment. Painted in the thirteenth century when gender distinctions in dress were not so marked and when both men and women wore similar long, loose-flowing robes, the two can be distinguished only by their positions, the man on Adam's side and the woman on Eve's, and by her covered head (long flowing hair was always an attribute of loose women). In all other respects,

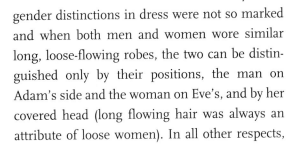

however, their bodies and gestures of astonishment form an uncanny symmetry and an equality of looks that indicates their attraction ("like attracts like"). These repetitive and rather static figures seem awkward to us today, since we associate love with spontaneity of feeling and expression. But for medieval people conventions and stereotypes produced intense pleasure precisely because their forms were known in advance and could be inhabited by viewers far more readily, like a well-loved robe.

The dart fired by the God of Love is shown as first entering the lady's eye as she accepts her kneeling lover's petition on an ivory mirror case (fig. 29). But its tip can also be seen protruding from the back of the man's head as he faces in the same direction. Again in this example, it is not their bodies that differentiate the male from the female, or their dress,

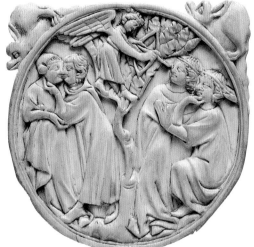

29. The God of Love shoots his arrow into the eye of a woman. Mirror case, Paris, c. 1320. Ivory, h. 3¹/₂" (9 cm). Cluny, Paris, Musée du Moyen Age.

which is almost identical. It is what they do. This lady unusually is shown chin-chucking her kneeling suitor but at the same time she twists her body and turns away from him. It is as if she has to look away from her partner toward Love himself, in order to fall in love. The two arrows depicted in the *Roman de la Poire* represented the simultaneity of falling in love, whereas this image evokes the sequence and perhaps even violence of joining two heads on one skewer.

It is very unusual that the arrow makes its mark anywhere else but in the eyes or heart. The witty illustrator of an Italian version of the *Lancelot* romance has his young hero struck by Love's arrow not in the eye, but in the crotch (fig. 30). The unusual backturned figure makes him, like us, an external viewer of Guinevere as she rides by. It also reveals his curvaceous rump and elegant legs, typical of later fourteenth-century fashions that began to eroticize the male body for the first time. The male body was just as rigidly controlled in medieval culture as the female. As male dress became tighter, the padded jacket or *pourpoint* emphasized the broad shoulders and thin waist, as well as making more visible the buttocks and legs, which had previously been covered by long robes. Significantly, however, whereas the woman is always presented frontally, this male object of desire is here seen from behind. Something else that suggests the self-consciousness of male desire is the figure of Love himself, whose gaze also focuses on its target – Lancelot's crotch. In mid-fourteenth-century manuscript illuminations of the *Roman de la Rose*, as in this Italian miniature, Love is a gorgeous curly-haired young courtier. The God of desire has become himself an object of desire.

Further north the power of love was not embodied in a male deity who mirrors the desire of the subject, but takes on the form of the object – "Frau Minne." German poets and manuscript illuminators often personify Love as a naked female figure, partly because of the feminine nouns *Liebe* and *Minne*, but also because in the north Ovid's influence was less marked. This introduces an ambiguity, since it is sometimes hard to tell whether the woman firing the arrow is meant to be a personification of Love or an image of the beloved in particular. Such a lover surrenders with his wrists crossed in submission to his lady, who points the arrow of love at his heart, on the painted inside lid of a small German oak casket (see fig. 16), not much bigger than a shoebox and related in style and date to the famous Codex Manesse manuscript now in the Cloisters Museum, New York. Arming the woman with the bow and arrow would seem at first to empower the female gaze upon a male object. But at these moments in the poetry at least, it is not her look that is emphasized but the male being "captivated" by the beauty of his beloved, making the male the wounded victim, a slave of love, in a tradition known as the *Minnesklaven*. This works to empower him as a subject since it makes him the suffering victim. The inscriptions on this box clearly function in this way and give him a voice: the one on the left reads *Genad frou ich hed mich ergeben* ("Gracious lady, I have surrendered").

Boxes such as this were gifts in the game of courtship, receptacles in which the groom sent his future bride jewelry at that stage in the process when the two had not yet seen each other but after the marriage had been arranged by the parents. Thus the object had to symbolize "love at first

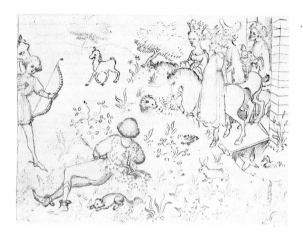

30. Bonifacio Bembo
The God of Love shoots his arrow into Lancelot's genitals, from *Historia di Lancilloto*, Milan, 1446.
Pen and ink drawing on parchment. Florence, Biblioteca Nazionale, Cod. pal. 556, fol. 58v.

sight" and the piercing arrow of desire for two young people whose minds had already been made up for them by their parents. That such objects were fashioned at the man's expense is suggested not only by documents of the period but also by the form of this box, which was meant to be viewed open. Only then would it have fully displayed the suitor on the lid and his gift in the form of money and jewels within. The cusped Gothic arches framing the figures are reminiscent of church architecture and suggest their eventual union as do the arms of a noble Rhineland family that fill one third of the lid. Once again, what looks like a very private and intimate object turns out to be a public statement about financial as well as erotic commitment.

The term *Minnekästchen* or "love coffers" was invented in the nineteenth century to describe these objects, which were known as *coffrets* or *Kistlin* at the time. Usually made of wood either carved or covered in metal or stamped leather,

31. *"Looking At This Will Then Make You Remember."* Casket with lovers around
the lock and two pairs of lovers on the lid, France, fourteenth century. Leather, 5 x 10^1/$_4$ x 7^1/$_4$"
(12.5 x 26 x 18.5 cm). Cluny, Paris, Musée du Moyen Age.

their decoration is related to their function with-
in courtship. The anxiety of looking must have
been intense for the young couple as they caught
the first glimpse of a partner chosen for them by
their families. The outside of one leather exam-
ple is inscribed with the Flemish words *Aen sien
doe doet ghedenkren*, or "Looking at this will then
make you remember" (fig. 31). The front side
shows two lovers peeping at each other around
the large hinged clasp and lock, the woman offer-
ing the man her belt, which she slides beneath
the lock. His gift is this very box. The woman is,
as we would expect, on the side of the keyhole,
which indicates her closed and virginal state.
Marriage was literally the key to open the box and
penetrate the body. But looking at the beloved,
inspecting the goods in the mutual exchange of
gifts and glances depicted here, had to come first.

Voyeurism is a major theme not only of
medieval courtly literature but also of images
associated with love. One of the most commonly
depicted scenes from a medieval Romance narra-
tive was that part of the story of Tristram and
Isolde where the couple are spied upon beneath a
tree by Isolde's husband King Mark, but they
notice his reflection in the water of a pool below
and thus are able to make it appear as though
their liaison was not intimate. Known as the "tryst
beneath the tree," this became an isolated subject
appearing on misericords and church sculpture
as well as mirror cases, boxes, combs, and even a
leather shoe excavated in The Netherlands. One
of the 57 cataloged examples of this theme in
medieval art is a beautiful enamel goblet base pro-
duced in Avignon (fig. 32). In one of its splayed
compartments King Mark's reflection appears in

32. King Mark watches Tristram and Isolde
from the tree. Enamel goblet base made in Avignon, c. 1320.
Milan, Museo Poldi Pezzoli.

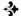

33. Giovanni di Paolo

Dante, the sun of love burning on his chest, encounters shadowy figures like those reflected in mirrors, from Dante Alighieri's
Divina Commedia (*Paradiso* canto iii), Siena, c. 1445. London, British Library, Yates Thompson MS 36, fol. 133r.

a circular pool and is pointed out by Isolde seated on the right. A perfect subject for a drinking vessel since it invokes the virtue of attentive moderation in pleasure, as we lift the cup to examine the subject or to drink from it our own reflections shimmer in the mirror-like metal, suggesting that we too are eavesdropping on the glistening lovers' tryst below. The viewer's own reflection, like that of King Mark, is evidence of our presence in the image, like our reflection in the eyes of the beloved. There is always someone else watching. Lovers are never truly alone in either song, poetry, or image since they are always figments of someone else's consciousness.

This reflection in the pool brings us to one of the most important but also misunderstood archetypal images of medieval love and looking – that of Narcissus. The most rarefied and elevated discussions of the power of love as vision

is Dante Alighieri's *Divina Commedia* of the early fourteenth century, which could be described as an allegorical vision of love, especially the *Paradiso* inspired by the poet's adoration of Beatrice and the everlasting vision of God that awaits the blessed. In the Sienese artist Giovanni di Paolo's rendition of *Paradiso* canto iii we see the poet, the sun of love burning on his chest floating upward after his beloved (fig. 33). Dante sees what appear to be shadowy, unclear faces, like those reflected in mirrors or in water. Yet Beatrice tells him that these are not illusions but real. Relying on his physical perception rather than spiritual sight, Dante too quickly accepted the evidence of his senses. The gifted artist contrasts this true vision that Dante has of the two Poor Clares Piccarda di Donati and the future Empress Costanza, shining within the white crescent of the moon, with two

examples of false vision on the ground below. The first shows a male figure looking in a mirror (most mirror-gazers in medieval art are female) and the second Narcissus at the fountain, who is specifically mentioned by Dante as an example of one who took the wrong image to be true. The higher power of visionary experience is thus compared with ordinary seeing, which is mere reflection.

This myth takes us to the heart of the medieval mistrust of representation. In the *Roman de la Rose* Narcissus had refused the love of the nymph Echo who died of grief, praying that "he who was so indifferent to love, might one day be tormented by a love from which he could expect no joy." Returning from a hunt one day, the youth bends over to drink from a fountain, "and saw his face, his nose, his mouth, clear and sharp. Then he was struck with wonder, for these shadows so deceived him that he saw the face of a child, beautiful beyond measure." Falling in love with his own reflection, he remained besotted by the watery reflection and died. The moral as drawn by Guillaume de Lorris is quite different from Dante's use of the story. It becomes a warning to women not to allow their lovers to languish alone and die like this youth! "Thus did he receive his deserved retribution from the girl whom he had scorned. You ladies who neglect your duties toward your sweethearts, be instructed by this exemplum, for if you let them die, God will know how to repay you well for your fault." The male Narcissus staring into the pool that will never return his desire thus becomes, from Guillaume's perspective, a model not of male desire but of the unresponsive coldness of the beloved.

The sin of Narcissus was not falling in love with himself, as in our modern Freudian notion of narcissism, but with an image. It is a myth about the thrall of art that especially in the fifteenth century became more and more a surface of illusion. Even a medium as materialistic as tapestry was able to suggest the watery reflections in Narcissus's pool within its warp and weft (fig. 34). This association with the creation of exquisite art objects was why the myth was so powerfully resonant in medieval love poetry – it emblematized the way in which the reflection in the water could take on a life of its own. In addition to the youth in all his finery and plumage, the tapestry contains another self-obsessed creature, the pheasant, who shares the youth's mirrory grave in observing his reflection in the water. In *Le Livre du Chase du Roy Modus* (before 1377) the pheasant is described as a bird that can be trapped using a mirror, not because he thinks it is himself but because he mistakenly believes it to be a rival after his mate, making him "jealous of his own reflection." Many of the other animals in the background of the tapestry also refer to vanity. Some art historians have seen in Narcissus's closed circuit of desire a homo-erotic impulse toward doubling, the male need to produce another like himself, while others have argued for the figure's feminization, representing woman as surface compared to man as substance. Yet the paradox of the image of Narcissus is surely that this youth has no identity, losing himself in the watery grave of image obsession. The humanist art theorist Leon Battista Alberti in his *Della Pittura* of 1436 described Narcissus as "the inventor of painting according to the poets ...

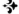

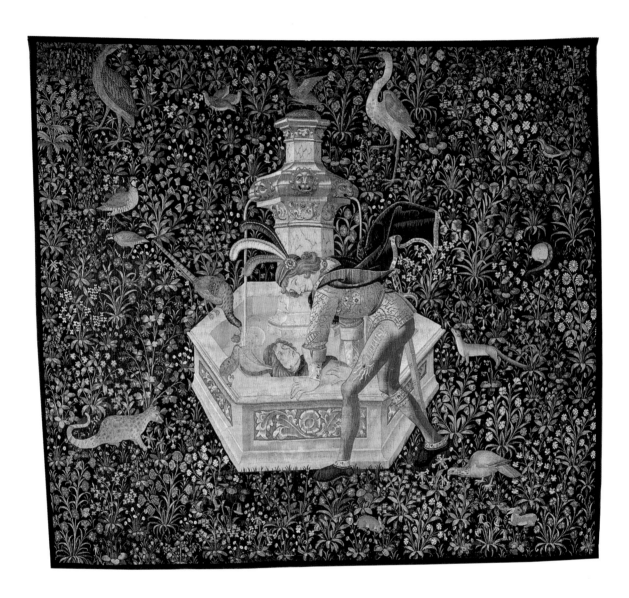

34. *The Gaze of Narcissus.* Tapestry made in France or
the Southern Netherlands, c. 1500. Boston, Museum of Fine Arts.

What is painting but the act of embracing by means of art the surface of the pool."

Significantly, no ivory mirror-backs have survived from the Middle Ages that depict the story of Narcissus. This is not surprising, considering its anxious instability around the act of looking itself. The only mirrors that are represented on the backs of mirrors are those belonging to the lady in another important medieval myth of being captured by an image, that of the unicorn, which is trapped by a young virgin used as a lure by hunters. In a fourteenth-century enamel medallion, perhaps a mirror-back, the hunter is able to spear the beast who has been enticed into the role of lapdog of a beautiful young virgin, just as the story is recounted and illustrated in the popular collection of beast-allegory, the Bestiary (fig. 35). This image was one of those that crossed from sacred to profane significance: the virgin girl is described in the Bestiary as the Virgin Mary who is necessary for the unicorn – that is, Christ's sacrifice. In this mirror, the lady is shown luring the unicorn with a mirror. But something remarkable happens to this attribute. What should be an object of her own self-regard, she holds out instead to catch the reflection of the beast. The unicorn is not usually one of those creatures, like the panther or monkey, that the Bestiary describes as fascinated by its own reflec-

35. *The Virgin Traps the Unicorn.* Medallion from Paris, c. 1320–30. Enamel and silver, diam. c. 2³/₄" (7.03–7.0 cm). Munich, Bayerisches Nationalmuseum.

tion. The mirror may have joined the iconography here as part of the virgin's attributes, linking her to the sin of *luxuria* and Idleness's mirror in the *Roman de la Rose*. But mirrors, like every other object in medieval art, have no single uniform significance but can mean a multitude of things, depending on the context. The mirror could also be a symbol of the faithfulness of love.

In the mid-fourteenth-century *Roman de la Dame à la Lycorne* the poet likens his beloved to a "mirror, clear, shining unsullied" in which he could see himself and also the love of his lady. Another explanation for the appearance of the mirror on the mirror case here could be the more mundane result of the artist miscopying from a model-book or an ivory that showed the lady trapping the unicorn holding a chaplet (see fig. 40) and misinterpreting it as a circular mirror. But even if this was no more than an artist's blunder, the mirror in the unicorn's capture was to reappear again later in our final example of love's looking.

The most powerful and paradigmatic example of self-regard and probably the most famous image reproduced in this book is the tapestry representing the sense of sight (fig. 36). Made for Jean Le Viste, a powerful royal administrator who was President of the Court of Aids between 1484 and 1500, it is one of a set of six large

tapestries depicting *Sight, Taste, Hearing, Touch, Smell*, and another subject that were made for the walls of one of his princely residences. Le Viste's emblems were the lion (his family were from Lyon) and the unicorn, renowned for its swiftness (the word *vitesse* punning on his name). The patron is thus positioned within this image, as he is in all six tapestries, as the subject looking, as the unicorn epitomizing speed, action, and desire. Many wonderful stories have been woven around the origins of these tapestries, seeing them as marriage gifts to a bride, carrying secret encoded messages in their love-knots and devices, and seeking to reveal the identity of the mysterious woman depicted in them. This woman, however, has no identity. Assuming the traditional symbolic position of the beloved, she wears the allegorical dress of the Five Senses. She is not one but five different women, each a facet of Le Viste's fantasy of self-regard. There is no better conduit for the authority and anxiety of male desire than the unicorn, an animal that never was. Like many of the images described in this chapter, what looks at first like a mutual glance turns out to be the gaze of autoeroticism. The unicorn is a voyeur only of himself, just as many of the medieval images of the art of love that we like to think idealize a relationship between male and female are actually one-sided viewpoints, articulating male identity. The sad, empty ovoid of the lady's face here seems to register, perhaps with sullen resignation, perhaps with wistful sadness on the part of the artist, some awareness of her secondariness, of her being the mere channel of desire, its object and not its subject. For at the very instant that she has played her assigned role and her purity and virginity have served their purpose of capturing the magical, phallic beast, the unicorn (Le Viste) looks no more into her eyes. He is staring absorbedly, just as the owner of this tapestry would have, only at his own superb reflection.

36. *Sight*. One of the hangings from *The Lady with the Unicorn*, a set of six tapestries made in France or the Southern Netherlands, c. 1500. Cluny, Paris, Musée du Moyen Age.

CHAPTER TWO

LOVE'S GIFTS

A lover may freely accept from her beloved these things: a handkerchief, a hair band,
a circlet of gold or silver, a brooch for the breast, a mirror, a belt, a purse, a lace for clothes, a comb,
cuffs, gloves, a ring, a little box of scent, a portrait, toiletries, little vases, trays, a standard as
a keepsake of the lover, and, to speak more generally, a lady can accept from her love whatever small
gift may be useful in the care of her person, or may look charming, or may remind her of her lover,
providing, however, that in accepting the gift it is clear that she is acting quite without avarice.

Andreas Capellanus

Among the 137 portraits of the Middle-High German love-poets or *Minnesänger* in the famous Manesse Codex is one in which the subject seeks to earn the love of a lady, not through knightly service or feats of bravery, but through the ostentatious display of things. Dietmar von Aist disguises himself as a travelling pedlar and arrives with his well-packed mule at the lady's castle to show off his wares (fig. 38). Dietmar's disguise involves him displaying a range of

37. Game with a hood. *Aumonière* made in Paris c. 1340.
Couched gold and silver threads on linen, 6¹/₄ x 5¹/₂"
(16 x 14 cm). Hamburg, Museum für Kunst und Gewerbe.

Gothic objects that are associated with women's bodies and examples of which still exist today in museums around the world. These luxury items – mirrors, belts or girdles, and purses – will be the focus of this chapter. The courtly pedlar holds out a brooch or clasp, in German *asp*, and thus a pun on his name ("Aist"), while his other hand holds the reigns and points to his mule, another playful allusion to himself (*Diet mar* means "the people's mule"). The lady, holding her lapdog in one hand, fingers the golden end of one of the hanging belts with her other. Representing the body and its parts, objects were more than fetishes in the modern sense:

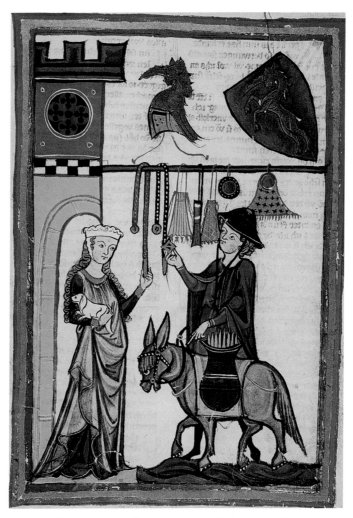

38. Dietmar von Aist disguised as a pedlar woos his lady with his wares, from the *Manesse Codex*,
Zürich, c. 1300. Heidelberg, Universitätsbibliothek, Cod. pal. Germ. 848, fol. 64r.

they served as social as well as sexual conduits of desire.

The important difference between a gift exchange and a commodity exchange is that a gift establishes a feeling or a bond between two people, while the sale of a commodity offers only a formal transaction. By presenting himself in the guise of a seller of things, Dietmar is in fact going against the courtly notion of the gift, given freely and out of love, ironically playing a role that no lover would want to assume. Lovers were not meant to be merchants but nobles. There were two basic pictorial conventions for showing a person's ownership of things in the Middle Ages. The first had negative connotations and shows a figure who places things in a chest, hiding them, as it were, from public view as personal possessions. This was how the vice of Avarice was

carved on the cathedrals of Chartres and Amiens. The second is used to suggest items for display in a public rather than a private context and presents them hanging on a rail, as here. Each of the things displayed – girdle, purse, and mirror – has a powerful symbolic and social significance. It would be wrong to associate them solely with women, since men were just as likely to receive and wear girdles made of leather and sets of jewels, brooches, rings, collars, and chaplets.

In his description of the markets on the right bank of the Seine in Paris, the early-fourteenth-century writer Jean de Jandun described how "On display here were all the objects to adorn the different parts of the human body: for the head, crowns, chaplets, and bonnets, ivory combs for the hair, mirrors for looking at oneself, belts for the waist, purses to suspend from them, gloves for the hands, necklaces for the breast, and other things of this type which I cannot list, because I lack the Latin terms for these objects." Images here outpace language's capacity to describe them and commodities far outstretch any Latin vocabulary in the new phantasmagoric world of objects. But probably the most important fact we forget today about these costly gifts was their exclusivity in terms of social status. The prerogative of the nobility, a French royal ordinance of 1283 ordered that "no bourgeois or bourgeoise ... shall wear or be allowed to wear gold or precious stones or girdles of gold or set with pearls or coronals of gold and silver." Such sumptuary laws, which were increasingly enforced throughout Europe by the end of the fourteenth century, as increased wealth brought social mobility and availability of commodities, were aimed especially at regulating lower-class female bodies from

becoming objects of fascination through their excessive fashion and at the same time keeping certain textiles, furs, and jewels as the exclusive symbolic property of the nobility. They were also gendered. In the *Yconomica* of the German canon Konrad von Megenburg (1309–74) women are described as having a greater right to costly dress and jewels, not only because they can preserve sumptuous raiment longer than a man since they labor less but "also it is more fitting that a woman should chain a man to her by her pleasing attire than the contrary, for a bird of freer flight requires the greater art in its pursuers."

Medieval culture was a gift-culture similar in some ways to those studied by modern anthropologists such as Marcel Mauss. Nothing was handed over free from the implications of reciprocity and contract. Gifts were given and repaid under obligation. Ceremonial exchange knitted communities together but also bonded persons so that, both in matrimony and as a prelude to it, gifts were fundamental to the courtship process. Just as the troubadour Giraut de Bornelh (c. 1162–99) described, "If the fair one, to whom I am a gift, is willing to honour me," the gift is most often represented as going from a man to a woman. But the gender of the gift itself is, as we shall see, more complicated. The objects of desire that Dietmar dangles before his beloved are lures but also in part representations of her own body. Women were circulated as a commodity and put up for sale to the highest bidder, as if just another item on the rack here. The beautiful fantasy objects discussed in this chapter are constructed in part in order to obscure or cover over the real, crude contingencies of the medieval marriage market.

THE MIRROR AND THE COMB

Mirrors were made of a variety of materials in the Gothic period, such as bronze (see fig. 13) and enamel (see fig. 35), but most surviving examples are made of the expensive and exotic imported material of elephant ivory. In the depiction of Dietmar the mirror is painted silver – but most medieval mirrors have lost their reflective glass interiors, leaving only their gleaming shells. A rare surviving pair that once opened and closed, like a modern powder-compact, shows eight pairs of lovers (fig. 39). Are these eight different stages in a single narrative as the great scholar of Gothic ivories Raymond Koechlin suggested? Or are they better understood as a multiplicity of "positions" that one could take up as one postured and positioned oneself before one's mirror? Courtly objects, like court life itself, produced an intense refinement of gestures and expressions of emotion

structured according to esthetic principles. These eight scenes are a catalog of the choreography of courtship around one of these significant symbolic objects – the chaplet. Chaplet-makers were an important guild in fourteenth-century Paris. Royal and noble lovers might have them made of gold and pearls, only fragments of which have survived, but even more ephemeral materials, flowers and natural greenery, evocative of springtime, sufficed for most couples. The couple represented on this pair of ivories play with a circular chaplet with all the anticipatory excitement that a contemporary couple might exhibit with a condom. Indeed in the same way the chaplet offered some kind of prophylactic barrier, at least symbolically. On one side the lady dangles it before the kneeling suitor who picks flowers to adorn it, while on the other she withdraws it behind her back, then places it above his head. She assumes the superior left position in all but one

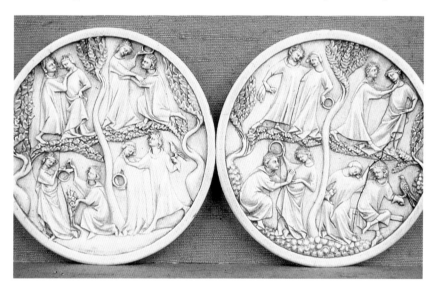

39. Circles and circuits of desire. A pair of mirror cases made in Paris, c. 1320. Ivory, h. 4³/₈" (11 cm). Paris, Musée du Louvre.

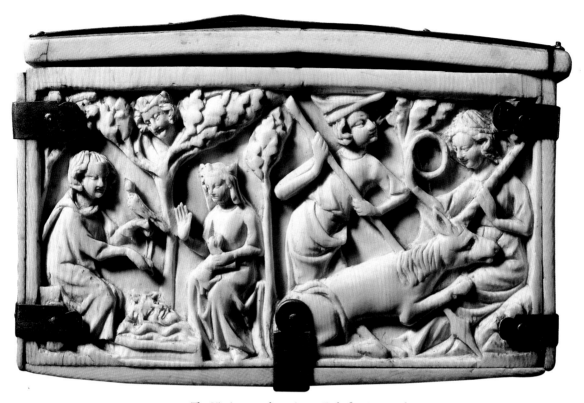

40. The Virgin traps the unicorn. End of an ivory casket
made in Paris, c. 1320. London, British Museum.

of the four scenes of the front and only when seated does she finally proffer him the circular crown on the bottom right of the back. The sexual meaning of this ring is made explicit in a sonnet by the late thirteenth-century Italian poet Dante da Maiano, who poses as a riddle: "A fair woman, in gaining whose favor my heart takes pleasure, made me the gift of a green leafy garland; and charmingly did she so; and then I seemed to find myself clothed in a shift she had worn; then I made so bold as to embrace her … I will not say what followed – she made me swear not to." Symbolizing love's never-ending desire, the circular form of the chaplet is also a simulacrum of the mirror itself. On the edge of

an ivory box made in Paris during the same period the virgin who traps the unicorn holds an object that could either be a mirror or a chaplet above the beast's head (fig. 40).

The chaplet was also associated with the hair and its coiffure, which makes it even more suitable as decoration for ivory combs. The same serrated leaves on the trees of the Louvre mirror cases also divide lovers on a beautiful two-sided ivory comb in the Victoria and Albert Museum, suggesting they might once have been part of the same set. One side of the comb, which amazingly has not lost any of its tines, includes a very similar central garlanding scene. As on the mirror, these couples seem to represent the various

41. Three courtly couples. Front of a comb
made in Paris, c. 1320. Ivory, 4^{1}/$_{2}$ x 5^{3}/$_{4}$" (11.6 x 14.5 cm).
London, Victoria and Albert Museum.

patterns and possibilities in love's performance rather than a sequential narrative (fig. 41). Two couples on the other side show the lady bestowing this same leafy crown upon the kneeling lover and then both holding the circular garland like a ring (fig. 42). This chaplet-grasping can also be seen in legal images from the same period. A youth presents a chaplet to a young girl in a very similar composition, before propositioning her to follow him in an illustration of the final *causa*, or case, in Gratian's *Decretum* (fig. 43). This describes how "A young man, through the use of gifts, attracted a certain girl without the knowledge of her father and invited her to dinner. After the meal the youth ravished this virgin. When this was found out the parents of the girl gave her to the young man. Provided with a dowry by the youth, she was publicly married to him." Instead of focusing on the legal outcome of the story and their marriage, the artist has emphasized the improper advances of

the youth using the garland. Unlike the sacred associations sometimes linked with them, as in St. Caecelia's garlands, those we see in ivories and miniatures are more often, like this, circular signs of the sexual.

A later mirror-back from Italy depicts the love-gift of a comb being presented to the lady (fig. 44). Since one of the things that distinguished a married from an unmarried woman was the looseness, style, and covering of her hair, the type of gift may be significant, encouraging beautification but also control of the beloved. A French royal account of 1316 describes four items bought for the royal family from Jean le Scelleur for 74 shillings: "1 mirror, 1 comb, 1 gravoir, and 1 leather case." Clearly objects now separated in glass cases in museums once fit snugly into leather cases such as that in the leather museum in Offenbach, which contains a stamped representation of lovers holding a heart and monsters on the outside. As

42. Three courtly couples. Back of a comb
made in Paris, c. 1320. Ivory, 4^{1}/$_{2}$ x 5^{3}/$_{4}$" (11.6 x 14.5 cm).
London, Victoria and Albert Museum.

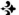

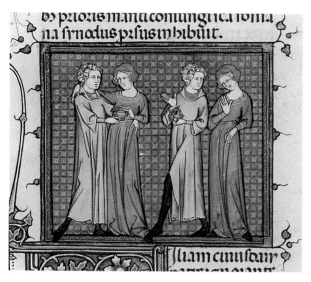

43. The lure of the chaplet in Gratian's *Decretum*, Causa xxxvi, Paris, c. 1300. Paris, Bibliothèque Nationale, MS lat. 3898, fol. 361r.

well as the circular mirror and comb, such cases also had a slot for a *gravoir* – a long thin hairpin or parter for the hair also of ivory. Surviving examples show various poses of the desire-filled duo we have seen before, but one has carved at the tip a parting couple, a divided couple for dividing the strands of hair (fig. 45). Although there exist marginal images of young men combing their hair, as critiques of vanity – and there is the erotic combing of a man's hair by his female friend on the lid of a painted and gilded leather box (see fig. 55) – these objects were powerfully gendered. This is especially true of mirrors, which since antiquity had been linked with the secret spaces of a woman's toilet. The inscription on an intricately patterned boxwood comb in the Museum of Fine Arts, Boston, bears the inscription "Take pleasure." The fact that it also has two compartments with sliding covers used to contain makeup indicates that the plea-

sure taken here is in one's appearance. It is this association with personal beauty that has been forgotten in discussion of these objects, especially the ivories, which must be placed in the context of cosmetics. The medium of ivory is at once the crystalline cold incarnation of distance and transcendent whiteness (the lady's teeth are often compared to it) but at the same time a substance suggestive of the flesh – creamy, undulating, and soft – and probably, after wax, the most fleshlike of all artistic media. Women were encouraged to paint their faces with blaunchet or wheaten flour and used dangerous lead-filled cosmetics in order to fulfill the ivory-white ideal. In a poem by the monk of Montaudon (c. 1180–1215) the statues of the churches complain to God that there is not enough paint left to adorn them because of all "the ladies who use rouge and cream." Apart from these dots of red

44. *The Gift of a Comb*. Mirror-back made in North Italy, c. 1390. Ivory, 3⁷/₈ x 3³/₄" (9.8 x 9.5 cm). Baltimore, Walters Art Gallery.

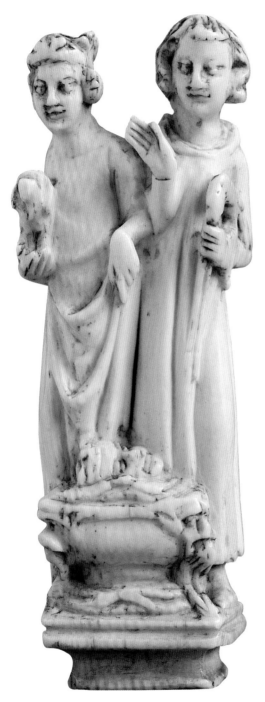

45. *Parting Lovers.* Tip of a *gravoir* or
hair-parter made in Paris, c. 1330. Ivory, h. 2³/₄"
(7 cm). Turin, Museo d'Arte Antica.

the beloved is always represented as ghostly. This was partly because she would never see the sun, being kept closely guarded behind closed doors, partly because women were considered physiologically cold in temperament but mostly because this was a visual convention of ideal feminine beauty that went back to antiquity.

In the first part of the most widely read and famous of all medieval love-poems, the *Roman de la Rose*, sometimes known as "the mirror for lovers," the dreamer is invited into the Garden of Love by a lovely girl holding a comb and mirror, as illustrated in this Parisian manuscript (fig. 46). The whole passage is worth quoting because it is very relevant for understanding ideals of female beauty, the positive image of the mirror and the comb, and, as we shall see, the very ladies represented on the ivories themselves. Conforming to the traditional formula of describing corporeal beauty, Guillaume's account begins at the top of the young girl's head, with her hair, and goes down to her feet, item by item, a veritable inventory of desire. We can compare this description of this ideal female visage with that of a large Parisian ivory statuette of this period (fig. 47):

She had hair as blonde as a copper basin, flesh more tender than that of a baby chick, a gleaming forehead, and arched eyebrows. The space between her eyes was not small but very wide in measure. She had a straight, well-made nose, and her eyes which were gray-blue, like those of a falcon, caused envy in the hare-brained. Her breath was sweet and savory, her face white and colored, her

mouth small and a little full; she had a dimple in her chin. Her neck was of good proportion, thick enough and reasonably long, without pimples or sores. From here to Jerusalem no woman has a more beautiful neck; it was smooth and soft to the touch. She had a bosom as white as the snow upon a branch when it has just fallen. Her body was well-made and svelte; you would not have had to seek anywhere on earth to find a woman with a more beautiful body. She had a pretty chaplet of gold embroidery. There was never a girl more elegant or better arrayed ... Above the chaplet of gold embroidery was one of fresh roses, and in her hand she held a mirror. Her hair was arranged very richly with fine lace. Both sleeves were well sewn into a beautifully snug fit, and she had white gloves to keep her white hands from turning brown. ... By the time she had combed her hair carefully and prepared and adorned herself well, she had finished her day's work. "I am called Idleness," she said, "by people who know me. I am a rich and powerful lady, and I have a very good time, for I have no other purpose than to enjoy myself and make myself comfortable, to comb and braid my hair."

The delightfully dimpled face of the ivory statue, with its carefully coiffed curls and chaplet, while being close to that described by Guillaume de Lorris, is, however, not that of a courtly lady from a secular ivory, but that of the angel of the Annunciation. Angels are supposed

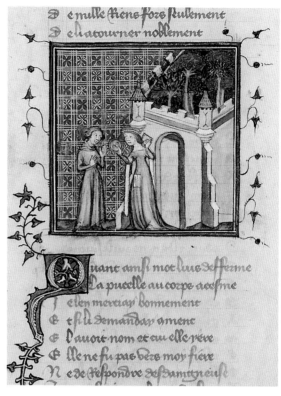

46. Idleness with her mirror and comb greets the lover outside the garden, from *Le Roman de la Rose*, Paris, c. 1380. Oxford, Bodleian Library, MS e Museo 65, fol. 7r.

to be sexless but often, as in the case of the angel-like God of Love himself, one gender sometimes predominates. The ideals of beauty and gesture that we think of as belonging to secular society permeated all Parisian products to the extent that in a handbook of student behavior a contemporary master of the University, John of Garland, urged young men to follow the examples of the statues they saw in churches as models of deportment. Just as these rough students modeled themselves on poised saints and androgynous angels in churches, the wealthy men and women of Paris who owned ivory mirrors and combs surely also learned to see them-

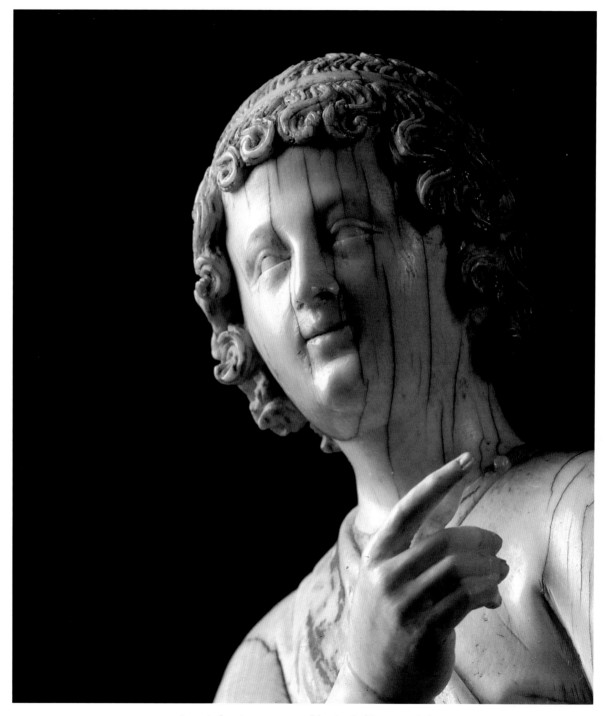

47. Beauty's face. Ivory statuette of the *Angel of the Annunciation*
made in Paris, c. 1280–1300. Paris, Musée du Louvre.

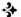

selves in these smoothly elegant although to us repetitive and formalized mannequins of desire. One has only to open a fashion magazine today to see these very same repetitions in the Paris fashion industry, played out with bodies just as impossibly idealized as those on medieval ivories.

THE GIRDLE AND THE PURSE

In the Provençal romance *Flamenca* of c. 1260 Flamenca's lover Guillaume owns a "great girdle" of Irish leather "with a buckle of French work: on it there was a full mark's weight of silver, even if you had allowed good weight, for it was a fair, rich, and delightful girdle." A silver-gilt buckle from such a belt, dating from c. 1200 and probably made for a man because of its narrow width, is a superbly cast and unusually complex example of the metalworker's art, of the same quality as the three-dimensional figures on Mosan metalwork (fig. 48). The chape, the oblong case of metal into which the end of the band of the girdle is fitted, shows a knight on his

horse, the flower of chivalry, followed by his page and approaching a standing lady whose arm is outstretched to touch his. The buckle shows the knight kneeling before his lady, who again lifts her hand to speak to him. The imagery of the meeting and homage of the two lovers recapitulates the binding and joining of the two ends of the belt into one, the active end, the male moving toward his own center in toward his right (as one thinks of it worn around his waist), but his lady, standing next to where the leather end would be penetrated by the tooth, is the fixed, immobile part. So even when the belt presented the binding of the lover to his lady, when it went around his own body it pinned her, as an object, to him and not vice versa.

Many medieval belts and girdles evoke in their decoration the divided human body – the notion of the rational human above the waist and the animal lust that drives what was described euphemistically as "below the waist." In Andreas Capellanus's *De Amore* the dialog between a man and a woman of the higher nobility involves a long scholastic argument about the relative mer-

48. A lady accepts her suitor. Buckle on a man's girdle
from the Mosan region, c. 1200. Silver-gilt, 3³/₄ x 2" (9.5 x 5 cm).
Stockholm, Museum of National Antiquities.

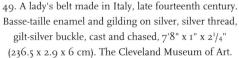

49. A lady's belt made in Italy, late fourteenth century. Basse-taille enamel and gilding on silver, silver thread, gilt-silver buckle, cast and chased, 7'8" x 1" x 2¹/₄" (236.5 x 2.9 x 6 cm). The Cleveland Museum of Art.

49a. (top) Lady playing a tambourine. Buckle on the lady's belt.

49b. (bottom) A suitor and a lady. End of the lady's belt.

its of the "upper part" and the "lower part" of a woman's body. The lady argues in favor of the lower parts, which, like the foundations of buildings, she says, are worthier. The man argues that to take too much pleasure in the lower part is to make rational humans into animals. Although he admits that the "final cause" in Aristotelian terms lies in the lower parts, "it is impossible to obtain pleasure from the lower without that from the upper, unless a most inappropriate and shameful physical position is adopted." The belt divides the beast from the beautiful woman according to this simultaneously misogynistic and erotic discourse. There are a number of

beautiful ladies' belts from the Gothic period that play upon this horizontal division of the body, by depicting human–animal hybrids. An enamel belt in the Museum in Baden-Baden is made up of half-human monsters, male and female, who meet around the waist, in the style of the minute art of the great Parisian illuminator of monsters Jean Pucelle. A later example, this time Italian, also contains hybrids (fig. 49). The belt is more than seven feet long and is decorated with twenty-one tiny quatrefoils of translucent enamel on silver. Its end was designed to fall down to the hem of a garment, indicating that it was made for a woman. The buckle proper is in the form of

a woman playing a tambourine (fig. 49a). The engraved and enamel designs are arranged so that they will appear upright when worn. Half-bestial men, not women, are engraved on the reverse side, which was hidden against the woman's body as it dangled down to the ground. Did the lady wearing this belt feel protected by its imagery? The final pendant suspended from the belt proper shows two scenes: in the first the male suitor seems a long way from the lady but on the lowest one he gets to embrace her at last (fig. 49b). If, as Marcel Mauss argued in his classic anthropological study *The Gift*, the ritual gift is "always possessed by the spirit of its giver," to proffer a lady such an object was to be very intimate indeed, as intimate as the man represented grasping his own possession in this example.

The haughty lady wearing the pointed headdress of the late fifteenth-century Burgundian court dangles a similarly long golden girdle before a kneeling knight – as if in anticipation of removing it – in a superbly painted parade shield (fig. 50). Here the belt is more like a chain and the woman holds it with both hands as if about to remove it in order to give it to her knight or perhaps even to bind him with it. The inscription *vous*

50. *"You, or Death."* Parade shield from Burgundy, fifteenth century. Tempera on wood, h. 32¹/₂ (83 cm). London, British Museum.

ou la mort ("You or death"), and the skeleton who stands behind him like a macabre patron saint, does not mean that the young man is pining away in love-longing. Rather he has chosen the ideal lady as a symbolic shield to protect him in a forthcoming tournament. In 1480 a poor German knight called von Schaumburg received from his mistress, to whom he had pledged lifelong service, all the ornaments, jewels, and trappings so as to strike a figure at the tournaments of Franconia. Sometimes these gifts given as prizes at tournaments would contain the lady's hair woven into the girdle or a bracelet. Like the green girdle that the mysterious lady gives to Sir Gawain in the Middle English poem *Sir Gawain and the Green Knight*, and which binds him within the circle of female control, these items of dress were also associated with women's semi-magical protective power.

From the belt would hang the purse, a major accessory in both the male and female wardrobe, since clothes did not contain pockets at this period. Called *aumonières* there were no fewer than 124 craftspersons known as *faiseuses d'au-*

51. The purse representing the goods owned by a husband and wife in common, from a French copy of Justinian's *Digeste*, c. 1280. Paris, Bibliothèque Nationale, MS fr. 20118, fol. 266r.

monières sarrazinoises listed in the Parisian guild ordinances, a guild dominated, like all the stitching arts, by women. A small group of splendid examples of these embroidered purses survives, one in the Cathedral Treasury at Troyes and another in Hamburg (see fig. 37). Made in Paris around 1340, the Hamburg example is embroidered in couched gold and silver threads and still has its drawstring handle with which it hung from the belt. It depicts a game in a garden in which the lady has grabbed a youth by his hood and is pulling him toward her in an effort to crown him with a chaplet. The exact meaning of the girl grabbing her lover by the hood is unclear. In Chaucer's poem *Troilus and Criseyde* (c. 1382) the young girl asks the old man Pandarus about how he is faring in "love's dance;" bemoaning his lack of a lover, he replies: "I hope alwey byhynde ... Loke alwey that ye finde/Game in myn hood." This playful sexual allusion of the hood is also emphasized in the

common association of the drawstring purse and the female pudenda in its shape, function, and position on the body. In drawing her lover toward her this lady is not only in control of the phallus-shaped hood that she has in her grasp, but can also pull the strings of the purse shut. What looks like an innocent frolic in a garden is charged, like all gifts, not only with the challenge of conflict but also the possibility of refusal.

This image of the lady bestowing the gift of the chaplet upon her lover is interesting considering the literary sources that describe a lady giving a purse that she has embroidered herself. Although this example was probably created by a professional Parisian embroideress, the lady would often present her own artwork. The *Roman de la Rose* argues: "A woman must be careful, no matter how much she claims a man as her lover, not to give him a gift that is worth very much. She may indeed give him a pillow, a towel, a kerchief, or a purse [*aumonière*] as long as they are not too expensive." The purse is one of the most charged signs in medieval art, dangling around the necks of the avaricious in Hell and a sign of monetary power. Goods owned jointly by husband and wife are symbolized by a similar large purse. In a copy of Justinian's *Digeste* in French (fig. 51) the purse changes its usual metaphorical association with the female vulva and becomes a playful pun on the male "sack" as the lady feels a man's "purse" in a contemporary miniature from the *Roman de la Rose* (fig. 52). This illustrates part of the long discussion of "Friend" who just before he describes the Golden Age when love was given freely, compares it to today's sad situation when women are more concerned with their lover's

material worth. "But if she saw a great heavy purse, all stuffed with bezants, rise up all at once, she would run to it with open arms; women are not so maddened that they would run after anything except purses." This lady is feeling for more than the "money," of course, as she fondles the bulging *aumonière* with its bobbles and fringes just like those in the Hamburg example. Some fourteenth-century French *aumonières* in the Musée National du Moyen Age in Paris have marvelous hybrid monsters on them, reminiscent of the male purse swinging here below the waist in the animal "lower regions." When, in one of the French *fabliaux*, a wife prays that her husband be transformed into a veritable porcupine of phalluses, her husband wishes that she be fitted with as many purses, meaning vaginas. The more that

52. The lady feels the lover's "purse," from
Le Roman de la Rose, France, c. 1280. Rome, Biblioteca
Apostolica Vaticana, MS Urb. 376, fol. 51v.

medieval objects can be linked to bodies, the more they can be brought to life again to perform the polymorphously perverse roles that they sometimes assumed.

THE CASKET AND THE KEY

Made of panels of stamped bronze fixed to a wooden frame, a Catalan casket with courtly lovers on its front is an example of a more mass-produced type of object from the end of the fourteenth century, adapting the same kind of imagery of the earlier wooden and ivory caskets in a different medium (fig. 53). Just as we know that ivory carvers created multiple examples of stock scenes that could be fitted in different combinations to form a casket, these stamped metal scenes are highly conventional "logos" of love. In the center a lover kneels with a falcon on his wrist; his beloved holds a bunch of flowers. The box with its metaphorics of opening and closing, interiority and outer surface, was always closely linked to the inviolable female body, open only to her husband-owner. This is true of chests of all sizes and types, from the small ivory caskets made in fourteenth-century Paris, through the slightly larger leather and wood *Kistlin* of fourteenth-century Germany to the trunk-size pairs of *cassone* chests used in the marriage ceremonies of Renaissance Florence. These items were usually bought by the groom and his family to transport gifts to his future bride or part of her dowry to him and then would serve as storage chests, furniture, or jewelry boxes in the couple's bedroom. Their imagery of control and containment makes them less private and secret objects than open

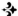

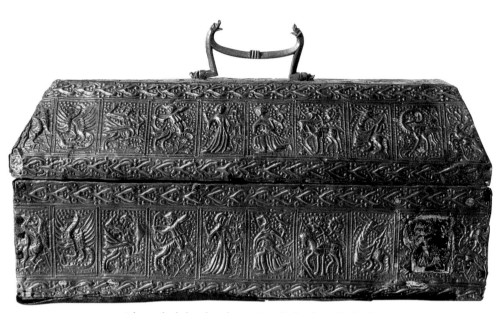

53. A lover, the beloved, and monsters. Casket from Catalonia,
c. 1400. Stamped bronze panels on wooden frame, 3¹/₂ x 15 x 4" (9 x 38
x 10 cm). Barcelona, Museum Nacional d'Art de Catalunya.

social signs of exchange and goods within a gift economy. As on the more intimate girdles, hybrids and monsters serve here as exemplars of the baser passions of the lower body; tamed, they now serve as protectors – like the centaur in this example. One should not forget the almost sacred status of property in medieval culture. Thefts and crimes against property were punished far more severely than crimes against the body, and much medieval art is not only to be seen as property in itself but as serving to protect it. Giving gifts was a serious business, as the three daughters-in-law of King Philip the Fair of France found out to their horror in a scandal that rocked the royal court in May 1314. Gifts that had first been given to them by their sister-in-law Queen Isabella, wife of the ill-fated Edward II of England, they had subsequently given to some young knights in their entourage.

Accused of having adulterous affairs, the princesses were incarcerated and their supposed lovers Philippe and Gaultier d'Aunay were publicly disemboweled in the Place de Grève in Paris. Anyone who doubts that the adulterous aspect of courtly love was only a fantasy should remember this instance when accusations of illicit behavior among the royal family were so ruthlessly punished.

The lady's taming and control of her suitor's animal passions helps explain the popularity of the theme of the wildman on the exterior of a number of German caskets. These gloriously shaggy creatures were used not only to represent the bestial side of human nature but by the later Middle Ages also came to articulate an early form of primitivism, a nostalgia for an earlier, ruder existence for those in the artificial courts of Europe who would later project similar myths

of the "simple life" on to their social inferiors. Two mid-fourteenth-century painted caskets, now in the Museum für Kunst und Gewerbe in Hamburg and in Cologne (fig. 54), depict a similar narrative in which a wildman of the woods battles with a young knight for possession of a lady. In the Cologne example he sits in a tree in the first scene contemplating the lady, as was the first stage in every proper lover's quest. To the right he rides after her and on the right end panel he is shown grabbing her. The young knight does not rush in to defend her with arms but produces instead a wedding ring, which he offers with an outstretched hand. The lady's choice is between the rough hairy monster representing sensuality and the refined courtly knight representing civility. In the Hamburg casket the young knight is rewarded for his valor by being crowned by the lady with a chaplet while two monsters, synonymous with the wild-

man's lust, cower in defeat. The odd thing about the Cologne version is that here the lady chooses the hairy wildman over the wimpish knight and ends up playing chess with her shaggy abductor on the last scene on the casket. The suitor who commissioned the casket, who may have been much older than his bride, was able to express his physical desire for her in the form of the hairy libidinous creature, while at the same time indicating that once his request was granted he was ready to be tamed. The wildman sits with a falcon on his wrist in the last scene, his brutishness turned to gentleness. The woman's role is not only to be an object of desire but to exercise civilizing influence over male sexual appetite. This object teaches both sexes their respective roles as regards courtly versus uncourtly behavior.

A Flemish leather casket brings together in one object a number of the themes and objects

54. The choice between the wildman and the knight. Casket made in Cologne, 1350–70.
Painted oak, right end panel, 4³/₄ x 9¹/₄" (12 x 23.5 cm). Cologne, Museum für Angewandte Kunst.

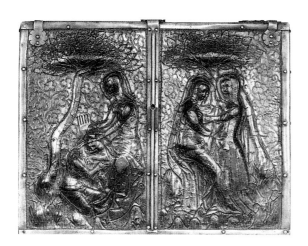

55. Lovers around the lock of the heart.
Lid of a casket from Flanders, c. 1400. Moulded and incised
leather over wood, 8¹/₂ x 6¹/₂" (21.6 x 16.5 cm). New York,
The Metropolitan Museum of Art.

discussed in this chapter, the exchange of gifts as well as the girdle and the box. Such caskets were made of soaked and softened leather that was molded and shaped around a core to create three-dimensional figures, this very technique suggestive of the fleshly encounters they often depict. On the lid is the unusual scene of the lady combing her lover's hair, and on the front around the lock she slips him the girdle from around her waist (fig. 55). This example also shows how we have to treat these objects as shifting and multivalent signs of corporeality rather than as crude sexual symbols. Here we cannot simply see the box as the woman's body and the keyhole as the point of penetration. The great heart that surrounds the keyhole is the gift of love from lover to beloved, ironically articulating the chaste and noble aspirations of the higher form of love that he presents to her. In a later chapter we shall return to this theme of unlocking the lover's heart in more detail. Here suffice

to say that the heart over the lock represents the lady's control over her lover. In Chrétien de Troyes's late twelfth-century poem *Yvain*, the hero rejected by his beloved Laudine returns in disguise and tells her: "Lady, you carry the key/ and have the casket in which my happiness/is locked." The imagery on this box celebrates the reciprocity of the gift – she combs his hair, he gets to embrace her, he gives her his heart, she gives him her girdle, he presents her with this object, and in accepting it becomes incorporated into his and the box's imaginary universe of relationships and rituals. The beloved holds the imaginary key to his heart but the suitor is more likely to have kept the key to the box itself.

As well as gifts, caskets were used to relay messages of love in the form of letters. A gorgeous grisaille drawing preserved on a fragment of parchment shows two messages being delivered to two women who have the undulating concave bodies created out of arcs of swelling voluminous drapery and tubular breastless torsos that were fashionable in the late fourteenth century (fig. 56). On the left one message is delivered by an older bearded man, who takes it out of his long tubular hood, and on the right a young beardless messenger opens a *layette* or casket in which dispatches and letters were sent, before another lady who is combing her long tresses. The older man may be feeling for the key to the lady's treasure that she has given the poet and which hangs around his neck, as recounted in Guillaume de Machaut's poem *Le Livre du Voir-Dit*, which we have already seen illustrated (see fig. 17). If this were so the two beauties represented in this drawing are Toute Belle and the ancient Queen Semiramis, who

abandoned braiding her hair during a threat to her kingdom. The flaccid hood of the old man hints at the loss of potency that haunts this poet's work. Rather than a piece of a model-book we might see this long strip of parchment as the visual equivalent of a love-poem – which in the Middle Ages was sometimes written on long strips of parchment to be used in performance – and which was inspired by Machaut's work, to be sent as a message not from a poet but from an artist to the double-lady of his dreams.

It is too simple to see representations of medieval lovers as "reflections" of "courtly love" that we imagine people practiced, rather as we practice "safe sex." The images in this book are expressions of less tangible desires, more equivocal cultural codes, and private fantasies. They are not pictures of everyday life in the Middle Ages. To think that would be like imagining that a thousand years from now people would be able to estimate everyday experience and people's appearance today from the images in current fashion magazines. We all realize that the latter are fantasies, idealizations, and distortions we find desirable. This drawing – a fantasy on the part of an artist – is an instance of how we cannot always find evidence of the exact social function of a medieval image. Yet the ritual it depicts clearly bears some relation to social practices and probably shows us how the caskets we have been looking at might be used. Not stationary objects in museums, but as "movables," boxes were themselves shifted and used to transmit messages, both in themselves and on themselves.

Opening and closing actions, together with the emphasis upon female hair that makes this drawing richly suggestive of male erotic desire, also form the culmination of the sixth panel of the famous series of tapestries in the Musée du Moyen Age, the other five of which depict the senses (fig. 57). Here within a tent glistening with golden tears that also seem like little spurting flames of fire, the lady stands between her two bestial supporters, the lion and

56. Two messengers and two ladies. Pen and ink drawing on parchment, Paris, c. 1400. Berlin, Staatliche Museen Preussischer Kulturbesitz, Kupferstichkabinett.

57. *The Lady's Desire* (?). Detail of the sixth hanging from *The Lady with the Unicorn*, a set of six tapestries
made in France or the Southern Netherlands, c. 1500. Cluny, Paris, Musée du Moyen Age.

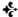

the unicorn, with a female servant who holds before her an open casket. Questions that have perplexed scholars for so long – exactly who is this woman in the six tapestries and to whom is she sending or from whom is she receiving this gift – overlooks how love functions most often as a fantasy, in which one gives something which does not exist, to someone created in one's imagination. The gift is the only real thing. The only real person in this scenario, as we have seen before in the tapestry representing *Sight*, is the patron, Jean Le Viste himself. The lady here who stands before her tent, it has been argued, is in the act of renouncing the five senses that have been represented in the other five tapestries, casting aside worldly glamor for a higher ideal of her own free will (*A mon seul desire*). This woman is not renouncing but neither is she taking. Rather she seems to be in the midst of giving, putting a jeweled necklace in the box and entwining it with an intimate item of her own clothing. By sending to her beloved a gift of her love, leaving her neck white and bare, she is combining two of the charged symbols of the body we have discussed in this chapter, the girdle, which like the necklace surrounded her own flesh, and the box that will carry her secret. What has not been noticed is that compared with the other women in the series this lady has short, even scraggy hair hanging down in a way that no courtly lady would have allowed, except for the fact that it signals her having cut off her own locks to weave them into the pearl and jeweled necklace that she places in the box. She has, as

in many literary and even some historical sources of the period, made the gift of her own hair to her lover. Rather there is an erotic charge of bare flesh against velvety rich textile, as in the description of Largesse in the *Roman de la Rose* whose "neck was disclosed, since, not long before, she had made a present of her neck-clasp to a lady. However it did not suit her badly that her collar was open and her throat disclosed so that her soft flesh showed its whiteness against her chemise."

We return again to the key question asked throughout this study. Whose desire is being represented here? The motto placed on the tent above the lady's head has been translated in many different ways: "To my desire alone," "To my own desire," "To my only desire" – or even "In accordance only with my will." Can this motto really refer to this lady's *own desire* to renounce her bodily senses for a higher love, when, as an object within this particular scheme, she can have no desire of her own? However you want to interpret these enigmatic words inscribed on the tent above her, they point beyond the tapestry to someone and somewhere else – to Le Viste, the patron. In many ways each of the six tapestries enacts the identical auto-eroticism of the unicorn looking in the mirror in the tapestry of *Sight*. Even if she does renounce the pleasures of the five senses for "my only desire" within the inexorable and paradoxical masculinist logic of the medieval image, her only desire (her desire *for* him) is actually *his* desire (for himself) and not really hers at all.

Quant dyane se fut de sa follye siede il faint en
partie de lacte² dess³ son sure il lessa la forest
dit et elle lot repu² ou dyane conuerse e trau

58. Robinet Testard

The gaze of Desire, from *Le Livre des échecs armoureux moralisées*, Poitiers, 1496–8.

Paris, Bibliothèque Nationale, MS fr. 143, fol. 198v.

LOVE'S PLACES

During this conversation we had journeyed a considerable distance, and we came to a
most delightful place, where there were most beautiful meadows laid out better than any mortal eye
had ever seen... In addition, the place had been fashioned in circular shape and divided into
three sections... In the first innermost section there stood at the centre a tree of remarkable height,
bearing fruits in plenty of all kinds... Down at the roots of the tree welled a wondrous spring
with the purest of water, providing for those who sipped it the sweetest taste of nectar...

Andreas Capellanus

In the fifth of his fictive dialogs, between a noblewoman who is hostile to love and a noble-man who tries to dazzle her with love's nobility and splendor, Andreas Capellanus introduces this image of the *locus amoenus*, or "beau-tiful place," a *topos* or convention taken from ancient and earlier medieval poetry fundamental to the medieval art of love. Unlike the great pilgrimage sites and cathedrals of the medieval West that can still be visited today, the sites in the South of France

59. Bethrothal in the garden of love. Marriage brooch made in Germany or Burgundy, c. 1430. Gold, enamel, and precious gems. Vienna, Kunsthistorisches Museum.

where the troubadours first sang of love, such as the hilltop castle of Les Baux in Provence, are now in ruins, as are most of the great secular buildings of France and England. Even when they are still standing, their interiors are stripped bare of most of the luxurious tapestries and paintings that created verita-ble gardens within the walls. Like the lost Paradise of Eden, the "beautiful place" has flowing streams and a tree in the middle. Appearing in countless poetic texts and images from the

60. The lover seeks entrance to the Garden of Deduit, from *Le Roman de la Rose*, Paris, c. 1400. London, British Library, MS Egerton 1069, fol. 1r.

Middle Ages, it appears most influentially at the beginning of the *Roman de la Rose* (fig. 60).

Rather than showing the usual dreaming scene described in the opening lines of Guillaume de Lorris's poem, the illuminator of this particular manuscript placed this in the initial below and chose to represent nearly full-page the poet approaching the wall of the enclosed garden, the Garden of Deduit (Pleasure, Diversion, or even Desire). At its center is the pool of Narcissus, which we have seen before. The great walled garden in the miniature also contains intimations of castle architecture in its crenelations, towers, and turrets. There are biblical echoes too of the lost joys of the Garden of Eden and the *hortus conclusus* or "enclosed garden" of the Song of Songs that was seen as symbolic of the virginal purity of the Virgin Mary. Love's places are, like this garden, imaginary. In this closed-off fantasy world the images carved on the outside walls represent those vices that

are excluded from the Garden of Love: "covetousness," "avarice," "envy," and "sadness." Represented as old hags hoarding their possessions like Avarice or staring with evil intent like Envy, these contrast with the young girl, who opens the door and lets the lover inside. This is the rich and powerful lady who has nothing better to do than comb her hair and whom we have met before – "Idleness," who tells the lover how Diversion had the wall built to exclude everything inimical to love. In the center the poet is shown again looking into the fountain, which is where he sees his first glimpse of the girl, Rose, the object of the quest. Self-reflection takes up the center, as if to emphasize the false nature of the fleeting Garden of Delight as just another image. Like so many images of love, this one too seems ironically to undercut its own superb setting, to want to disturb the waters of its mirror-like surface with distortion and ripples that destroy its illusion, since what is at the center of the Garden of Desire is not the beloved object, but once again the subject himself.

THE GARDEN ENCLOSED

The garden served to circumscribe an artificially produced space separate from the real world. Carved around the curves of an unusual French ivory cup are the trees of a garden in whose shade pairs of lovers play music to one another, read to each other from the "abc" of love, and exchange chaplets and crowns (fig. 61). This emphasizes the civilizing aspects of the garden as a place of relaxation, learning, and refinement, where brute nature is controlled and cultivated just like the baser human passions. The

61. Pleasures in the garden of love. Cup made in France, fourteenth century. Ivory, 3" (7.7 cm).
Vannes, Musée d' Archéologie de Morbihan.

same circular form binds smaller objects behind an enclosure recalling both the chaplet of flowers and the ring of betrothal itself in an enamel brooch that probably depicts the betrothal of two wealthy young people (see fig. 59). Dressed in the blue of constancy, the couple plight their troth bound by a fence of woven gold chased so as to suggest the rough texture of bark twigs. Pearls are set in the lower part of the fence and two jewels, a triangular diamond above and a ruby below, suggest a duality of elemental symbolism between the hot and the cold that we often find in love imagery. The crystalline clarity of the diamond also represents the constancy and durability of love while the ruby placed below, associ-

ated with love's fiery force, makes the hierarchy within this particular betrothal very clear. Such a brooch could be worn by a man or a woman and one very like it of "a man and a woman in white" set with four rubies, a sapphire, and eight pearls was given by Catherine of Burgundy to her bridegroom Leopold of Austria at their wedding in 1388. Like a worldly version of the "O" initials opening monastic manuscripts of the Song of Songs two hundred years before, this circle is still a "garden enclosed" although instead of a languorous embrace the *sponsa* stands stiffly beside her bridegroom, extending her left hand toward his. This is more the protective brooch described by Johannes de Hauville when he

62. Lovers go shopping, from *Le Chevalier Errant*, Paris, c. 1410.
Paris, Bibliothèque Nationale, MS fr. 12559, fol. 167r.

wrote: "My bride shall wear a brooch, a witness to her modesty and a proof that hers will be a chaste bed. It will shut up her breast and thrust back any intruder, preventing its closed approach from gaping open and the entrance to her bosom being cheapened by becoming a beaten path for any traveler, and an adulterous eye from tasting what delights the honorable caresses of a husband."

By the late Middle Ages the garden, like the fountain and the castle, was already an unreal space of nostalgia. Many of the most beautiful gardens in France, like that in the royal palace on the Ile de la Cité, were in the middle of cities.

The garden was not the site of love and certainly not the actual site where these images and objects were produced and perused by the noble patrons. Rarely does the real social space in which these objects circulated – the market – make it into the rarefied world of Romance and the pastoral glades of poetic discourse. In one sumptuously illustrated Romance, full of the usual gardens and castles, the lovers are shown doing something new, something that lovers still do in Paris today – they go shopping (fig. 62). In a "city noble and beautiful" they see "a multitude of people who have come to the fair held there." Like an anti-garden of love this is a

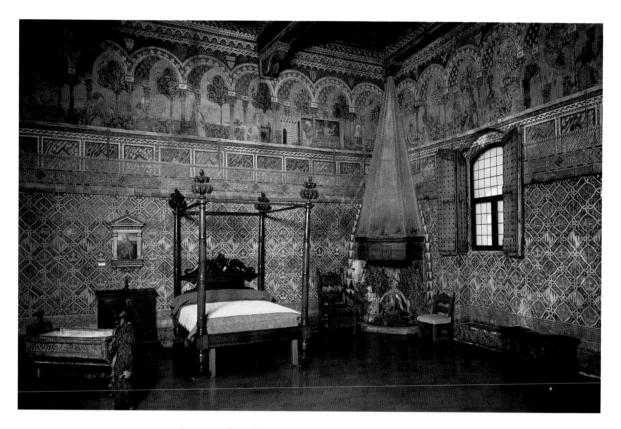

63. Scenes from the romance of the *Châtelaine de Vergi*, c. 1390.
Fresco. Florence, Palazzo Davanzati.

circular space of visual desire, walled in like the Garden of Deduit in the *Roman de la Rose*, except that the houses that enclose the market contain not an ideal vision of nature but many delectable and valuable things made or, in the case of animals, raised by human ingenuity. This urban milieu saw the production of visions of an already lost and idealized landscape of desire like that described and illuminated in the *Roman de la Rose*.

The garden in an urban setting can be seen in the heart of that great European metropolis, Florence, where merchant patrician families such as the Davanzati sought to bring some of

that old flowery feudal world of France into their palatial living quarters. Of the four frescoed rooms of the Palazzo Davanzati painted in the 1390s, all decorated with flowers and hedges, one has an even more elaborate narrative series of frescoes (fig. 63). These are based upon a story of feudal loyalty, adultery, secrecy, treachery, and death already popular in France where it adorned ivory caskets (see fig. 87): the *Châtelaine de Vergi*. In the Florentine palace the theme is adapted to the nuptial bedroom. The paintings tell the story of the love affair between the young chatelaine and a knight, which she insists they keep secret from her uncle the duke.

64. Falconer and Gemini as lovers, the May page from the *Hours of Simon de Varie*, Paris and Tours, c. 1455. The Hague, Koninklijke Bibliotheek, MS 74 g 37a, fol. 92r.

porting the fireplace on the corner of the east and south walls, while the Davizzi arms appear opposite. It is startling too that in a bedroom – even one decorated for a nuptial festival – the scenes show the duchess withdrawing from her husband in bed as part of her treachery. The garden becomes a continuous setting of the story of the *Châtelaine de Vergi* from the moment the lovers first meet, as the young knight comes upon the lady, to the south wall, where the duke kills the wicked duchess after discovering how she caused the death of the two lovers. This is a strange story about secrecy and privacy in the nascent bourgeois setting, celebrating not so much the old feudal virtues of liberality and openness but the civic virtues of keeping faith. The last wall shows the suicide of the lady followed by that of her young knight and then the angry duke hacking off his wife's head. Not very pleasant bedtime viewing, this old French tale, but it must have served as a mesmerizing moral lesson to the Davanzati brides as they lay in their beds, not to follow the course of the evil duchess who is shown jumping out of bed in a frenzy of jealousy, but to remain silent and faithful beside their husbands. It is also, like most marriage tales, about genealogy and status. As the Italian version of the story opens: it is "a new story to give an example to whoever wants to love, of a knight and a lady, of noble lineage and of high deeds – and how because of love each one died."

Secrecy is the central theme of the tale: "the greater the love, the more grieved are true lovers when one of them thinks the other has told what he should conceal." The duke's wife, enamored of the knight herself and jealous that he should love someone of lower station than herself, tricks her husband into forcing his young kinsman to tell all; being discovered and, she thinks, betrayed by her lover, the chatelaine commits suicide. The narrative, which was supposed to happen in far-away Burgundy, takes place in a garden, to which one looks out from behind a hanging tapestry that fills most of the height of the room but stops short of the floor. The Alberti escutcheon is carved on the left-hand corbel sup-

If wall paintings made love-gardens luxurious settings for wealthy aspiring city dwellers, another important medium for creating an imaginary space of love was the book, whose unfolding pages were often bedecked with flowery borders and lush vines. It was especially in manuscripts,

luxury objects that for the most part contained prayers for the pious and wealthy to whisper in the private confines of their own chapel or even bedrooms, that the imagery of the love-garden is most developed. If the garden was the space of love, springtime was its time. In calendar illustrations appearing in Books of Hours, the "labor of the month" of May is in fact not a labor at all but the aristocratic leisure of the knight riding out to hunt both animals and ladies. The amatory joys of spring, celebrated in images of bursting buds and frolicking animals by all poets from the troubadours to Chaucer, are vividly embodied by the zodiac sign for May, which should depict the astrological sign Gemini as twins but often makes them partners in an erotic, incestuous play. As a naked male and female they sometimes fondle and even kiss one another. Even when they stand discreetly behind a shield to hide their nudity, as in the Hours made for the rich bourgeois of Bourges Simon de Varie, who was ennobled by Charles VII in 1448, their coy exchange exudes a sexual charge that links them to the springing hound, sprightly rabbits, and eager hunt going on above (fig. 64). We should not forget when thinking about these images that girls were considered sexually active at twelve and boys not long after and that men often married women much younger than themselves. Most of the images of lovers that we see in medieval art represent unions that would be considered illegal in many countries today.

The obsession with flowering plants, fresh herbs, and sweet smells in the Garden of Love is more than esthetic and has a practical, medical aspect. In fifteenth-century manuscripts of the *Tacuinum Sanitatis*, a health handbook with full-

65. Lovers and aphrodisiacs, from a *Herbal*, Lombardy, c. 1400. London, British Library, MS Sloane 4016, fol. 44v.

page illustrations, we see lovers playing with bitter apples under trees, men squeezing breasty melons and enjoying other vegetables as symbols of sensuous pleasure. A related pictorial tradition was that of the Herbals, which come out of the medical Latin tradition of Salerno. In these certain "simples," organic substances that were believed, when taken alone, to cure all sorts of ills including those of love, are beautifully represented by Italian artists of the fourteenth century. Every flower and vegetable had not only its manifold symbolic meanings but its medicinal uses. On each page two or three "simples" are represented, with human actions showing their therapeutic effects (fig. 65). Here jacinta or

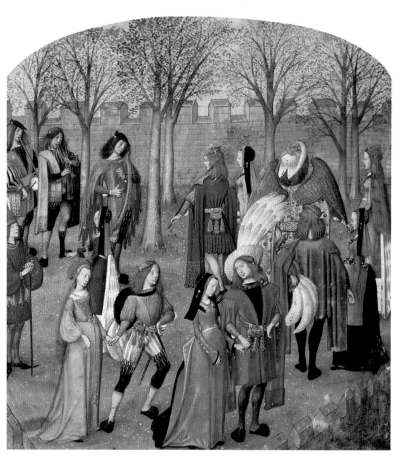

66. The dance of Desire, from *Le Roman de la Rose*, Flanders, c. 1490.
London, British Library, MS Harley 4425, fol. 14v.

hyacinth on the right is seen as aiding urinary problems and menstruation while next to *hyppuris* an elegant couple are seated on a bench, suggesting its aphrodisiacal powers.

Some of these medicinal and magical plants appear preserved like pressed flowers in the amazing shows of naturalistic virtuosity that appear in the botanically detailed borders painted by late medieval illuminators. One example of this is the late fifteenth-century Flemish *Roman de la Rose* made for Engelbert of Nassau, a knight of the Burgundian chivalric Order of the Golden

Fleece. It also evokes more of the dense surface texture of clothing and luxurious stuffs described in the text (fig. 66). Strutting like peacocks, the male figures are even more sumptuous than the young ladies in the full-page scene depicting the Carole or Round Dance of Deduit. To the left Courtesy stretches out her hand to invite the dreamer/poet to join in the dance. Leading the dance are Diversion, who still has the down of adolescence on his cheeks, and "Joy ... the sweet singer who, when she was no more than seven years old, had given him the gift of her love."

Next is the winged God of Love with his lady, Beauty. Next is Lady Wealth and her "kept boy," whose back is turned to us so that we cannot see his face. The two prominently placed young men in the foreground are also unnamed in the text, one being the knight companion of Generosity and the other the partner of Openness, "a young bachelor, I did not know his name." One might see in these two handsome youths portraits of particular people, relatives of Engelbert of Nassau himself. The female figures are idealized personifications but these males are, by contrast, stations for male identification once again. Whereas fourteenth-century manuscript illuminations had presented the bare bones of a story in bright but simply articulated figures against rudimentary backgrounds, the fifteenth-century painter was compelled to make the dream into a real "mirror for lovers" so that later owners of the manuscript, such as Engelbert's young nephew Heinrich, might have seen themselves literally present within its flowering pages.

Toward the end of another luxurious and very large late medieval manuscript produced for Louise of Savoy, mother of King Francis I, we see a lover standing not within but outside Desire's Garden (see fig. 58). This garden is set out in a grid of rectangular plant beds although the artist has used space here not to provide a rational perspective but to position the female personifications as optimum optical objects within an elaborate allegory of male desire. This work is the anonymous *Livre des Echecs Armoureux* (1370–1430), an allegory based partly on the *Roman de la Rose* but with even more complex and confusing classical trappings. The garden even looks like the squares of a checkerboard and presents the poet with serious choices. Ruled over by Nature who stands at the gate with the key, it contains three women. From outside the poet accompanied by the dashing peacock-feather attired young Deduit debates the choice between Venus (representing the amorous life), Juno (the active life), and Pallas (the contemplative life). Pallas appears as the highest spatially of the triad and also as the end-point of the poet's line of sight. Through the wiles of optical art the poet is allowed to have it both ways. Coming at the end of the work, where Pallas presents the claims of reason against carnal delight, the scene can be interpreted as the poet looking up at her as the ultimate ideal object. But at the same time he is looking at Venus, whose sensual way he chooses earlier in the poem, in a sense looking through her naked reality toward a clothed ideal. This network of lines of sight and grids of desire exemplifies how much the image of the garden was as tightly constrained and constructed as the bodies within it, into a rigorous regime of surveillance and domination.

THE FOUNTAIN OF YOUTH

Water cascading off the curves and contours of sleek, dripping-wet flesh is a way of erotically objectifying bodies that is still used today. The wet body had even deeper erotic potential during the Middle Ages when the theory of the four humors – blood, yellow bile, phlegm, and black bile – combined with the four elements meant that every human body literally ebbed and flowed with the flux of desire, changing with the tides and the turning planets above. Medical practice was based on this system and for many doctors love was treated not as a psychological state but a

67. *The Fountain of Youth*. Panel of a casket made
in Paris, c. 1320. Ivory, whole casket 8^1/$_4$ x 5 x 2^3/$_4$"
(21.2 x 12.7 x 7.3 cm). London, British Museum.

physical illness. Since Galen physicians had taught that men were hot and dry in complexion whereas women were cold and wet. Although it was not water but fire that was love's element, the opposition of water to fire was also a means of separating and contrasting the female and the male body. At the center of the garden in the *Roman de la Rose* is a fountain, which is not only that in which Narcissus stared himself to death, but also that in which the lover catches a glimpse of his beloved Rose in two crystals that represent her eyes. Rock-crystal, much used in medieval jewelry, was believed to be a kind of eternal ice, magically potent solidified water. Life-giving liquid can always be found in the *locus amoenus*, "the fount of running water," but the most popular fountain in medieval art – and often pictured in luxury objects as well as wall paintings and tapestries – was a variation on this theme in which life-giving water rejuvenated love's failing corporeal equipment – the Fountain of Youth. Also sometimes called the Fountain of Love, it is referred to in the *Alexander Romance* and in classically

inspired narratives in which it appears as an actual geographical site, which travelers to the East might find along with Eden and other distant Wonders of the World.

On the front of one of a group of superb early fourteenth-century ivory caskets produced in Paris, a doddering old man carries his tiny shriveled-up wife on his shoulders toward the magical waters (fig. 67). These are the dried-out ones. The popularity of the Fountain of Youth has to be seen in the context of medieval medical attitudes to ageing, which was seen by doctors as the inevitable drying out or desiccation of the body, which gradually loses its moisture, dries-up, and dies. The nubile young things in the next plaque, splashing beneath the gargoyle spouts of the Fountain of Youth, are the same elderly couple transformed into the newly smooth ivory flesh of rejuvenated youth. Next to these scenes Aristotle is first shown playing his proper aged role as teacher and then being ridden by the young girl Phyllis with whom he becomes besotted. These two narratives of cold and dry old age reversed and flowing with all the hot juices of youth that appear on the casket's front are accompanied on its lid by a depiction that we have already seen of the tournament and siege of the Castle of Love (see fig. 25). We should not forget that Andreas Capellanus argued that old age was a bar to love because "after the sixtieth year in a man and the fiftieth year in a woman, although one may have intercourse his passion cannot develop into love." In seeking the Fountain of Youth these men and women are seeking not eternal life but eternal love.

On the Parisian ivory the miraculous transformation of the flesh is not visualized and we see only the wizened approaching and then the

68. *The Fountain of Youth*. Tapestry made in Strasbourg,
c. 1430. Colmar, Musée d'Unterlinden.

young in the fountain. By contrast later versions of the subject show old men dipping themselves directly into the transforming waters. In a tapestry made in Strasbourg the fountain is not at the center of a walled garden, but has its own wall and the garden outside is where the flowers and leaves of the spring wither in the winter of the world (fig. 68). Moving toward the center of this garden is thus a return to a kind of Eternal Eden. Hobbling old men carry their bent-over wives in baskets and trundle them in wheelbarrows at the bottom and on the left toward the gate to the enclosure, suggesting the perennial joke about the old man's desire for a young wife. A pair of semi-naked lovers fondle in the very middle of the fountain where a pliant, puckered female emerging on the right of the bath is helped out by a youth covered in spring leaves and flowers.

For the Fountain of Youth is above all a male fantasy about loss of potency – and in an age when most men were married late to wives who were often in their teens. The two great anxieties of this period, brilliantly expressed in the character of the old man January in one of Chaucer's *Canterbury Tales* (after 1386), were the constant danger of his young bride's adultery and his own growing impotence. The inscriptions on banderoles in this tapestry, both spoken by men, are evocative of this fear. "Ich lob Dich Gott, ich alter Man, das ich den Brunnen gefunden hab," says the old man with crutches about to enter the doorway, "I pray dear God that I the old man have found the Fountain of Youth;" above, the noble blond young rider in his green-leafed robe that will wither away in the winter says: "Sind wir gewesen die Alten, so ist unser Geld gar wohl

69. Follower of Giacomo Jacquerio
The Fountain of Youth, c. 1411–16. Fresco, 7'10$\frac{1}{2}$" x 3'11$\frac{1}{4}$" (24 x 12 m).
Piedmont, Great Hall of the Castello di Manta.

behalten" ("Since we shall become old so then shall we keep our gold"). At the end of this banderole on the right another young couple sit feasting. Both young and old men are addressed as the subjects of this tapestry, which may have looked down over many feasts with its admonition to enjoy life while you can. Ironically it is time too that has worn away the drawn-in features of both the old and the young faces that were once surely smiling as they splashed in the rejuvenating waters.

Reversing time rather than representing its end, like a parody of the resurrection, the frescoed Fountain of Youth painted along one wall of the Great Hall of the Castello di Manta shows figures pulling off their heavy robes to plunge into their newly sensate flesh (fig. 69). Its Gothic pinnacles assume a pseudo-ecclesiastical appearance suggesting the rites of a second Baptism in one of the great Italian baptistries of the period. The God of Love surmounting the whole structure is now a statue. On the left the old and infirm of all classes, including kings, cardinals, and peasants, arrive while the middle of the fresco is an excuse for the painter to display his skill in depicting nudes in complex comical poses. In the second tier of the structure a young man, newly virile, chin-chucks a girl and

those who have recovered the rosiness of youth don the youthful fashions of the period before enjoying embraces and kisses. Unlike modern youth cultures, such as that promoting "free-love" in the 1960s, the "flower-children" of the courts of the early fifteenth century were part of the establishment, luxuriating in excesses that were only possible because of their political power. Moreover, this highly eroticized fresco of the Fountain of Youth faces on the other wall a much more serious and politically charged series of standing figures representing the worthy men and women of Antiquity.

Fountains of youth for the lower orders were available at the bath-houses of medieval cities such as Paris and Bruges, which were associated in the popular imagination with brothels. The artist of a sumptuous *Alexander Romance* pictured in one of his hundreds of racy marginal scenes such an *estuve*, which recalls less the May-baths of the countryside than the money-making baths of the city. A naked couple are about to enter a little hut on the left and embrace in the hot-tub on the right (fig. 70). Without the elegant etiquette of traditional love scenes these figures have more of the elasticity and awkwardness of the everyday, the man coyly protecting his genitals or hiding what Augustine had

70. The urban fountain of desire – the brothel, from the *Alexander Romance*, Bruges, 1344, under the direction of Jean de Grise. Oxford, Bodleian Library, MS Bodley 264, fol. 75r.

described as his unruly member, while the woman runs unclothed in the same direction. A female servant trudging up to the curtained tub with two heavy pails of hot water adds a touch of ordinariness, even of bathos to the scene, for unlike the Fountain of Youth this water is not magically, but manually produced.

The most famous imagery of the bath-maid-en-prostitute occurs in the manuscripts made for Emperor Wenceslas IV of Bohemia, whose Bibles, astrological and even political treatises are filled with hydropathic and balneotherapeutic beauties carrying pails and bunches of leafy twigs, and blue silk love-knots. The love-knot in which the bearded old ruler is trapped between five bathing beauties in the margins of the *Imperial Golden Bull* (c. 1390) is also the first letter of his own name (fig. 71). The bath-maiden to whom he stretches out his hand on the left has been related to a legend about the young king's being saved from his enemies by a bath-maiden. But as Czech scholars have recently shown, the bath imagery in these manuscripts does not represent royal fantasies or legends but rather royal realities and the king's hopes for an heir and successor. The astrology-obsessed

Prague court looked to the planet Venus, embodied in the sensuous symbol of the bath-maiden and the fertility sign of the leafy twigs, pinning their hopes for an heir to the throne on Wenceslas's new young bride Sophia of Bavaria, whom he married in 1389 but who was to remain childless for the twenty years of their marriage. Under the guise of courtly erotic games a frantic plea for potency is being rehearsed, suggested here by the young girl at the left who holds up her round breasts, less in the role of concubine than as mother and nurse.

In fifteenth-century manuscript illuminations of men and women bathing together, which often illustrate historical and literary texts, they are often shown eating a banquet at the same time, the table set up in the bath itself. This combination of food and sex, or what the preachers would have decried as gluttony and lechery, occurs in a spirited series of drawings of the *Children of the Planets*, depicting those who came under the influence of Venus (fig. 72). The naked goddess carries the same emblem of the fiery brand she had in the earlier German Manesse Codex (see fig. 26). She rules her heavenly sphere and its signs from the same cosmological position as on

71. Emperor Wenceslas IV in a love-knot surrounded by bath maidens, from the *Imperial Golden Bull*, Prague, c. 1390. Vienna, Österreichische Nationalbibliothek, Cod. 338, fol. 1r.

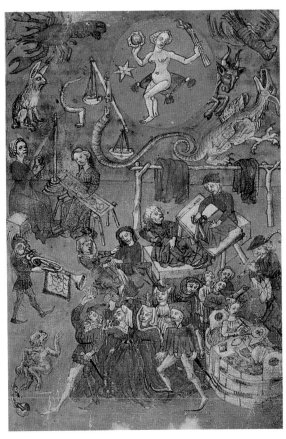

72. *The Children of Venus.* Colored pen-drawing from the *Children of the Planets* series, Germany, c. 1500. Tübingen Universitätsbibliothek, MS Md. 2, fol. 270r.

the Italian birth tray (see fig. 23). The mirror in her other hand is also a powerful sign of gender, being associated with women as the attribute of *luxuria* and with their cold, wet temperaments, which impel them toward fiery lust. Astrology came to rule all aspects of everyday life in this period: not only medicine and politics were influenced by the stars, so too was love's course. In medieval psychological terms one's personality and capacity for love were conditioned by the planets. Those who were thought to be ruled by Venus included tailors, musicians, and entertain-

ers of all kinds but also lovers, exemplified here by a couple dining in a great bath-tub. Venus was seen as an inherently female planet, controlling heat and moisture, menstruation, and sexual desire of women, who are in the majority in this German drawing. There are also different social groups: the wealthily dressed courtiers dance in the lower center whereas the women weavers are further back. The children of Venus, explains the text, are happy on earth whether they are rich or poor. Round-faced and plump they enjoy music and are inclined to be unchaste. Like the monkey with its ball and chain, however, they are all bound to their bodily desires. Now it is not only the legendary male lovers of the past who are brought under her power but men and women in all walks of life, no longer exclusively aristocratic but persons of all social classes, even a squabbling housewife and husband near the center of the drawing. The influence of the stars not only made love a matter of cruel fate, outside the control of those fortunate or unfortunate enough to come under the sway of Venus, astrology equalized persons who had hitherto been on different rungs of the social ladder. The hot-blooded redness that suffuses this whole drawing of the children of Venus is the most potent pictorial marker of sexual license, visible on the faces of all of Venus's ruddy children.

THE CASTLE BESIEGED

Although the male poet longs to become a prisoner of his beloved, trapped in the chains of love, it was in reality the lady who was physically and spatially bounded and constrained. In poems and pictures she often appears enclosed, not in a gar-

den but atop a tower or castle that simultaneously represents the superiority and power she holds in fantasy and the isolated and restricted position she held in reality. Actual women, like actual castles, were hemmed in by high walls (of prohibition), deep moats (of marital jealousy), and armed guards (of ladies in waiting). Much as he would attack a castle, a knight could besiege the lady and try to take her by force. Such are the intimations of rape that lie behind the playful subject in Gothic art known as the *Siege of the Castle of Love*, which appears in the margins of the Peterborough Psalter (fig. 73). The chain-mailed knights are shown being easily repulsed by a team of ladies from the battlements. The contrast between their vast longswords and the little flowers that defeat them was surely meant to have

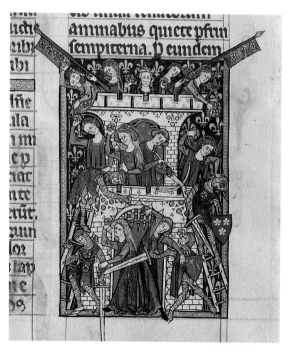

73. *Siege of the Castle of Love*, from the Peterborough Psalter, England, c. 1300. Brussels, Bibliothèque Royale Albert 1er KBR, MS 9961, 9962, fol. 91v.

strong sexual implications. A song in the *Carmina Burana* told from the point of view of a violated young girl laments how under this linden tree: "He threw aside my lovely dress with body uncovered,/And hastily invaded my fortress with desire erect." Here the rose is not plucked but is a weapon against male aggression, just as it was in the ceremonial performances that actually enacted this allegorical scene on special occasions, first recorded at a festival in Treviso in 1214 but also for the wedding celebrations of Charles VI and Isabeau of Bavaria in 1385, when a *tableau-vivant* of the subject was paraded through the streets of Paris. The Peterborough Psalter example was not meant for the eyes of courtiers, however, but was made for a wealthy abbot who would have seen this overcoming of phallic violence by the flowers of virginity perhaps in terms of his own enclosure away from the violence of the world.

A pendant-case with translucent enamel, which perhaps hung from the belt by the two handles, shows the lady in her inviolable tower not repulsing but handing a knight his weapons (fig. 74). The knight being armed by his lady was a standard part of the repertoire of love images in the Gothic period, appearing in the Manesse Codex and also in more historical contexts. A contemporary chronicle describes how at a tournament held in Lincoln in the 1320s a knight called William Marmion was presented with a helmet by his lady and instructed to make it known in the most perilous place in the land, so he marched off recklessly to fight the Scots at Norham Castle, then under siege, and was nearly killed. Protecting weak women but at the same time humbling himself before them was

fundamental to the ethos of chivalry. On the other side of the object a knight is shown spearing a wildman and another wildman reclines on the bottom of the rectangular case, suggesting a contrast between base and noble desire. There is even a pseudo-religious suggestion in the inscription which reads "Ave Maria Gratia pl[ena]" ("Hail Mary Full of Grace"), the angelic salutation. If this was a little container for a jewel or perhaps for an amulet that might have protected the warrior on the battlefield, its being bestowed by a woman re-enacts the image on its face, the lady bestowing the knight with his masculinity. For she too grasps the long lance, the male's virile weapon, near its sharp point. But if it was a love-token given by a knight to his lady, it would have functioned

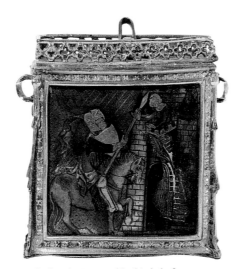

74. The knight is armed by his lady from a tower. Pendant case, England, c. 1325–40. Silver-gilt with translucent enamel, 2 x 2⅛" (5.1 x 5.3 cm). London, Victoria and Albert Museum.

more as authorization of his position, which as protector of her body was also its penetrator. The meaning of this multi-faceted object is quite significantly altered when it is worn by a man and when it is worn by a woman.

Those who might think that this argument pushes a "phallic" interpretation of objects such as towers, spears, and doorways in castles too far need only look at the margins of a *Roman de la Rose* in Paris to see the medieval manifestation of ideas we would today call "Freudian." Here on the left a nun leads a monk by a rope tied to his genitals and opposite she stands as the unapproachable object of his ardor as he climbs up a tower to try to reach her (fig. 75). In some parts of France the public humiliation of being led by the genitals was the punishment

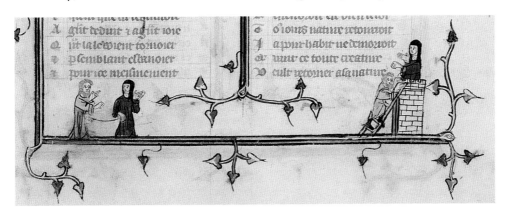

75. Jeanne de Montbaston
A nun leads a monk by his penis, he climbs a tower, from *Le Roman de la Rose*,
Paris, c. 1345. Paris, Bibliothèque Nationale, MS fr. 2446, fol. 106r.

76. Stone fireplace from Le Mans with
pairs of lovers, late fifteenth century. Cluny, Paris,
Musée du Moyen Age.

meted out to adulterers but here the joke is on the man who is being led by his own desire. In the opposite scene he is shown again climbing a ladder up to a tower toward the nun, the inaccessible lady who will have intercourse later in the manuscript's margins. Here the ladder recalls the *gradus amoris* or the five steps in the lover's gradual approach toward the woman's body, as well as the traditional siege of her castle. A whole series of *bas-de-page* scenes in this manuscript, including the same nun picking phalluses off a tree full of the luscious fruits, represent the fantasy of women's control over male desire. What is remarkable is that these spirited illuminations are

the work of a documented female illuminator, Jeanne de Montbaston, who together with her husband, the *libraire* Richart, produced this manuscript sometime before his death from the plague in 1348. It represents a wonderfully witty visual gloss on that part of the *Roman de la Rose* written by Jean de Meung as an allegory of the battle between the sexes rather than a celebration of love. These two scenes occur in the lower margin of that part of the text of the poem where the Old Woman "La Vieille" discusses man's natural inclination to lust and "the man who goes into a religious order and comes to repent of it afterward." This section also contains the most "feminist" arguments in the poem. The Old Woman compares the plight of a woman with that of a caged bird longing for the woods: "all women of every condition, whether girls or ladies, have a natural inclination to seek out voluntarily the roads and paths by which they might come to freedom, for they always want to gain it." Jeanne's position as a female illuminator allowed her to poke fun at the penis because part of the verbal and visual language of love at this time was its radical inversion in parody and laughter.

Most women, like Jeanne, held dominion not over a castle but over a home, a domestic sphere in which they had control. Whereas our century has coined the phrase that women are "chained to the kitchen sink," medieval women would have complained about being imprisoned next to the hearth. The fireplace in its production of heat and its cooking possibilities was often identified with the house, called its "womb" and imbued with generative female symbolism. A stone fireplace from a burgher's half-timbered house in Le Mans (demolished

in 1843) shows a freize five courtly couples exchanging gifts. In the center the male and female stand on either side of the tree, not as Adam and Eve or as Tristram and Isolde but as a family unit of husband and wife on either side of their coat of arms, which hangs on the branches of a tree whose roots extend down into the generative fire below. This is their family tree, their power (fig. 76). The fireplace is both the symbolic center of the domestic unit of the family and its stronghold. Extant examples from wealthier medieval houses are often crenelated like castles and carved with love imagery, suggesting the importance of joint property relations in marriage. This example also shows the couple again as corbels holding up the fireplace and here, significantly, the wife has assumed the stage-right, superior position, in this realm which is under her control.

The tower or donjon that contained the lady – whether it was the hearth of the home or the castle tower in which the jealous husband of so many romances immured his lady – was synonymous with her body. Toward the end of Jean de Meung's continuation of the *Roman de la Rose*, as the lover gets closer to plucking his rose, Venus attacks the tower of shame, shooting her arrow at a loophole between two columns, the shrine that encloses a silver maiden, described as love's idol (fig. 77). One of the reasons that allegory was so popular in this period was its capacity to cover up unwelcome reality. In some miniatures of this moment in the narrative the goddess is shown firing her arrow between two columns that are the allegorical means of representing the lady's legs. But the artist of one manuscript wanted to be more literal and represent more of what lies

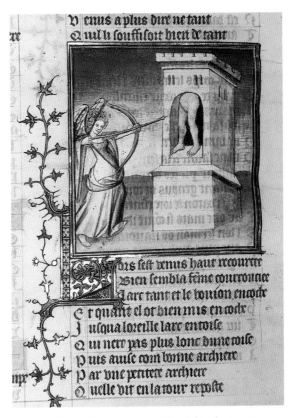

77. Venus aims her arrow at the idol in the tower, from *Le Roman de la Rose*, Paris, c. 1420. Malibu, The J. Paul Getty Museum, MS 83. mr.177 (MS Ludwig XV.7), fol. 129v.

beneath the surface of the allegory. Venus's arrow here is not that of her son Cupid, which embodies the look that dare not touch, but a far more physical assault.

In a later manuscript of the *Roman de la Rose* the metaphor of the lady's body as a building receives a more monumental if allusive interpretation (fig. 78). In this large miniature the crenelated walls seem to project out of the picture right up against the viewer, presenting, in its multiple moated layers of watery reflections, flowering white roses smelling of virginity and labyrinthine crenelations as hard as the lady's coldness. The male personification Dangier

78. The Castle of Jealousy, from *Le Roman de la Rose*, Bruges, c. 1490. London, British Library, MS Harley 4425, fol. 39

guards the entrance, and the object of desire, the rose in a white wimple, appears guarded by a whole miniature army at the front. Alone and outside the sealed space the dreamer/lover is pictured at the very top left-hand corner of the scene. The painter has separated the viewpoint of the lover inside the poem from us, the readers, outside it. Our perspectival trajectory goes from the looming face of Dangier staring at us in the foreground, through a single axis to the rose, which has never been more vividly presented as the focal point of desire, the lover's single aim and goal.

It is fascinating to compare this superb allegory of the body's defenses with actual architecture of the period, such as the Louvre palace completed by Charles V (1364–80), which had a similar configuration of a central donjon sur-

rounded by layers of curtain walls. Allegories only work when their surface accords with the contours and expectations of reality. Later amorous architectural allegories appear in a famous German manuscript known as the *Housebook*. In addition to recipes for aphrodisiacs, this work contains forty pen drawings of war-machines, a series depicting the *Children of the Planets*, and a large composition of a brothel/bath-house, a very unusual Castle of Love (fig. 79). Spread across a double-page opening, this composition has been called an ill-defended Castle of Love because, apart from a few women beckoning invitingly from its various windows, the ladies have all wandered outside its protective gates. This would have presented a shocking spectacle to contemporaries, an example of what happens when women are let loose from the tight bonds of marital control and their closed-off confines in the inner chambers of castles. As if to suggest this potential freedom, the talented fifteenth-century draftsman set this scene of chaotic coupling within a deep three-dimensional space where couples cavort with a dainty, whimsical, if sometimes knock-kneed elegance. The women do not defend their castle but have come out into the courtyard to lure men inside. A peasant dangles upside down from a tree, caught helpless in an animal trap, while more noble young men are being lured in the foreground. The girl by the well tries to attract the attention of a young fellow whose underhose is falling down as he feeds the geese. The castle is even viewed through the back door, drawn not from the front moat like the great castle in the Harley *Roman de la Rose* (see fig. 78) but displaying the stable yards and kitchens, its "lower"

79. A castle of unbridled female desire, from *The Housebook*, Middle Rhine, c. 1475–85.
Wolfegg, Fürstlich Leinningensche Sammlungen Heimatismuseum, fols 23v–24r.

quarters that are bursting with the bums of horses and stooping stable-boys. Here predatory females tempt servants as well as well-dressed nobles from their proper places and duties, which makes this a rather chilling comedy, especially when one considers that the rest of the *Housebook* is of a pedagogical nature. The question of how the patron of this unusual treatise, the notoriously reluctant warrior-emperor Frederick III (d. 1493), could have made use of such elusive and parodic images of love alongside diagrams of siege engines is still unclear, except of course that the art of love was never that far removed from the art of war in the medieval imagination. What makes this image so funny and at the same time so disquieting is that its humor rests upon the fact that it depicts the impossible. That noblewomen might ever leave the confines of the castle and go in search

of love on their own, moving their bodies with the wonderful rhythms and angular articulations such as are drawn here, could only be a fantasy. And of course while such freedom must have been the fantasy of many historical women, here it becomes an erotic fantasy for the male artist and his audience. Here at the end of the Middle Ages the traditional symbols that once radiated so much security – the garden, the fountain, and the castle – are each turned upside-down or even inside-out. The garden of spring becomes a wintry branch on which a witless youth dangles topsy-turvy, the fountain turns into a watery well of lubricity from whence a harlot beckons, and, most perverse of all, the Castle of Love itself, the edifice that should present the perfectly proportioned portal for frontal penetration, reveals itself to be, like the ass of the maiden grabbed by the young man on the far left, love's backside.

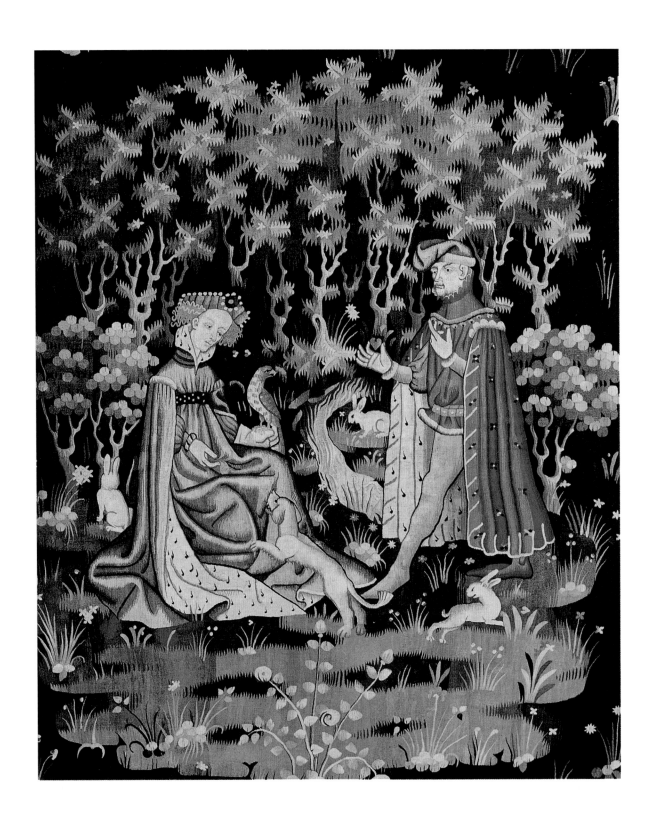

80. A lady with a dog and a falcon and the offering of the heart. Tapestry made in France or
the Southern Netherlands, c. 1400. Paris, Louvre.

LOVE'S SIGNS

Sometimes we observe falcons of slight build pin down by their courage large
pheasants and partridges just as a boar is frequently cornered by a hound of modest size.
On the other hand we observe many noble falcons and peregrines frightened by the
grubbiest sparrows and often routed by a kestrel. So if the kite or kestrel is found to be spirited
and bold, diverging from its parents' class it deserves to be honoured with the perch
of the goshawk and to be carried on the left forearm of a knight.

Andreas Capellanus

This argument is made in Andreas Capellanus's treatise by a man of the middle class who claims his right to woo a lady of higher social rank than himself, using animal and bird analogies to argue his case. Just as any bird can act with the bravery of a falcon – the noble bird used in the exclusively aristocratic sport of falconry – any man can develop the nobility to love higher than his station. These symbols are more than coincidental but part of the visual as well as the verbal language of love. Just as the hunting bird represents the nobler aspirations of the lover, others "who wish to indulge their lust with every woman they see" are compared to "a shameless dog" and are unmoved "by man's true nature, which makes us distinct from all animals by the difference of reason." One superbly preserved tapestry shows a pair of lovers in the usual flowery *locus amoenus* with a stream running down the center (fig. 80). Here are included all the symbols of love discussed in this chapter – the animals such as the falcon, dog, and rabbit as well as the various flowers and the focal symbol of the heart. It is the lady who is seated on the ground who bears the beautiful specimen of a falcon on her left hand, a sign of her nobility and her hunting role in this relationship. In her

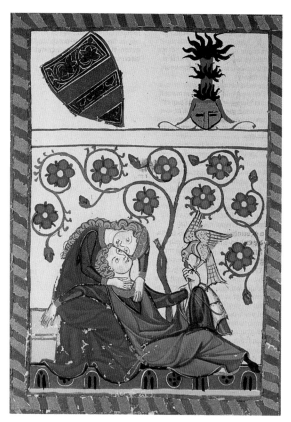

81. Konrad von Altstetten as hunter and hunted,
from the Manesse Codex, Zürich, c. 1300. Heidelberg
Universitätsbibliothek, ms Cod. pal. Germ. 848, fol. 249v.

other hand she holds a flower, sign of her virginity and the gift she might bestow upon her lover. Her suitor is of equal rank and strides toward her with one great leg stretched out, holding a tiny heart like a sweetmeat between his fingers. The bird of prey turns to eye the small red object. Despite these violent intimations of falcons ripping into pieces of human flesh, the whole point of this heart symbolism is to express the spiritual rather than the physical part of the lover's suit, since he is proffering that intangible and organless aspect of himself – his love. The physical aspect of this relationship is

evoked by the other animals in the garden, especially the lapdog that jumps at the lady's flower. This was the position that every lover longed to be in and small furry animals such as dogs and squirrels, which were also kept as pets, were common signs of male sexuality. Other intimations of animal passions are woven into the tapestry in the form of three rabbits, which in Old French were known as *con* – literally spelling the name of the female sexual organs. The menagerie of meanings – zoological, biological, and even magical – that surrounds these two lovers is a way of making explicit what cannot be depicted, of presenting the experience of love through a secret, symbolic language.

THE HUNT

Both men and women are depicted as falconers in medieval art and the falcon itself could be used as a metaphor of either the lover, the lady, or even Love itself in poetry of the period. When the lady is shown holding the bird of prey, as in the tapestry, it usually means that (within the amatory fiction at least) she has her lover under her power. When a man holds the falcon, however, it does not necessarily mean that he is in control of the love situation. One of the most splendid pages of the Manesse Codex shows the poet Konrad von Altstetten holding a falcon feeding on a small piece of meat used as part of the lure on his elegantly gloved hand (fig. 81). Who is feeding on whom here and who is really in control? The bird surely represents his lady who has her arms around her prey and feeds on him with her kisses. She is in the dominant spatial position in the image, but, like Konrad's fal-

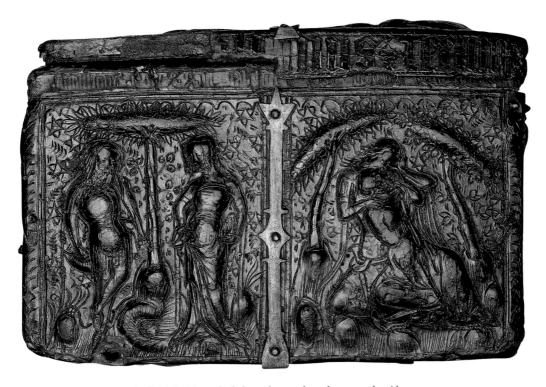

82. A knight and a lady, and a couple embrace, on the side
of the "Talbot" casket, Flanders, c. 1400. Incised and moulded leather over wood,
10 x 7¹/₂ x 5" (25.5 x 19 x 12.5 cm). London, British Museum.

con, she is actually the object of his manipulation. The lady is also equated with the falcon as in Gottfried's *Tristan*, which describes Isolde as "exquisitely formed in every part ... as if love had formed her to be her own falcon" and her figure is described as "free and erect as a sparrow hawk's." Although the falcon is the bird of prey it has been tamed to hunt by its master. The poet is presented here as both hunter and hunted, orchestrating his own engorgement by the beautiful bird that looms above him.

A more direct use of the falconer image can be seen in the so-called Talbot casket said to have belonged to the Englishman John Talbot, Earl of Shrewsbury (1388–1453). On one side a falconer is offering the bird a piece of meat from a purse at his belt while the lady stands aloof. On the other she has taken the bait in one of the most wonderfully entwined and animal kisses in fourteenth-century art (fig. 82). A twelfth-century German poem described how "Women and falcons are easily tamed, if you lure them the right way, they come to meet their man." The gesture with the purse is here what stirs the lady's attention and in the scene alongside she is shown "under" her lover as the "caught" prey, in the position of Konrad in the Manesse Codex. Here the falcon would seem even more directly to represent the male hunter's luring of the lady.

A woman is shown as an expert falconer in a tiny enameled gold brooch (fig. 83). For the aristocracy, used to the daily handling of these splendid birds, this scene would have been recognizable as that part of the falcon's handling where it is trained to rest on the leather glove of its master or mistress, by offering it a *bechin* or tiny morsel of fresh meat tied to the lure on the falconer's hand. Also visible here is the long cord, the *créance* or *filière*, that kept the bird in check during training. Training the falcon involved getting the bird first to accept human beings, which involved using a hood to blindfold the creature and calm it and then letting it fly off to hunt, but always tethered by the leash or *créance*. Progressing slowly, the training of birds took tremendous patience and sensitivity to the creature's moods on the part of its handler. No wonder it became the pre-eminent symbolic system for articulating relationships between men and women. Disgruntled wives would complain that their husbands cared more for their falcons than for them, but in fact the language used by both men and women by which they learned to articulate their desires was often based on the pleasant pastime of the hunt.

An embroidered *aumonière* showing the return of a lover to his lady also subtly expresses the sensuous relationship between falcon and falconer (fig. 84). This fragment of a velvet pouch with applied linen is superbly embroi-

83. A lady and falcon capture the lover's heart. Gold and enamel brooch made in France, c. 1400. Berlin, Kunstgewerbemuseum.

dered with silver-gilt thread and silks, satin, stem, and split stitches ornamented with sequins and cabochons. On the back is a more standard image of a falconer but the front is almost a "close-up" on the delicate relationship between the creature being trained and its mistress. The lover here, his enormously long arms flapping out like wings and a hood on his shoulder, is assimilated to the noble bird who has to become used to being hooded, that is, having his eyes covered to induce calm and relaxation.

Flying back into her arms, as described in a contemporary poem which elaborates on this analogy between the lady and the falconer, this hawk-eyed youth stares at his mistress who puts a hand on his shoulder as if to stop him while holding the *créance* in her other hand. "The falconer knows full well how to call him back to the lure, to which he now returns to take his pleasure." Clarity of vision was one of the bird's defining characteristics, for it had to be able to see its prey or its master or mistress from a long distance away. Although a man might have worn such a purse, its unusually direct and strong female subject-position and its focus upon the lady falconer as the point of return for the flighty bird suggest that this was probably a lady's *aumonière*, woven by one of the greatest nameless embroideresses of the fourteenth century.

That the rabbit was associated with the female and the dog with the male is made explicit in one of the most beautiful pages

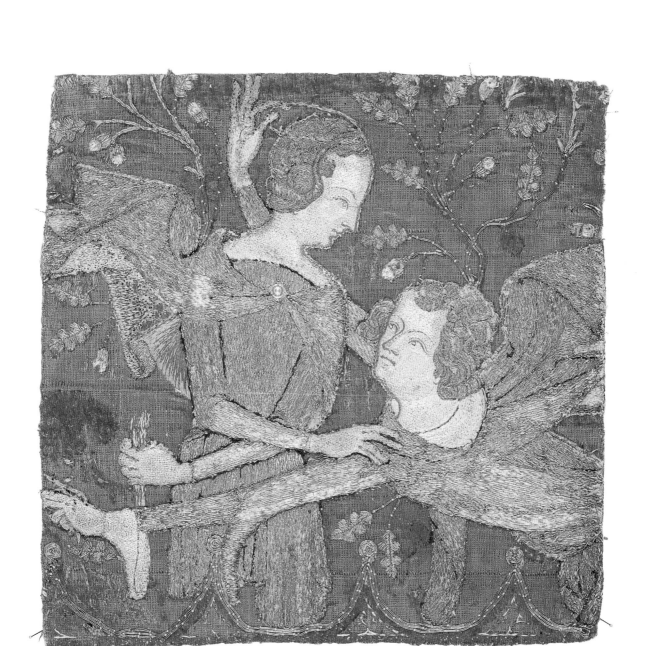

84. The falcon's return. Embroidered *aumonière* made in France, c. 1320. Silks and silver-gilt thread on velvet with applied linen, 8¼ x 7¾" (21 x 20 cm). Lyon, Musée de Tissus.

Amours eust point de A renouueler

poer ie men deusse bien du iolit tans

apercuoir qui lai serui mestuet co

e tout mon uiuant de E Nec

cuer loiaumīt mes ie cro

of a late thirteenth-century songbook or *Chansonnier* (fig. 85). Here a complex motet for three voices by Pierre de la Croix about love's sorrows and delays is introduced by a similarly complex visual scheme. The most upper voice, the *triplum*, opens with the phrase "S'amours" and shows a pair of seated lovers, each of whom pets or strokes their respective animal to arousal while simultaneously stretching out a hand to touch the other. The lady fondles her own smirking rabbit and her lord's thigh while he strokes his puppy and places his white-gloved hand on the lady's shoulder. In the adjacent letter "A" of the lower, slower musical line known as the *duplum*, which was sung at the same time as the *triplum* to the left, sits an isolated and disconsolate lover. His dejected figure contrasts with the words sung here: "At the rebirth of the joyous season, I must begin a song, for true love, whom I desire to serve, has given me reason to sing. He caught me in his gentle, laughing game and now I can think of nothing else but her ... " A single songbird next to him represents perhaps his plaintive lone voice compared with the conjugations of quadrupeds going on alongside. The small "E"

85. A lover with a dog and a lady with a rabbit, from a *Chansonnier*, Paris, c. 1280. Montpellier, Bibliothèque Universitaire de Médecine, MS H196, fol. 270r.

86. Lovers go off hunting. Mirror case made in Paris, c. 1320. Ivory, h. 5" (12.5 cm). London, Victoria and Albert Museum.

below him on the left of the second column is not illustrated but represents the third "part" in this three-voiced song, the *tenor*, which consists of the repeated word in Latin, *Ecce!* "Look!" near where hunters have sighted a stag in the beautifully drawn *bas-de-page* scene. The medieval musical theorist Johanees de Grocheo claimed that such motets cannot be appreciated by the common people, but are "for the learned" and "those seeking subtleties in the arts." Just as it was a challenge to hear this motet being sung with its three separate strands of multiple voices, we are urged to look hard at this complex layered visualization of amorous passion. Each part singing different words, the page presents a multiplicity of visual subject positions – the lover and his lady, the isolated lover, and the hunters below.

As the predominant blood-sport of the nobility in medieval Europe, hunting provided a whole host of signs for structuring human power relations. There was even a medieval poem of a lady allegorically represented as a stag, the anonymous *Li Dis Dou Cerf Amoroeus*, in which the lady, figured as a deer, is chased by hounds personified as "thoughts," "memories," and "desires." In another poem of 1332, Jean Acart de Hesdin's *L'Amoureuse Prise*, it is the male narrator who is pursued by the beauties of women in the guise of dogs named "pleasure,"

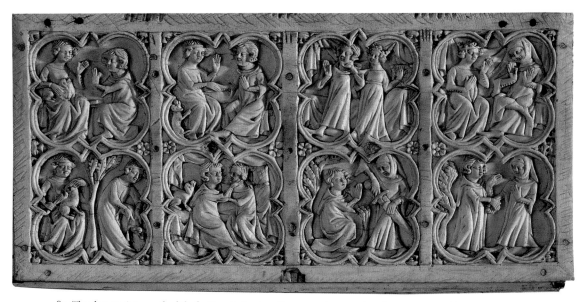

87. The dog as sign, on the lid of a French fourteenth-century ivory casket showing scenes from the romance of the *Châtelaine de Vergi* 9 x 4¹/₄ x 3³/₄ (22.6 x 10.8 x 9.7 cm). London, British Museum.

"will," "thought," and "hope." The lover can be both the hunter and the hunted. The dog has pounced on the rabbit in the lower part of an ivory mirror case showing a young couple starting off on a hunt (fig. 86). In the Old French version of Virgil's *Aeneid*, the *Roman d'Eneas* (c. 1160), when Lavinia's mother tries to persuade her daughter that Aeneas, being a sodomite, is not worthy of her love, one way she puts this is to say that he has disdain for the *pel de conin* or "rabbit fur." It reminds us of the description in the *Roman de la Rose* of those "delicious games of love" which include how "Here in the wood you may hear the dogs barking in chase of the rabbit." The violence of this metaphor is interesting for in reality, as in the ivory carving, the dog pouncing on the *con* does not desire to copulate with it, but to kill and devour it.

To some extent the appearance of animals here serves to disguise or euphemize the sexual

act – to keep it a secret. The dog is used as a sign in the actual process of an adulterous affair in the popular romance of the *Châtelaine de Vergi* carved in ivory on the lid of a casket (fig. 87). We already saw this story played out in the bedroom of the Palazzo Davanzati in Florence (see fig. 63) but here in miniature it serves to keep closer to the body the secret of a box. In the first of the eight quatrefoils the lady, seated with her lapdog, explains to her kneeling lover the plan by which they could meet in secret; in the second they shake hands in agreement that she will send her little lapdog out to signal that the coast is clear, as she is doing in the third scene below. In the next quatrefoil the dog is a little furry witness to their meeting, jumping up on the knight's side of the bed as if in sympathy with the young man as he embraces his lady.

The most animal-obsessed and animate objects of the art of love are those most intimately

connected with the body. A variety of beasts appear on a fragment of the upper part of a lady's leather shoe, found in London during the nineteenth century but thought to be French work of c. 1400 (fig. 88). A young girl beats a dog on the left and a young man offers a mirror to a monkey on the right, marginal images of male lust and female vanity being brought under control, in contrast to the pair of lovers seated beneath a tree in the central roundel. Here an older lover offers a lady a gift in the form of a small circular object. Whereas today the lady's shoe has become a symbolic object of male fetishism, this medieval leather shoe, with its images of animal chastisement, had in addition to any erotic fascination a more complex discursive moral content. It was "readable" to the lover as he knelt down at his lady's feet in his proper subservient position, but it was also visible to the woman who wore it. The shoe impressed her authority to regulate the animal passions of her suitor, and was perhaps a gift from one of them, with its inscription *Amour merci je vous en prie*.

Even more closely connected to the lady's body than her shoe was her ring. A large fifteenth-cen-

88. A dog, a monkey, and a lion, and the lover offers the lady money. Fragment of a lady's leather shoe made in France, c. 1400. London, British Museum.

89. The lady with a squirrel. Gold ring with sapphire setting made in France, fifteenth century. London, British Museum.

tury French gold ring set with a sapphire has a squirrel incised inside, another of the small furry pets of the lady's lap (fig. 89). Images are here combined with even more sophisticated and furtive forms of wordplay in two inscriptions linking love to grammatical exercises. On the outside appear the words *une fame nominative a fait de moy son datiff par la parole genitive en depit de l'accusatiff* and inside, next to the lady holding a leashed squirrel with one hand and a bunch of acorns in the other, is the inscription *tm [on] amour est infiniti[v]e ge veu estre son relatif.* The first inscription thus means that the ring has been given to a named lady as her possession despite her opposition – "A nominative lady has made me her dative by the genitive word despite the accusative." The more secret inside inscription, "love is infinite for her relative," suggests that this was a witty wedding ring since the lover has now become a relative of the lady, happy within her "unending" or "infinitive" circle. It has more innuendo still, since

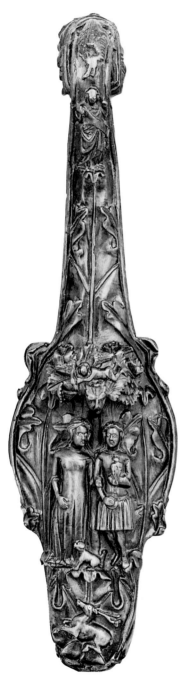

90. Lovers with a dog, a falcon, and a stag,
carved on a *mandora* or *chitarino* made in North Italy,
c. 1420. Boxwood, rosewood, l. 1'2" (36 cm). New York,
The Metropolitan Museum of Art.

the squirrel was often euphemistically used to describe the penis, as in the French *fabliau L'Esquiriel* where Robin searches in the "belly" of his beloved for nuts eaten the day before; when asked to explain to the girl what that bulge is in his clothes, he replies that it is the squirrel coming out of its hole. The male is "inside" the ring, worn next to the skin of the lady's finger where she has the squirrel on a leash enjoying his infinite supply of nuts. The nut or kernel also represents the secret, or truth, contained within something. The large sapphire on the front of the ring was, by contrast, thought to "make a man chaste" and "cool internal heat," which adds yet another magical dimension to this multi-faceted finger-ring.

Another suggestive late medieval object from the point of view of animal signs is the little cousin of the guitar, a stringed instrument called a *mandora* or *chitarino*, made in Milan around 1420 (fig. 90). It has been described as the perfect nuptial gift for a bride. The rosewood instrument, carved deeply at the back, shows yet another variant of two lovers beneath a tree. The lady stands on the left, her lapdog yapping at her feet. In this case it is the male suitor who holds a falcon in one hand and puts his other hand "where his money is," that is, on the purse at his belt and on his sex, as if guaranteeing his potency in the future. A small naked Amor fires an arrow down at the lady from the tree above and a startled stag leaps below. Toward the top stands a severe-looking figure with one hand upraised and a scroll in the other, looking like a prophet who has accidentally stumbled out of an altarpiece on to a musical instrument by mistake. But of course there is no mistake. He stands above for a purpose, to sanction the union carved below, adding

the blessing of the Christian God to the pagan God of Love. Can we gender this object? On the front of the peg box is carved the small seated figure of a woman plucking an instrument shaped just like this one, suggesting the object's original use. In showing once again the female control over male sexual appetite, the lovers on its back appear like reformulations of Adam and Eve in Eden, except that here the daughter of Eve has the serpent literally in her hands and "plays" him, for the curving head of the instrument is carved so as to represent, from the side, a monstrous dragon.

In this zoo of conflicted natures and animal appetites it is important not to see these signs as having any one single or uniform meaning. That these could change according to the gender of the viewer is suggested by what remains the most extensive literary work of the Middle Ages linking love to animal forms, the *Bestiaire d'Amour,* written by Richard de Fournival (1201–60), chancellor of the Cathedral of Notre-Dame at Amiens, book collector, and licensed surgeon. His *Bestiary of Love* uses animals such as the lion and the beaver as symbols, not of Christ as in the traditional Bestiary, but as arguments of his own desire. In manuscripts of this work we see not only miniatures of the respective animals but Richard arguing with his lady, using *paroles et paintures*, that is, words and pictures. As well as the dog, Richard uses the wolf, viper, crow, weasel, and crocodile to describe the love of women. Elaborating on the traditional association of love with the eyes, it is compared with the crow picking out men's brains through the eye sockets. Trained as a cleric to see women as leading man astray, Richard desires the lady only insofar as she accepts the animal's maternal role,

nurturing him like a mother. But Richard did not have the last word. In a text that appears after that of his in a number of manuscripts there appears the Response to the *Bestiaire* in which the lady gets to answer back, refusing all his metaphors and using the same animals to make opposite arguments: "Although the crow seizes man through his eyes ... although Love captures man and woman through the eyes, it does not follow from that that the crow resembles Love. Say, rather, that one must with the eyes of the heart, compare it to hate." In swooping down from the sky, the falcon, she reminds Richard, "strikes death into its victim." Likewise she sees the unicorn asleep in the lap of a virgin not as an image of a man trapped by the lures of women but as a warning about the guile of such creatures to entice their way into women's affections through beguiling speech. The lady knows all too well that the male writer is using the combination of words and images (*dites et paintes*) to argue his case and that clerics like Richard use learning to "overtake unknowledgeable people." "For this reason," she says, "I call them birds of prey, and would do well to be protected against them." In the *Response* woman is seen as the victim of male tyranny, aggression, and deceit. This literary work, which may have been penned by a learned lady in response to Richard's own text, is important testimony to how the animal symbolism discussed in this chapter might be resisted by those who were most objectified by it.

A beast not mentioned in the *Bestiary of Love* is the griffin, a powerful mythical creature, which comes between the lover and his lady in a superb Swiss tapestry (fig. 91). The young man holds a scroll reading: "schone frowe. begnodent mich

91. The griffin protects the lady. Tapestry made in Basel, c. 1460 (detail).
Whole tapestry, 3'5¹/₄" x 4'10¹/₄" (1.05 x 1.48 m). Berlin, Kunstgewerbemuseum.

mit Eurer Liece" ("Lady bestow upon me your love"), and she replies: "der Griffe betüttet. mir den list. dz. rehter liebe. nim uf erden ist" ("The griffin here tells me of the trick that true love on earth no more exists"). Half-eagle and half-lion, griffins were the fierce signs of unchastity and faithlessness. They also appear on contemporary German love-caskets as guardians and protectors of the contents. In the tapestry the beast not only guards the treasure of the lady's body like a monstrously oversized lapdog, but stands between her and her would-be lover. The images dealt with in this book idealize human relationships to suggest that controlling one's lover is as easy as keeping a pet dog in check. Perhaps it is only the terrifying griffin in this tapestry with his eagle's head and leonine body that gives us a better sense of the fear of sexual violation felt by many women in the Middle Ages. This lady, like the woman who replies so wittily to Richard de Fournival, knows that men will try any trickery to get what they want. If the beauty of the falcon and the aristocratic experience of using real animals provided a rich resource of animal signs for various dynamics of male desire, it was imaginary animals, fantastic beasts like the unicorn and the griffin, that provided not only protection but also something of a sympathetic subject-posi-

tion for women. This is not because women, as a number of scholastic writers of the period were to argue, should themselves be seen as deformed monsters. It was because like these strange, beautiful, and hybrid creatures they too were so often the impossibly imaginary and constructed objects of fantasy.

THE ROSE

In the *Roman de la Rose*, immediately following the description of the Fountain of Love at the center of the garden, in which proud Narcissus gazed, the poet describes how "Among the thousand things in the mirror, I saw rosebushes loaded with roses; they were set off to one side surrounded by a hedge. I was seized by so great a desire for them that not for Pavia or Paris would I have left off going there where I saw this splendid thicket." Intoxicated by their perfume he singles out one bud "that was so very beautiful that, after I had examined it carefully, I thought that

92. The lover yearns to pluck the rose, from *Le Roman de la Rose*, Paris, c. 1380. Oxford, Bodleian Library, MS e. Mus. 65, fol. 22r.

93. The game of the rose and lovers playing chess, on the end of a painted wood casket made in Konstanz, c. 1320. Zürich, Schweizerisches Landesmuseum.

none of the others was worth anything beside it." In the poem the lover cannot reach the rose at this point in the text because of the thorns surrounding it and has to wait until the very end of the poem; one illuminator shows what the rose represents – not only the lover looking at the flower of his desire but its incarnation as a lovely girl wearing a flowery chaplet (fig. 92).

Flowers of one kind or another are present on almost every image in this book, either as the backgrounds to tapestries or as the borders of manuscript pages. Flowers should never be considered merely decorative elements in medieval art, whether they appear growing in stone in cathedrals or as they luxuriate in the trellises between texts. On one of the ends of a painted wooden casket, which has scenes of hunting and feasting on its other faces, a lord and lady are shown playing chess (fig. 93). The young man, falcon in hand, is watching attentively as the lady makes the first move. Right in the center of the image is one of the studs holding the box togeth-

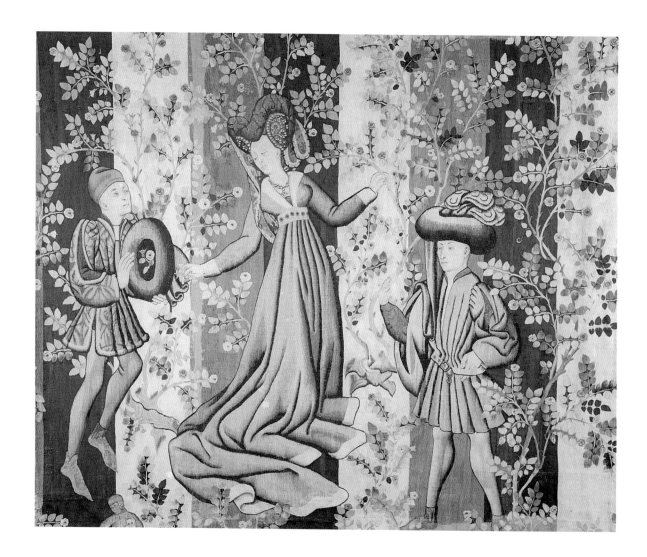

94. The lady plucks the rose, one of four fragments of a tapestry
set showing *Figures in a Rose Garden*, Southern Netherlands, c. 1450–55. Wool, silk, and metallic yarns,
9'5³/₄" x 10'8" (2.89 x 3.25 m). New York, The Metropolitan Museum of Art.

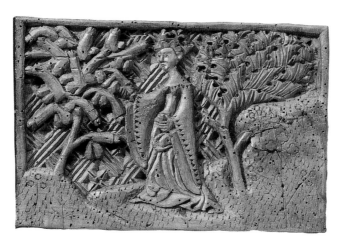

95. The lady plucks phallus-fruits from a tree.
Wood casket probably made in Basel, early fifteenth century.
Villingen-Schwenningen, Franziskanermuseum.

er, which the artist has wrought as a six-petaled flower. Covering the red and white checkerboard it makes clear what are the stakes of this game. The lady's lapdog has given up already and snoozes below the flower and the gameboard.

Compared with such intimate and playful objects, we might think that tapestries would be more formal and public in their presentation of love. Rulers such as Philip the Bold, Duke of Burgundy, spent far more money on tapestries than on paintings because these complex woven objects were part of the princely magnificence and splendor of the fifteenth-century courts. But they could become highly personalized objects too, often moving with their owners from one castle to another. Bearing not only family arms but personal love-mottoes, they could create eternal spring on freezing winter nights, their thousand-flower backgrounds enveloping beds, boudoirs, and even the bodies that moved against them and which seemed almost to take part in the woven world of unicorn-hunts and garden frolics. The

figures set in a rose-garden in a set of four enigmatic tapestries from the Southern Netherlands are nearly life-size. In the center of one a lady plucks a rose from a bush, pushing it through the hat of a young male figure who stands before her, so that it appears framed by a dark nimbus (fig. 94). Is this an erotic game in which the sign of the chaplet and hood of an earlier period has been replaced by the voluminous velvets of these great Burgundian hats and headdresses? The recipient of the rose here fares better than the standing gentleman on the right who grasps the thorny stem of the same bush from which the lady plucks the flower. This type of triangulation of desire in which a woman is placed between two men is here worked into a variation on the traditional theme of love's two branches – pleasure and pain.

Flowers need not always signify the female body. On the short end of a German casket a lady is carved in the act of plucking not roses but penises, which grow together with their pendulous fruits on a tree, and collecting them in a

96. Pierre Sala presents his heart to a Marguerite (daisy),
from his *Emblèmes et devises d'amour*, Lyon, c. 1500. London,
British Library, MS Stowe 955, fols 5v–6r.

sack (fig. 95) – a rare instance of the visualization of a woman's own sexual desire through the objectification of her partner. Her desire is seen as equal to the man's, for on the other end of the casket he stands next to a tree bursting with leaves in the shape of vaginas.

More conventional flowers that are still the staple of Valentine cards and love-gifts appear everywhere in the *Emblèmes et Devises d'Amour*, a little book of love poems by the royal courtier Pierre Sala, written in gold ink on purple-stained parchment for his beloved Marguerite Bullioud, whom he had loved since childhood. When he gave this book to her as a gift around 1500 she was actually married to someone else – Antoine Bautier, the king's treasurer – and only after his

death in 1506 was Marguerite free to marry Pierre. Also extant is the manuscript's wooden carrying case decorated with flowers of red leather, fitted with rings so that Marguerite could wear it hanging like a purse from her girdle. The case as well as the pages of the book are filled with the letter "M" for Marguerite. The intensely personal nature of this manuscript as a gift of love is shown in the very first miniature in which Pierre is shown placing his heart inside a giant Marguerite (fig. 96). The painter from Lyon who created this page left the face of Pierre blank here so that a more accomplished illuminator and expert portraitist, Jean Perréal, might add it, just as he added his beautiful miniature portrait at the end of the manuscript. But this never hap-

pened. This little book, while it looks back to the symbolic language of flowers and hearts in the art of love of the medieval period, also looks forward to the Renaissance in that it presents the portrait image of the beloved, constantly before the eyes of his mistress, as a crucial image of selfhood. The unfinished face of Pierre in this miniature stands as a lovely emblem of how the lover (unlike his lady) needs to be more than an empty slate waiting to be filled in. Marguerite, unlike Pierre's particular personality that fills this manuscript, remains a flower.

The Heart

That the "heart-shaped" symbol we still use today is, as we all know, not actually shaped like the muscle that pumps blood through our bodies, should alert us to the deeply symbolic ways in which all parts of the human body are manipulated as signs in culture. One of the most superb Parisian ivory mirror cases usually called "the offering of the heart" was carved before this symbol became a universal one, so it looks less heart-shaped (fig. 97). Holding his organ in uplifted hands snug in the folds of his cape, the kneeling lover surrenders it to the standing lady, who bends slightly, her left arm extended in acceptance and her right arm crowning him with a chaplet. The kneeling presentation resonates with the image of the Magi approaching Christ with gifts, but also evokes a far more central and important rite in Christian life. This is the transformation of God's own body in the miracle of the Mass itself, when, during transubstantiation, matter is turned into the very body of Christ. An *elevatio* of the heart trans-

forms it from matter into spirit, from a bodily organ into an eternal bond. The host was not just an object of veneration and adoration, and so here too it is not the woman's body that is the focus but the lover's love. The lady's body becomes the altar table on which Christ's bloody death and resurrection are celebrated, as an analog to the lover's suffering and sacrifice.

This would be a "chaste" reading of the ivory, one in accordance with the important motif carved on the left of the two grooms beating the lovers' horses that is a sign of their having tamed their lower animal passions. An alternative understanding of this same ivory would see the heart here less as a disembodied pseudo-sacred symbol and instead as a deeply corporeal and lascivious piece of palpitating flesh, akin to the way in which the heart appears in contemporary literature as a constantly translatable organ of appetite, moving from lover to lady and back

97. The offering of the heart. Ivory mirror case from Paris, c. 1320. London, Victoria and Albert Museum.

again. In *Cligés*, written by Chrétien de Troyes in the twelfth century, the hero and heroine undergo extensive heart-swapping, so that at one point the heroine Fenice describes her heart as now being lodged in that of her lover Cligés, where it is a slave to his. Sometimes equated with the phallus, the heart was synonymous with the male's "courage." If the kneeling suitor here is presenting the lady with a symbol for his own member, the chaplet, she in preparing to place it over his head is the sign for her own body. The heart was far more than a pumping mechanism. It was the source of life's vitality, the seat of sensation, the fount of feeling, thought, and even memory (as we still say "to learn by heart") so that in centering the self there people were locating their desires within the middle of their bodies, whereas modern people tend to place everything higher. The animal spirit, an instrument of the outer and inner senses, was thought to be located in the brain; natural spirit, the instrument of nutrition, rested in the liver; and the most subtle part of the blood, called by doctors and philosophers the vital spirit, resided in the heart. The spirit accompanied the individual soul from the transmission of life from the father to the infant in fertilization to its re-ascent toward salvation and could leave the body in states of ecstasy. When the lover removes his heart and

98. The God of Love locking the lover's heart, from *Le Roman de la Rose*, Paris, c. 1380. London, British Library, Add. MS 42133, fol. 15.

presents it to his beloved we are witnessing the medieval equivalent of an out-of-body experience.

The heart was also crucially linked to the eyes in medieval doctrines of love: beauty strikes through the eye and direct to the heart. In manuscripts of the *Roman de la Rose* the miniature immediately following that of the lover looking at the rose often shows him being struck in the eye by the arrow of the God of Love and then becoming his vassal, culminating in a scene depicting the God of Love locking the lover's heart (fig. 98). This key is much larger than that described in the text but draws attention to the radical violence of the act:

Then from his purse he drew a small, well-made key made of pure refined gold. "With this," he said, "I shall lock your heart, and I require no other guarantee. My jewels are under this key; it is smaller than your little finger, yet it is the mistress of my jewelbox, and as such its power is great." Then he touched my side and locked my heart so softly that I hardly felt the key. "I wish and command you to put your heart in a single place so that it be not divided, for I do not like diversion. Whoever divides his heart among several places has a little bit of it everywhere ... Take care, how-

ever, that you do not lend it; for if you had done so, I would think it a contemptible act; give it rather as a gift with full rights of possession and you will have greater merit.

This passage is of great relevance to understanding many of the caskets and coffers with their locks and hearts over the keyhole that are reproduced in this book (see fig. 55). The heart is both a gift given by a man to a woman, as in the tapestry showing a pair of lovers (see fig. 80), and is equated with wealth, like jewels or gold, stored in a chest. The lover's imagining his heart as a phantasmatic object, a part-object that can metonymically stand for the gift of his whole being or self in love, might at first seem like a dangerous ploy for the male to use. Making him into a vulnerable and dependent figure in conflict with the actual codes of male superiority, the exposing of his heart might seem like a self-emasculation. But within the logic of the gift this presentation of the center of the self to the other

foreclosed any threat of vulnerability and detonated the danger of female usurpation of the male role. For it is predominantly men who end up taking out their hearts and shoving them into the hands of their beloveds. More than wearing their heart on their sleeve they presented it at every opportunity, whereas in images, as in the lyrics and Romances, women tend to keep their hearts more privately to themselves. The margins of the Bodleian *Alexander Romance* show two contrasting scenes on the lower parts of an opening that are often described as the lady offering her heart to her lover contrasted with a lady being tempted by the offer of a purse (fig. 99). But it would be rare to see an image in which the lady's heart is exposed so blatantly. It is surely an image of the lady accepting the gift of the heart of her lover, his gesture of touching his breast indicating the source of the organ. The lady looks carefully at the proffered gift in one case and in the other rightly turns away. The contrast here is between love and money, between an elevated spiritual love proffered and

99. The offering of a heart, and the lover offers the lady cash,
from the *Alexander Romance*, Bruges, 1344, under the direction of Jean de Grise.
Oxford, Bodleian Library, MS Bodl. 264, fol. 59r.

100. *"With All My Heart."* Padlock made
in France, fifteenth century. Gold, diam. ⁷/₈" (2.2 cm).
London, British Museum.

but provided a series of conventions that could be adopted and used when necessary. Whatever was locked by the tiny gold padlock that bears the inscribed motto *de tout mon coeur* ("with all my heart") it was secured by the idea of the heart's wholeness and truth (fig. 100). An enameled gold brooch in the British Museum dating from c. 1425 bears the inscription *Je/suis/Vostre/sans/ partier* ("I am yours inseparably"), again suggesting that the heart was given by a lover to his or her beloved to represent feelings of eternal attachment. But the day after giving such heart-felt gifts the feelings of one or the other could have changed. Objects in this sense are less fickle than people, the golden heart is more durable in its

accepted in the guise of the heart and a base, physical offer of money.

Although the heart is the greatest gift of the self, it is only an image, a sign that has no guarantee of authenticity. The author of the French translation of Ovid's *Art of Love* made this point clear:

> The author says, and it is true, that one who wants to begin his love affair well must pretend that he is prepared to do every service, every wish, and every private duty that he can for his lady. Because of this the youths say in their songs that they want to show their loves that they are prepared in word and deed. They sing this in their little song: "To serve my lady/I have given my heart and myself."

Likewise, the images and objects described here did not necessarily represent true feelings

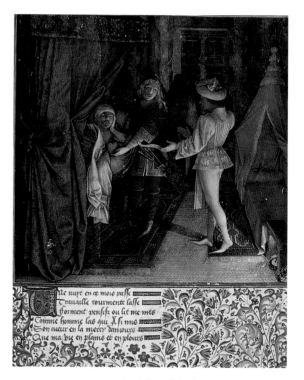

101. Barthélmy d'Eyck
Desire Takes the Heart, from the *Livre du Cuer d'amours epris,*
Aix-en-Provence, c. 1460–70. Vienna, Österreichische
Nationalbibliothek, Cod. Vind. 2597, fol. 2r.

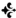

102. A lady grates her lover's heart. Casket made in Basel,
c. 1430. Wood. Basel, Historisches Museum.

embodiment of desire than those whose feelings it might, for a time, express.

The heart can undergo transformation, sensitive to every slight and vulnerable to the most exquisite torments of the lady's fingers. On one wooden casket, right next to a great lock, the lady performs an unusual chore that looks at first as if she is scrubbing her lover's heart clean on a scrubbing-board, but she is being even more cruel than this. She is grating it into a mortar (fig. 102). Her inscription, *das herze din lidet pin*, refers directly to this action ("The heart suffers pain"). Nothing could be further from the flat abstraction of the modern heart-shaped symbol than the vulnerable fleshy object being tortured here. Seen as an inevitable part of the love-process, this lover's agony was not so much a form of masochism, which is played out for pleasure, but rather a form of prayer, submitting one-

self to the higher power of the *jungfrei[lin]* whom the lover addresses with her own speech scroll.

The most compelling of all medieval images of the travails and suffering of the male heart is the first miniature in the superbly illuminated manuscript of the *Livre du cuer d'amours espris* written by King René of Anjou in 1457 (fig. 101). The dream poem describes how one night the God of Love takes the poet's heart from his breast and hands it to the Page, "Ardent Desire," who has risen from his little bed next to that of his master, his hands open to receive it. All that gives away the role of Desire here are the tiny flames of desire that light up his short skirt, which reveals his shapely white-tighted legs. In the rest of the poem the heart, personified as the knight Coeur, will fight various battles until it finds favor with the lady, who is something of an absence throughout the poem and its illustra-

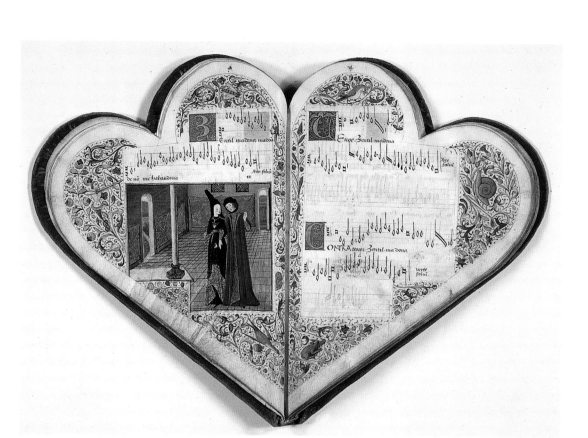

103. *Songs from the Heart,* from the *Chansonnier de Jean de Montchenu,* Savoy, c. 1475.
Paris, Bibliothèque Nationale, MS Rothschild 2973, fols 3v–4r.

tions. The talented illustrator Barthélmy d'Eyck seems far more interested in the gentle gazes and gestures that take place between males than the end of the quest: the preening perfection of homosocial rather than heterosexual desire. What happens in the delicate shadows of this great canopied bed is the sensuous handling of crimson flesh by male hands, those of the Self, Love and Desire.

Since the heart was associated with memory as well as love it is not surprising that a number of heart-shaped prayerbooks existed in the fifteenth century. But there is also a superb heart-shaped *Chansonnier* that contains fifteen French and thir-

ty Italian chansons by great composers of the time, such as Dufay and Busnois (fig. 103). The miniature of an interior with a strolling couple seems ill-fitted on to the curving page, but perhaps it is because it cuts a hole into the heart, into the shape that we want to see as always whole and inviolable, that makes it so disturbing. For its owner it would have evoked the heart as a sacred as well as a sensuous storage place, a coffer of memories, songs, and images "learned by heart." But this unusual manuscript belonged not to a knight but to a high ecclesiastic from Savoy, Jean de Montchenu, and was made for him just before he became Bishop of Agen in 1477. If this example seems to do violence

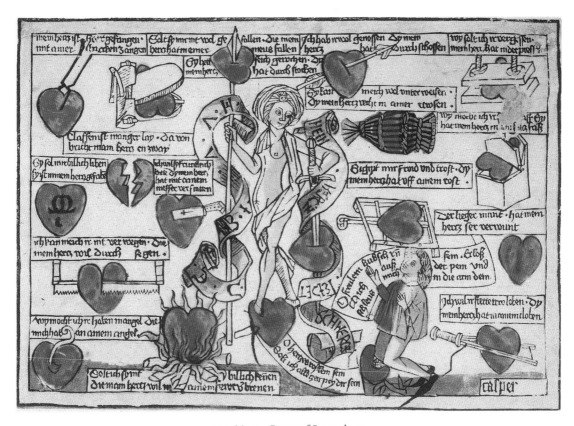

104. Master Caspar of Regensburg

Frau Minne's Power over Men's Hearts, 1479. Woodcut. Berlin, Staatliche Museen Preussischer Kulturbesitz, Kupferstichkabinet.

to the integrity of the heart it is nothing compared with a colored German woodcut by Master Caspar of Regensberg, which displays the brutal tortures of the lover's unfortunate organ (fig. 104). No fewer than eighteen hearts are pummeled, squeezed, sawn in half, pressed with thumbscrews, and speared like so many kebabs by Frau Minne. The inscriptions in German refer to the power of women over men's hearts. No image better represents the fantasy of pain and fragmentation that men constructed and enjoyed and which served to reverse the real situation and make women the rulers not only of men's bodies but of their souls as well.

The most remarkable two-dimensional representation of this power is a little anonymous panel-painting often called *The Love Charm* (fig. 105). A naked girl with long blonde hair has captured a bleeding heart in a chest and with one hand kindles the flames of love over it with a tinderbox and with the other quenches its fire with drops of water from a sponge. All the themes that we have seen before, of love running hot and cold, all the intervisual associations of objects as diverse as coffers, hearts, dogs, birds, flowers, and mirrors are brought into play within this space, except that their symbolic efficacy is now held together by the translucent web of painted

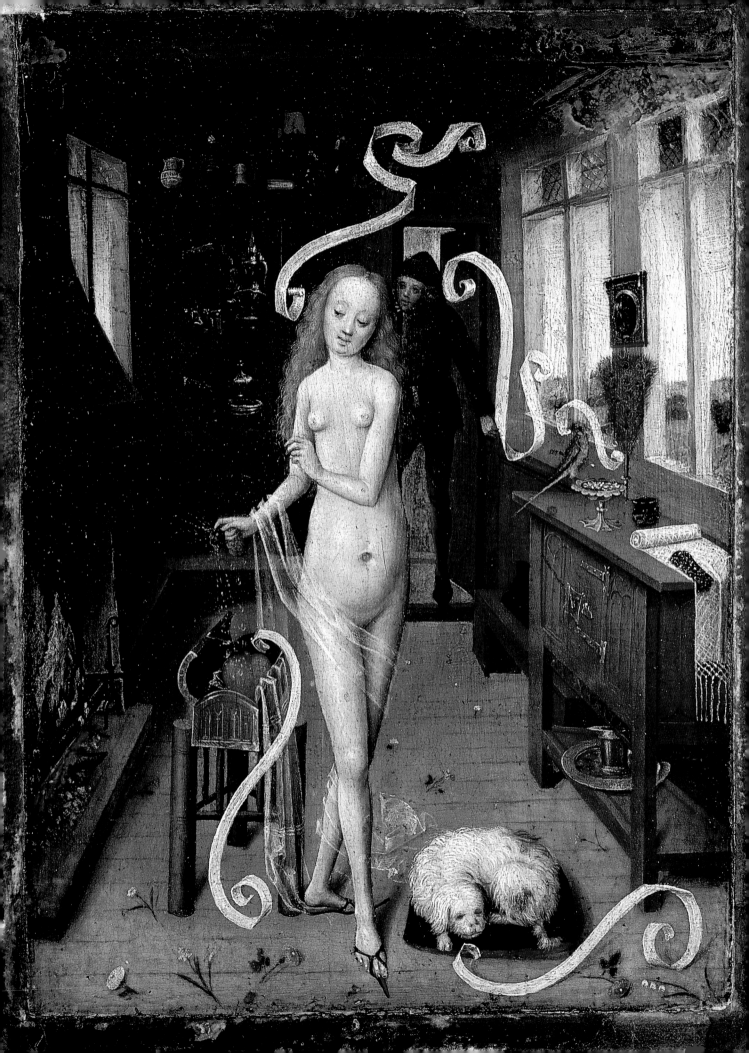

reality. The object of desire stands by the hearth, the site of female power and control totally naked, her transparent shift serving to reveal rather than conceal her voluptuous body. Like a parody of the Annunciation, which we often forget is an image of sacred love, in which the Virgin Mary conceives the Christ Child, the young girl looks demurely down. Here however the subject of desire, the young male visitor, has no wings but has to open the door to peek within.

What he sees inside has been identified by some scholars as a depiction of traditional fertility rites of the night of St. Andrew, which took place on 30 November. But anyone can see that yellow corn is ripe for the harvest outside the girl's window and that this is therefore midsummer magic. If it does represent a moment in the erotic calendar it is more likely to be the Feast of St. John, which was celebrated on 28 June. Lighting bonfires, picking aphrodisiacal herbs, and binding one's lover were all part of the pagan rites of summer's beginning that galvanized communal energy for the coming harvest. A sixteenth-century writer describes in a poem the magical substances that a prostitute keeps in her chamber, including "the kindling wood from the fires of St. Jean," as well as a parrot, a bird evocative of lust, which here in the painting perches on a tray of sweetmeats. The enchantress has cast her spells to make the young man fall in love with her. The realism of the depiction lures us into thinking that this is a record of some actual folkloric rites, but it is just as much a fantasy on the part of a male artist as are the other images in this chapter. The magic here lies not in what is represented but in how it is represented – the new medium of oil paint that makes every spark and droplet, every fold of flesh, apparent to our senses in new ways.

The besotted boy's mundane, almost vacant look is perhaps the first instance in Western art of the pornographic gaze, especially since we the viewers from outside the picture are urged to identify with him, lured as though we were his external double, to stare into this mirror. His gaze is surely meant to mirror that of the viewer outside this picture, a male observer who can enjoy this objectified image that is supposedly luring him to her by the magic spell but which is doing so in reality through the new magic of paint. It was probably made to hang in a private room similar to this one. As is usual, the male subject of desire seemingly captured by the image of a desired object is in control both of making the picture and of observing it. Here a woman is represented not as weaving textiles to sustain the disavowal of her deficient body, but weaving a series of magic spells that allow it to be uncovered. The author of the fourteenth-century *Ménagier de Paris* uses the ominous term *ensorclere* or bewitch to describe a wife's way of gaining control over her husband. This painting would be better called "the young witch" since it bears witness to the beginning of that disturbing and dangerous set of associations that, over the next two centuries, will lead to the trial, torture, and execution of thousands of bodies like the young girl's here, a murderous form of institutionalized Early Modern misogyny, more irrational than anything that took place during the Middle Ages.

105. *The Love Charm*, made by an anonymous Rhenish painter, late fifteenth century. Oil on panel, 9¹/₂ x 7" (24 x 18 cm). Leipzig, Museum der Bildenden Kunste.

106. The "woman on top:" Aristotle and Phyllis. Aquamanile made in The Netherlands, c. 1400. Bronze, h. 13³/₁₆" (33.5 cm). New York, The Metropolitan Museum of Art.

LOVE'S GOAL

Since ancient times four separate stages of love have been distinguished. The first
stage lies in allowing the suitor hope, the second in granting a kiss, the third in the enjoyment
of an embrace, and the fourth is consummated in the yielding of the whole person.

Andreas Capellanus

The unmistakable dynamics of love's fourth and final stage, what medical and scientific writers described as coitus, preachers as fornication, poets as de-flowering, ordinary folk as fucking, and the more prudish with the Latin euphemism *factum* – or "doing it" – can be seen on a tiny tin-lead badge recently excavated from a Dutch riverbed (fig. 107). Such a cheap object might have once adorned a butcher's cap rather than a prince's cloak, represent-

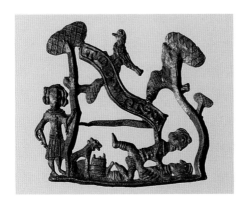

107. Copulating couple with dog, bird, and onlooker. Tin-lead badge from The Netherlands, c. 1375–1425. Cothen, M.J.E. van Beuningen Collection.

ing one of the millions of more mundane and ordinary orgasms that punctuate human existence. But it is more than that. The little bird holds a banderole with the word amours, which is why I include it in our discussion of the medieval art of love. The couple are accompanied by a dog licking from a barrel and are being watched from behind a tree by a gentleman (a husband?) bedecked with buttons. Perhaps this told a story from a popular romance. The medieval art of love, although its

108. The Tree of Love illustrating the poem
Ci Commence del Arbre d'Amours, Paris, 1277. Paris,
Bibliothèque Sainte-Geneviève, MS 2200, fol. 198v.

ultimate aim was sexual possession, rarely focuses on this moment. For, like death, sex is ultimately unrepresentable. Happening in time, its instinctual responses and sensations cannot be registered in the still medium of the image, which places us always on the outside of the act, as voyeurs like the man on the left here. This is the paradox at the heart of the medieval art of love; that its longed-for goal can so easily seem banal, even ridiculous. Sex is layered with symbols in order not so much to conceal its physical nature but rather to give it some semblance of meaning. Like many over-eager lovers, we are getting ahead of ourselves, however, rushing too quickly to the end before properly preparing the way with caresses, embraces, and kisses.

TOUCHING

The lover's expectation to gain access to his beloved by a series of hierarchical steps is represented in a thirteenth-century miniature illustrating the poem *Ci Commence del Arbre d'Amours* (fig. 108). In the lowest level he kneels in supplication but the lady refuses even to look upon him, turning away with one hand on her heart. Still kneeling in the scene above he makes the gesture reminiscent of feudal homage we have seen before. On the third level he has reached the third stage of embrace or physical contact. Both are seated on a horizontal surface, a crucial equality that announces the possibility of intercourse, and he reaches out to touch her shoulder. Her own outstretched arm reciprocates, moving now not as below with measured, ritual gestures but with impetuosity. The man is on the lady's right, which is traditional for cou-

109. The Tree of Marriage illustrating the forbidden degrees of affinity,
in Gratian's *Decretum*, Cologne, c. 1300. Cambridge, Fitzwilliam Museum, MS 262, fol. 71v.

ples who appear in contemporary manuscripts of Canon Law as part of the Church's increasing regulation of marriage (fig. 109). Unlike the upward-spurting branches of the tree of love, this one, with all its evocations of Adam and Eve's fall into sex, reproduction, and death, reads downward as a descending pair of "blood lines" separating the kin groups of husband and wife. The permitted degrees of consanguinity between partners were set at four by the Fourth Lateran Council of 1215, making marriage between first cousins illegal. The marital status of the couple coming closer together in Love's branches is undescribed and would have been

110. The chess-game of love. Mirror case from Paris, c. 1320.
Ivory, diam. 4¹/₄" (10.8 cm). Paris, Musée du Louvre.

deemed dangerous precisely because such ambiguity threatens, through the production of illegitimate offspring, the patrilineal line of descent that was so crucial to noble identity. In these two trees we see the contrast between the idealized sexual relationship implied in the art of love on the one hand and the realities and constraints of the medieval marriage-market on the other.

That courtly couples were constrained by a different set of moves, which made love into a game, can be seen in an ivory mirror case representing a couple playing chess (fig. 110). Even when a couple are shown at the second stage of love and not physically touching as here, there are hints that the third, fourth, and fifth stages are quickly approaching. This mirror is an elaborate allegory of desire in which the man is about to "check" his mate as he crosses one leg elegantly over the other in expectation and

grasps the central tent pole like a phallic lance. This thrusting imagery continues in the presentation of the lady, whose body has literally been gouged out of the creamy ivory in a series of swaying Gothic folds, emphasizing her penetrability. Even the parted curtains that frame the whole intimate scene are, as we shall see again, a well-understood sign, not only of the curtains around a bed, but also the anatomical opening of the woman's body, which cannot be represented as such. The two servants have here been given the job of carrying the traditional symbols of lovers – the feeding falcon and the chaplet – since so much focuses on the battle for possession of bodies on the board.

Chess was the perfect allegorical device because it articulated the playful tension and the often violent conflict inherent in the strategies of seduction that formed the medieval art of love. Associated with warfare, mathematics, and male rationality, the chessboard became a simulacrum of medieval society. A superbly intact Burgundian chessboard from a century later still plays on these allusions between the game and the conquest of the lady in its delicately carved outer frame (fig. 111). Armored knights with immensely long lances tourney along the outer edge of one, perhaps the male player's side of the board, while elegant ladies in their pointed Burgundian headdresses picnic and dance on the other. This object literally spatializes gender difference across its playing-field, making every game of chess a literal war between the sexes.

Some medieval games involved courtiers in more intimate physical maneuvers. One of these was a kind of "blindman's buff" known in

111. Love's playing-field, with the man's side at the bottom and the woman's side at the top.
Chessboard from Burgundy, late fifteenth century. Ivory and wood, 26 x 25³/₄ x 2¹/₂" (66.2 x 65.6 x 6.1 cm).
Florence, Museo Nazionale del Bargello.

French as *main chaud* or *hautes coquilles* and in German as *Schinken klopfen* or "bottom-slapping," in which the man put his head under a lady's dress or was otherwise blindfold while other ladies beat him from behind. Once the name of the striker had been guessed correctly the roles were reversed or sometimes the winner received the reward of a kiss. Represented on ivory writing tablets in Ravenna and the Louvre, as well as in the famous *Hours of Jeanne d'Evreux*

(1325-8), this game is among a number of courtly pastimes represented on a magnificent tapestry attributed to the Alsace region (fig. 112). Frau Minne is enthroned on one end in an isolated enclosure, surrounded by courtiers of all stripes who are frolicking in a great garden before a castle. She referees another game known as quintain, a violent form of "footsy" that involved kicking or thrusting the sole of one's foot against that of one's opponent. Here a splendidly

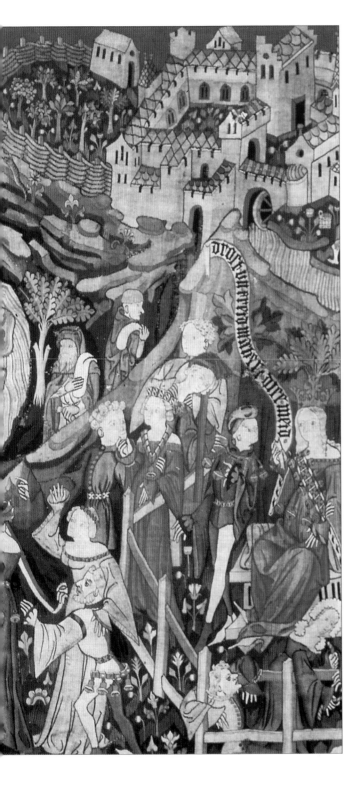

dressed lady wearing a collar made of a chain of the letters "E" lifts up her long red robe and, held from behind by a younger man, thrusts the sole of her foot against that of her male opponent. She has a banderole that reads "din stosen gefelt mir wol/lieber stos als es sin sol," which can be roughly translated as "I love thrusting/ Rather a thrust than as it should be;" her lover, wearing a belt of silver bells, replies: "Ich stes gern ser/so mag ich leider nit mer," or, "I like to thrust/But in this manner I don't want to thrust any more." Here the game of "thrusting" is the sexual act that the lady prefers to avoid by playing this game, and to which the man wants to move on directly. The speech scrolls in German tapestries are often wonderfully direct speech acts like this, unlike those in Franco-Flemish examples, which tend to be descriptive. Often these utterances express the split between male and female subject positions, the war between the sexes. Here the words bring out how differently the same game is perceived by its male and female participants. Behind the thrusting pair stand another young couple, perhaps the bridal pair for whom the tapestry was woven.

Just as the lady lets her beloved lie in her lap in the Gothic game, so does Christ let his beloved disciple St. John the Evangelist lie in his in a type of carved wooden devotional image popular in German convents in the later Middle Ages (fig. 113). The "beloved disciple" asleep in the Lord's bosom, based on the Gospel text of the Last Supper, shows that the same gestures and intimate touches can mean entirely different things

112. Courtly games before a castle. Tapestry made in Alsace, 1385–1400. Nuremberg, Germanisches Nationalmuseum.

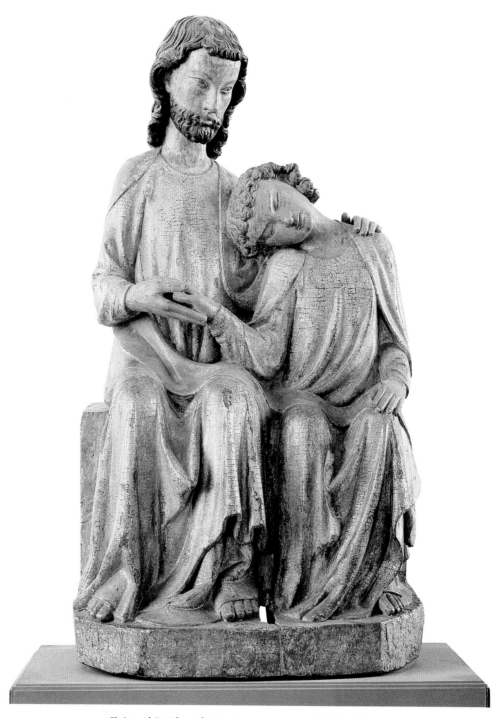

113. *Christ and St. John.* Lake Konstanz, c. 1310–20. Oak, h. 35" (89 cm).
Berlin, Staatliche Museen Preussischer Kulturbesitz.

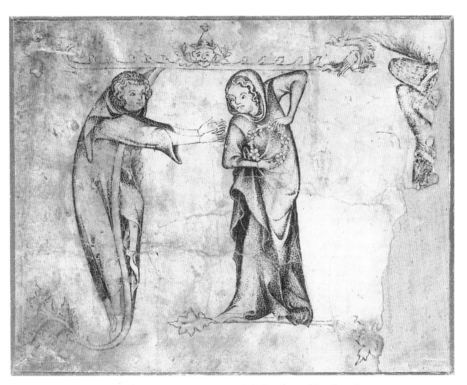

114. The over-amorous suitor. A design for an illuminated
letter "A," c. 1300. Pen and ink with touches of vermilion, on
vellum. Oxford, Ashmolean Museum.

in different contexts. It would be anachronistic to project homoerotic desires on to the makers and users of this image, who were for the most part nuns. By identifying with St. John the cloistered women were able to escape from always being the beloved and could seek more intimate contact with *their* beloved, as was traditionally possible in their reading of the Song of Songs in which they would identify with the bride. John was the archetypal lover of Christ in the mystical sense and such a statue in a chapel setting in a church or convent would have provided a site of identification for various kinds of viewers, lay as well as cloistered, men as well as women. The gentle, yet protective hand on the shoulder, the hands that touch but do not grasp at each other, provided those married to flesh and blood rather than wood with a site of identification that was meant to transcend the body's urges.

Whether it did or not is debatable. For everywhere in fourteenth-century art one sees more frantic gropings, as in a letter "A" formed from an elegantly coiffed youth whose fingers reach for the flowery chaplet that a lady withdraws with a deft maneuver as if to say "Oh no you don't!" (fig. 114). This little scrap of parchment may have been part of a pattern-book used by a Flemish or east French artist in the years around 1300. Pattern-books of the period from France, Germany, and Northern Italy show that artists

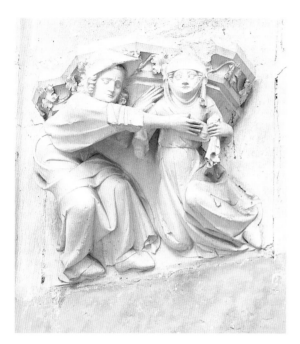

115. The "grab." Stone console in the
nave of Auxerre Cathedral, c. 1300.

were collecting the clichés of love as much as the schematic heads and bodies that could be fitted into religious narratives. Indeed, the number of secular themes visible in medieval model-books draws attention to how many more secular art-works have been lost compared with sacred objects. Letters spelling out lovers' names entwined to form secret codes on sumptuous fabrics, girdles, and even in the margins of manuscripts. This "A" could be used to indicate the object of desire, some "Anne" or "Agnes," or perhaps "Amour" itself. While it is easy for us to see three-dimensional functional objects such as mirrors and purses as working with the body, it is not so clear how flat, two-dimensional draw-ings and miniatures in manuscripts worked in more corporeal contexts. One hint of this is provided in the Occitan romance *Flamenca*

(1240–50) which involves the lover William sending to his beloved Flamenca a short poem and an image of the adulterous couple on parch-ment: "Often they folded and unfolded them and were careful not to damage them by rubbing so that neither letters nor pictures look in the least erased." The importance of this flat image is that it can be kept secret and can be as close to the body as any girdle. Flamenca actually takes the picture to bed with her and plays with it inge-niously: "She was able to fold them so neatly that she could make them kiss each other." She places them on her breast and says "Friend, I feel your heart in place of mine," and in the morning when she gets up she stares at the image of William and talks softly of love to it. Here, unusually, it is the woman who is described using images in sensuous and erotic self-gratification.

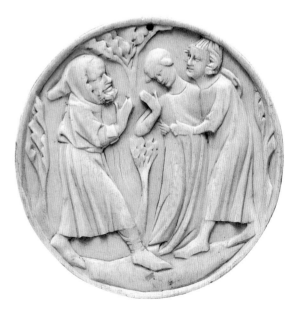

116. The churl Resistance and the lovers. Ivory mirror-back,
c. 1320. Cluny, Paris, Musée du Moyen Age.

In contrast to the lady's withdrawal within this letter, a large carved console, well above eye level inside the nave of Auxerre Cathedral, shows a woman allowing herself to be touched (fig. 115). Like a parody of the traditional biblical scene of Doubting Thomas, she pulls aside the robe from her breast to let the young man wearing a hunter's cap feel her living flesh. That this part of the woman's body was already by this period a focus of erotic attention is suggested by a gold ring brooch in the British Museum, which bears the inscribed motto: "I am a brooch to guard the breast. So that no knave may put his hand into it." More than being just an erotic sign, the breast, both male and female, was the site of the self and sensation, the location of the heart and the place that was thought to correspond to the "inside" of the box, the "chest" where all one's secret thoughts and desires are kept.

Even in an object of courtly luxury there are gestures that sometimes go too far. In the *Roman de la Rose*, a figure called Dangier or Resistance personifies the lady's unwillingness, the guard she puts up against intruders. This giant ogre, "keeper and guard of all the rose-bushes," appears on a mirror-back warning the lover who embraces too strongly to back off (fig. 116). While this might at first look like a young girl being rescued from a wildman or her choosing between a rough hairy lover and a young courtly one, as is represented on some caskets, I would interpret this scene as a narrative all about the lady's "No!" This is perhaps why the young girl is turning to greet the great giant since he actually has come to her rescue. He embodies her own strength of denial. But can such a protector be any match against the

117. The "little death:" Jaufré Rudel dies in the arms of the Countess of Tripoli, in *Chansonier* manuscript, North Italy, thirteenth century. Paris, Bibliothèque Nationale, MS fr. 854, fol. 121v.

advances of the young man, whose arms already encircle her waist as tightly as any girdle?

The ideal lover was less extreme and active. In the tradition of troubadour poetry it is the lady or *dompna* who takes the initiative while the lover often represents himself as passive, frozen in rapt adoration, and unable to touch the object of his desire. There is no better image of this reversal of sexual roles in troubadour culture than an initial painted in a thirteenth-century North Italian manuscript of troubadour poems, which presents a visual "portrait" of the famous troubadour Jaufré Rudel (fl. 1120–48; fig. 117). According to this poem, "Jaufré fell in love with the Countess of Tripoli without ever having seen her, on the strength of glowing descriptions he had of her from pilgrims traveling from

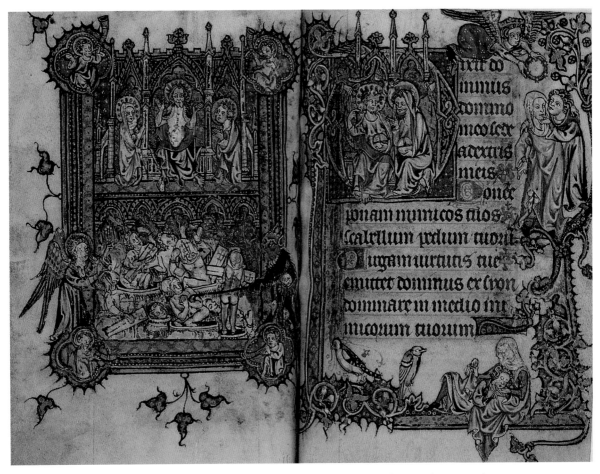

118. The Last Judgment and the lady helps to resurrect her lover's flesh, Psalm 109, Psalter,
Ghent, c. 1300. Oxford, Bodleian Library, MS Douce 6, fols 79v–80r.

Antioch." On his way to meet her he fell sick at Tripoli but the countess came to his bed "and took him in her arms. And he knew that she was the countess, and immediately recovered his sense of hearing and smell, and he praised God that he had sustained his life until he had seen her. Then he died in her arms." It is this tragic climax that the illuminator has painted: the poet's eyes are closed, in the "little death" that Aristotle had described as accompanying orgasm.

A less sublimated image of a woman arousing a man is amazingly illustrated at the opening of Psalm 109 in a tiny Psalter. Just as the dead rise up to stand "in the flesh" at the Last Judgment on the left page, in the opposite margin a young man asleep in the lap of his lady is experiencing his own fleshly resurrection – an erection (fig. 118). The association between the power of God *Dominus* and the power of the lady as *Domina* works here on a number of levels. The word *vit*, meaning "life," was also the

French word for the male member. The sin of Adam, which forever moved man's body against his will, has here been redeemed by Christ, who shows his bodily wounds to arouse the dead to life. The phrase *virgam virtutis*, the "rod" or "scepter of virtue" of the second Psalm verse on this page, was what probably cued the artist to make this striking analogy: "The Lord will send forth the scepter of thy power out of Sion: rule thou in the midst of thy enemies." The man's powerful "rod" is emphasized, even though it is under enemy control. Probably made for a couple as a marriage gift, this little Psalter may have also worked on the level of promising fertility to its owners. Was it because sexual arousal was so often co-opted by medieval religious art, precisely in order to ridicule or subvert its pleasurable potential, as here, that makers of courtly secular images so often avoid picturing it?

KISSING

On the west portals of the Cathedral of Notre-Dame in the bustling city of Amiens a series of *Virtues and Vices* served as a warning to the urban population about what would prevent them getting into the heavenly city. Below the seated personification of *Chastity,* "A virgin whose mouth has never been kissed" according to Alan of Lille, is a couple whose mouths meet (fig. 119). During the twelfth century the image of *Luxuria* had been depicted on Romanesque churches as a woman whose genitals are bitten by toads and serpents in Hell. Now it is a sin that is sealed with a kiss. This change, from depicting the eschatological outcome of vice to enacting its perpetration in the here and now, is best understood in

119. The sinful kiss: the vice of *Luxuria,* stone carving on the west front of Amiens Cathedral, c. 1225–30.

the context of the Fourth Lateran Council of 1215, which instigated the confession of such sins for every Christian. More intimate than the image of *Luxuria* carved at Chartres Cathedral, where the man merely puts his hand on the lady's shoulder, this pair have moved on to the next stage, the vertical alignment of lips coming together directly above the genitals with their hidden and uncontrolled moistenings and movements.

Whereas for us today the kiss has a primarily sexual meaning, it was then an important part of the feudal system of gestures. Men kissed men in public both in the ritual of vassalage, the *osculum feodale,* and in church at the end of the Mass in the kiss of peace. Women were exempted from this feudal kiss "for the sake of decency," suggesting that there existed

120. The feudal kiss: Tristram and King Mark exchange a kiss. Tile from Chertsey Abbey, England, c. 1250–70. London, British Museum.

The kiss had a complex series of religious and even liturgical meanings, influenced of course by the imagery of the biblical Song of Songs, which we have already seen opens with the phrase "Let him kiss me with the kisses of his mouth." Another mystical meeting of mucous membranes was painted by a Bohemian artist in a manuscript made for Cunegonde, Abbess of St. George's Monastery in Prague (fig.

121. The mystical kiss, a mother and her son, from the *Passionale of Abbess Cunegonde*, Prague, 1314–21. Prague, The National Library of the Czech Republic, MS xiv a 17, fol. 16v.

a clear hierarchy of kisses. The kiss of Tristram and King Mark is one of the most eloquent of the ceramic tiles found at the abbey of Chertsey that probably once narrated the famous love story on the floor of a great royal palace (fig. 120). This kiss represents a pledge of faith rather than an erotic contact, a record that is written with the lips just as an oath is spoken with them. What makes it especially compelling of course is that Tristram will later fall in love with Mark's wife. Here in fact the young man assumes the "female" object position in this ritual. This reversal in which Mark holds the face of the youth in his fingers, like a lover gazing into the eyes of his beloved, perhaps hints at the king's possessive and jealous nature, just as his disordered drapery flows with intimations of obsession.

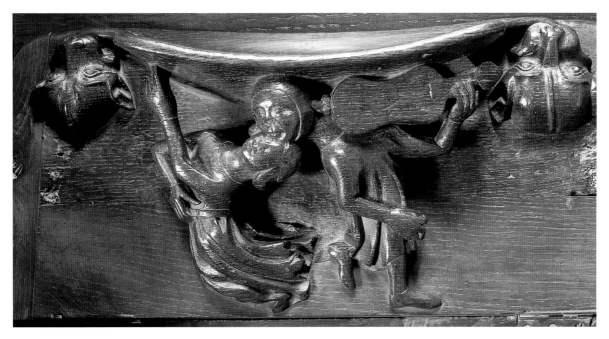

122. The villein's kiss. Carved misericord in Chichester Cathedral,
c. 1320. Wood, 25 x 10" (63.5 x 25.5 cm).

121). With his right hand, the wound of the cross still freshly bleeding, Christ caresses his mother's cheek. Her right hand embraces her son's shoulder and hair while her left foot treads on his. Inscribed "Jesus Christ salutes his mother with the kiss of peace," it is the Virgin who is the focal subject here, actively taking on the dynamic position of the Bride and encouraging the nuns to follow her example, in mingling with their Father/Son/Lover.

For the peasant, whom Andreas Capellanus had described as incapable of love, the kiss was thought to be just an animal act, empty of any of the associations that gave it significance in the context of secular art or, for the royal abbess Cunegonde, in mysticism. As against the upright proper kiss of the nobility, the unstable dance of a low-class couple is carved on a mis-

ericord, one of the seats in the choir of Chichester Cathedral (fig. 122). The wonderfully elastic bodies of the fiddler and dancer twisting and turning to touch lips are attractive to us today, but these uncontrolled gestures would have signaled the lubricity of this uncourtly couple to the canons of the cathedral, who would have sat on them during services. It is fascinating that, unlike the literature of the period, which often describes sexual union across class boundaries, most commonly in the genre known as the *pastourelles* in which a knight would woo a shepherdess, images of such combinations are rare. In the visual realm, partly because images were so often used to cement real social bonds, couples tend to be equal, either both noble or as here both *vilain*, uncouth or uncourtly.

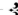

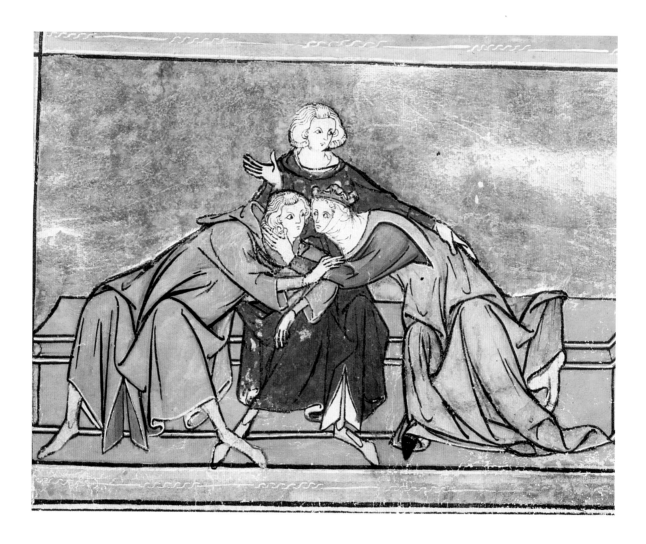

123. The first kiss of Lancelot and Guinevere,
from *Lancelot-Graal*, Amiens, c. 1300. New York, The Pierpont
Morgan Library, MS 805.6, fol. 67r.

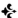

124. The first kiss of Lancelot and Guinevere, from *Lancelot-Graal*, Artois or Flanders,
c. 1320. London, British Library, Add. MS 10293, fol. 78r.

The most famous first kiss in all medieval romance is that between Lancelot and Guinevere (fig. 123). In text and image, however, there is a strange ambiguity in this clandestine kiss, since it is attained only with the help of Lancelot's friend, the high prince Galehot, who sits between them so as to make it appear that they are only conferring. It is not Lancelot in fact but Galehot who repeatedly solicits the queen to kiss the quivering and timid Lancelot: "Go on, kiss her in front of me to begin your true love," he pleads. It is this zealous go-between whose hand curls around the lady's body here and not that of her lover. The artist was paying close attention to the text here, which describes how Guinevere finally grabs hold of her lover "by the chin and kisses him for quite a long time."

There have been many interpretations of this love-triangle, ranging from intimations of the three figures as the Holy Trinity with Galehot playing God the Father, to suggestions of lechery suggested by having more than two partners. Another view, however, might describe the composition as echoing a marriage ceremony, in which the central priest would assume Galehot's position here. Looking at the same moment in another North French manuscript (fig. 124) reveals that this love-triangle could be even more charged. Here the central figure is Guinevere, squeezed between Lancelot and Galehot, who grasps his beloved Lancelot by the wrist. She comes between the two embracing knights, who with their vast shoulder epaulettes form mirror-images of one another.

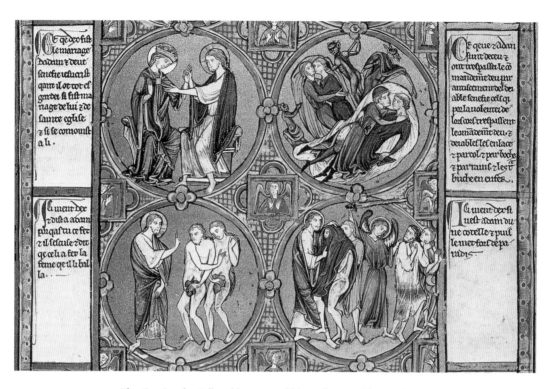

125. The *Creation*, the *Fall*, and homosexual kisses, from a *Bible Moralisée*, Paris,
c. 1220. Vienna, Österreichisches Nationalbibliothek, MS 2554, fol. 2r.

One theory of the dynamics of courtly love has been to describe it as homosocial, that is, as a relationship between men in a military society in which the lady is simply a mediator, or a screen on to which the real desire of the young man for the power of his lord can be projected. As Georges Duby has argued: "in serving the prince's wife it was the love of the prince which the young man wished to gain." Such implications make these scenes of triangulated desire complex but not necessarily sexual in our modern sense of the term. Andreas Capellanus, whose treatise is built on conflict, argues that love can only exist between persons of the opposite sex. Images of homosexual sex exist in medieval religious dogmatic art, nowhere more

explicitly than in the great compilation the *Bible Moralisée*, where Adam and Eve who "sin by the mouth" in eating the apple of the forbidden fruit in the roundel above are interpreted as those who sin "by the body and mouth" below. A cleric and his beloved, wearing a round cap often worn by heretics and Jews in this manuscript, are shown lying on a bed in the foreground. The two male faces meet in a loving gaze, the *perversis oculis* of visual desire that had led Adam and Eve to taste the forbidden fruit (fig. 125). The rare depiction of a lesbian couple alongside them follows far more closely the conventions of courtly art that we have traced, chin-chucking and kissing, whereas the male couple are more unconventionally intertwined. Even in their "sin

against nature" men who love their own sex are seen as distinct from women who do the same. The illuminator of this image was unable to imagine female to female sexual intercourse, which explains why he has presented it in the most conventional terms. By contrast, he points out the physical desire of the male homosexuals with subtle signs of penetration and perversion. The layman is on top of the tonsured cleric yet has a long split in the back of the robe exposing his white underwear. This revealing rent in addition to his effeminate dress indicates that of the two he is the sodomite, the passive partner of anal intercourse. Contemporary confessors' manuals show that a distinction was made between the active and passive roles and that the latter was deemed the more serious sin. What we call today homosexuality was not the most serious "sin against nature," it was but one of a whole group of sins that, according to Thomas Aquinas, included masturbation and the most serious, bestiality. More than the act of non-procreative intercourse, the coupling of a man with a man and a woman with a woman was seen as a rejection of God's Law. In this page of the *Bible Moralisée* God is shown joining the hands of Adam and Eve in marriage, but visually this is a separation of the two, the male to the right of God and the female to the left. These are the positions they keep even at the moment of the Fall opposite. But those contemporary fornicators depicted below mix up these pre-assigned roles and positions, so that the two women embrace on the male right side while the priest and his male concubine stretch out to the left, female side. In the thousands of images created for the four great versions of the *Bible Moralisée*

made for the French kings under theological supervision in the first half of the thirteenth century, a sophisticated pictorial vocabulary was developed for representing the debased human love of the flesh with the divine love for God.

The *Roman de la Rose* was written at the same time and yet its ethos was totally different, being a veritable encyclopedia of kisses, many of them pleasurable and often given between persons of the same sex. There are a number of places in the illustrated manuscripts where the game of personifications creates some ambiguities, especially with the male character "Bel-Acueil," or Fair-Welcome, who is portrayed in very intimate interactions with the lover. In another late fifteenth-century manuscript, painted by Robinet Testard, the feudal kiss bestowed upon the God of Love by the lover is different from the mutual kiss of feudal agreement depicted in earlier manuscripts (fig. 126). The handsome young God of Love seems over-eager to grasp the lover,

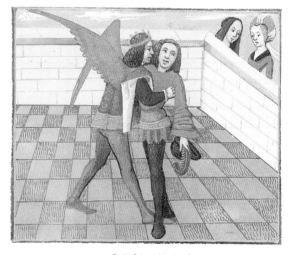

126. Robinet Testard
The God of Love embracing the lover, from
Le Roman de la Rose, Western France, c. 1480. Oxford,
Bodleian Library, MS Douce 195, fol. 15v.

who describes how "I grew very proud when his mouth kissed mine, this gift gave me great joy." As if to emphasize this homosocial desire between males in an arena of intimacy that places women elsewhere, the artist places two female figures outside the wall looking on. This miniature exemplifies one of the ways in which courtly love works as a discourse between men to exclude women. By placing his lady at such a distance, or on a pedestal, it has been suggested that the courtly lover was freer to engage with the real object of his desire – the other knights or his social superiors. What makes this emphasis upon the male gaze more complex still is the fact that Robinet Testard's beautiful manuscript, in which the lover looks out of the miniature, was made for the eyes of Louise of Savoy, wife of Charles of Orleans.

"Doing It"

If the medieval art of love often adorns rich objects such as caskets and textiles that were publicly given as gifts, the medieval art of sex occurs more frequently in between covers, not of the bed, but of the book. A miniature illustrating the tenth chapter of Bartholomeus Anglicus's *Livre des Propriétez des Choses*, or "How material things are made," places sexual intercourse firmly within the sphere of procreation and within a space in which the couple are visible not only to us the viewers looking through the cut-away wall at the front of the miniature but also to two internal spectators who peek through a window on to the marriage-bed at the left (fig. 127). These men are not voyeurs but probably represent the fathers of the pair who are making

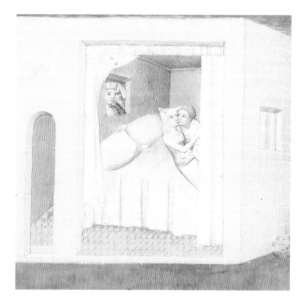

127. *"How Material Things Are Made,"* from Bartholomeus Anglicus, *Livre des Propriétez des Choses*, Paris, c. 1400. Wolfenbüttel, Herzog-August-Bibliothek. 1.3.5.1 Aug.2 fol. 146r.

sure that the marriage is being properly consummated. One crucial difference between sex as it is understood today and as it functioned during the Middle Ages was that whereas today it is an intensely private, identity-producing, and personal act, then it was far more public. For the noble spouses who owned the objects described in this book, the marriage-bed was a site of public spectacle in which they had to prove to their relatives, who would sometimes wait to see or hear the event, that they had legally consummated the marriage by the act of the male penetration and ejaculation. When the act is represented in medieval art it most often has nothing to do with love, but is rather seen in the anxious terms of legal or medical requirements.

It was exactly this constrictive framework that made the illicit and adulterous love described in romances so appealing. Lancelot

and Guinevere consummating their adulterous love is stressed in one lavishly illustrated volume of the Vulgate Cycle or *Lancelot-Graal*, a vast five-part prose narrative of Arthurian stories, which was in vogue among the French aristocracy of the early fourteenth century. This book contains no fewer than three miniatures focusing upon their sexual relationship. The first shows Lancelot breaking into the queen's room through a barred window to spend the night with her, and two more show them in bed together. The second of these was later defaced by a prudish reader, leaving only one extant of the couple copulating (fig. 128). These two bodies becoming one is, as usual, hidden beneath the covers. It can be compared to a symbolic illustration of the union of the two lovers in the same manuscript as they appear on the two sides of the "split shield," which is earlier pre-

129. Lancelot and Guinevere joined on a shield, from *Lancelot-Graal*, Artois or Flanders, c. 1320. London, British Library, Add. MS 10293, fol. 90v.

128. Lancelot and Guinevere joined in bed, from *Lancelot-Graal*, Artois or Flanders, c. 1320. London, British Library, Add. MS 10293, fol. 312v.

sented to Guinevere by the Lady of the Lake (fig. 129). This shield shows a knight on the left and a lady on the right, separated by the split that divides them vertically. The two bodies are joined only in the middle by a horizontal strip described in the text as the *bras de la borcle*. Only when their love is consummated, it is explained, and the two halves of the shield joined together, will Guinevere be released from her suffering and find joy. This symbolic object is introduced into the narrative as a powerful sign of the future sexual union. Moreover it can show what that later scene cannot – the joining of their genitals. Held by two women the split shield articulates the power of images to embody union. It is in many ways more erotic than the sexual act itself toward which it points. This potent heraldry will also protect Lancelot in future battles where he will "fight like a lion" since his virility has been proved by his consummating his love with the king's wife.

The reason why the Arthurian cycle rarely represents the act of sexual union – and even when it does, as in this example, it is more effectively conveyed through symbols – is due to the fears that surrounded the sexual act as a performance. This can be seen in the image of copulation in Aldobrandino of Siena's *Régime du Corps* (fig. 130). The first hygienic and dietary treatise to be written in a vernacular language during the Middle Ages, this work was similar to the modern self-help sex-guide to the extent that it uses the combination of texts and image to inform lay readers of "truths" contained in a more prestigious "scientific" discourse. A golden-lettered rubric announces that the subject of the seventh chapter is about "how to co-habit with a woman." Also of burnished gold is the background, as glittering as that behind a *Crucifixion* in a contemporary Bible except that here it provides the foil for a fundamental rather than a transcendental moment. Within the initial a man and a woman are revealed in the midst of intercourse by parted green curtains. Curling at the edges to form a kind of lip, these represent the opening that cannot be represented. The fact that the curtain joins with the woman's hair on the left side of the initial, and does not touch the male figure at all, reinforces this association between the rent cloth and vaginal penetration. The act literally takes place, as it does in the scene of Lancelot and Guinevere, "under the covers." The artist has skillfully evoked the powerful muscular spasms of limbs in the rhythmic pulse of thick black pen lines that criss-cross the bed to reveal mostly the massive curved thighs of the woman. Yet the body in question here, the body whose health is being maintained according to the accompanying text, is male.

This initial opens a powerful prescriptive statement aimed directly at the male reader: "He who has sense and discernment should devote his understanding and all of his efforts to learning how one should cohabit with a woman, for it is a principal means of maintaining one's health and whoever does not do this moderately has a body that is good for nothing." The author goes on to detail the proper disposition of the male body, especially focusing on the *bonne eure* – the best time for engendering children. What is going on in this image has nothing to do with pleasure. It is about maintaining one's health, if one is a man. The male is the body that matters. The author of the *Régime* repeats the Aristotelian and Galenic view that all parts of the male body furnish material for the sperm and how his veins carry the seminal matter (*le matere*) from his brain down into the testes. The man's tight white nightcap, tied under his chin in the initial, is an important detail in this respect. It indicates the major problem for the male partner in sex – "loss of heat," which endangered his vulnerable body. The male figure stares blankly into space as if set on his task. The whole emphasis is upon his performance. Men who indulge in too much sexual intercourse, who are drunk, or are too young or too old, will not easily, the text warns, "engender infants." Much of the chapter concerns choosing the right moment when the male has eaten certain foods and has enjoyed a prescribed amount of rest. If medical discourse was all about finding the right time in terms of the humoral balance of the body, the discourse of Church law was concerned with the right time in terms of the liturgi-

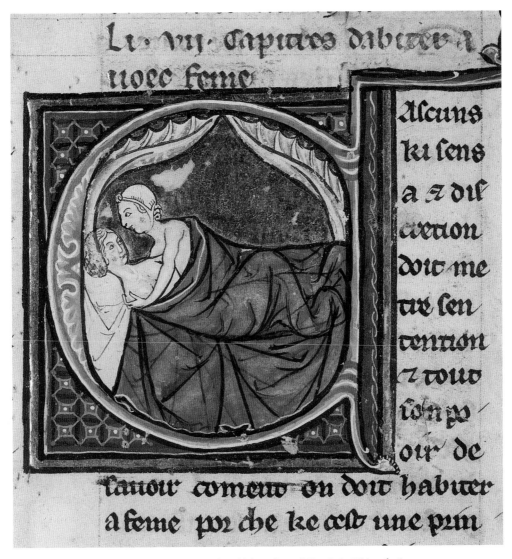

130. A medieval "sex manual," Aldobrandino of Siena's *Le Régime de Corps*,
Lille, c. 1285. London, British Library, MS Sloane 2435, fol. 9v.

cal calendar. Copulation was not permitted on Sundays, Wednesdays, or Fridays, on any church feast and during Advent and Lent. Prohibited during pregnancy and after childbirth, Gratian also advised husbands to keep themselves chaste for up to eight days before accepting the eucharist, for fear of contamination. Conception could only occur, it was thought, with the kindling of the male's innate heat and insemination with his perfect seed, his "form." The male planted his seed, or his idea, inside the female, who had no active role in conception.

If the initial represents the perfect progenitor at the optimum moment for procreation, what

of the woman underneath him? Like her part-
ner, she wears her hair tight in a net. This indi-
cates her married status and legitimates the act
portrayed as taking place within the marriage-
bed. She looks up to her husband and the illu-
minator has curved the line of her lower lip
upward to suggest a smile. Thirteenth-century
artists often utilized such expressions of joy, not
only in the statues of smiling angels at Reims
Cathedral, but in depicting lovers in secular
manuscript illumination. Does the use of this
facial expression here imply that she is experi-
encing a pleasure that is nowhere ascribed to her
in the text? The *Régime du Corps*, unlike some
contemporary medical tracts, contains no men-
tion of the opinion, held by some medical theo-
rists, that female orgasm was necessary for con-
ception to occur. It is hard to say whether the
illuminator's putting a smile on the lady's face
here is an allusion to that medical belief or part
of the misogynistic tradition that attributed
desire, and its dangerous insatiability, more fre-
quently to the female, in her urge to heat her
cold, wet body. Both figures have tiny touches of

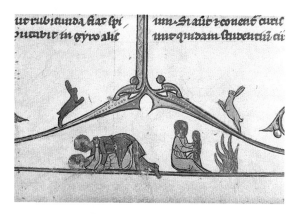

131. Before and after sex, from Aristotle's
Historia Animalium, Book ix, Paris, c. 1280.
Oxford, Merton College, MS 271, fol. 65v.

red on their cheeks, representing their healthy
status, but also in this case indicating the blood
that is flowing through various veins at this cru-
cial juncture. The act of intercourse was struc-
tured in the *Régime du Corps* so as to have none
of the psychological and identity dimensions evi-
dent in any modern sex therapy manual. This is
because the sexual body and its organs were not
linked to an identity that was sustained and
expressed through sex, but were thought of only
as tools in a predominantly "male" performance.

One aspect of this image needs to be exam-
ined as constructed by, rather than as natural to,
medieval culture. It is fixed and fostered
through representation and should not be seen
as a reflection of some "medieval reality." The
man is on top of the woman. This pictorial con-
vention, with its origins in classical art, of the
male body on top of the female body in the act of
performing sexual intercourse was already well
established by this date. A major source for
Aldobrandino had been Aristotle whose newly
translated writings became part of the university
curriculum in the course of the thirteenth cen-
tury. In a marginal scene illustrating Book ix of
Aristotle's *Historia Animalium* in a manuscript
produced for the University of Paris around
1280 there is a kind of before and after
sequence, both in the initial and in the lower
margin, where the clothed couple, suggestive of
furtive rather than properly sanctioned sex with-
in the marriage-bed, are joined together on the
left, and on the right the woman nurses her baby
beside a fire (fig. 131). If the anxiety around cop-
ulation for men was their proper performance,
for women it was more often this sometimes
unwanted outcome. The fire that warms the

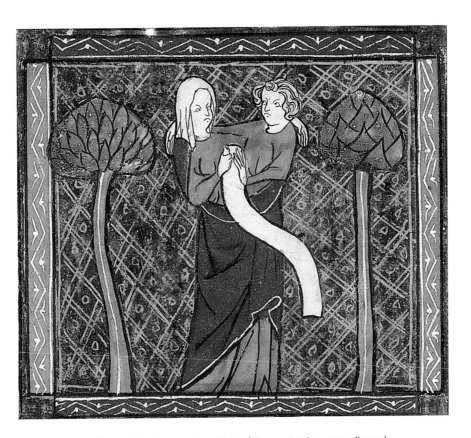

132. Lovers joined as one, from *Li Ars d'Amour*, Artois, c. 1300. Brussels, Bibliothèque Royale Albert 1er, MS 9543, fol. 22v.

newborn baby on the right signals not only the heat required for generation (the *Régime* also describes how it is better to have sex when "the body is warm rather than when it is cold"), but also the Aristotelian conviction that the male as the fiery principle of the form gives life, not the cold, wet female, who provides only matter through her menstrual fluid. The two erect rabbits on either side are an obvious allusion to sexual arousal and its consequences, projecting any hint of pleasure into the bodies of animals.

Scholastic philosophers, with their usual love of classificatory schemes, debated the pros and cons of the various coital positions. In the thir-

teenth century Albert the Great listed four alternative or dangerous ones in addition to the traditional "natural" position: lateral, or side by side, seated, standing, and finally backward or *a tergo*. The notion of a couple copulating standing up is hinted at in many of the images of the kiss examined earlier, and in the split shield episode. An unusual miniature representing the union of two lovers in one body shows them holding a scroll, suggesting the legal union of marriage (fig. 132). It also makes them into something monstrous. Here object and subject become one as described in contemporary legal theory, which described how, following Apostolic

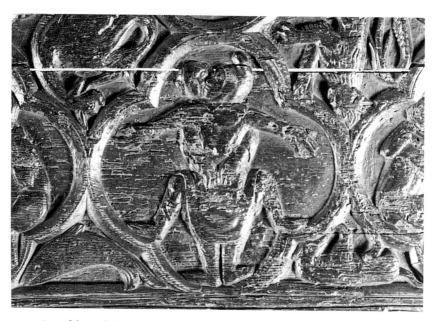

133. One of the prohibited positions: the lid of a wood casket showing a couple copulating
standing up, France, fourteenth century. Cluny, Paris, Musée du Moyen Age.

authority, the husband and wife did not possess his or her own body, but that of the spouse. It was precisely this sexual symmetry that meant that both partners could demand the marital debt of intercourse. Male impotence was one of the few arguments through which a woman might gain a divorce. Peter Lombard and other scholastic commentators argued that whereas in other realms of life the husband has dominance over the wife, in sexual relations there was gender equality.

A rare example of a couple actually copulating standing up occurs on the lid of a small wooden casket (fig. 133). Viewer discretion was never advised in the medieval image. The female is standing in front, which also suggests that the man is sodomizing her from behind. This was the fourth position described by Albert the Great as *a tergo* or backward and which brought most

condemnation. Still illegal for married couples in some states of the USA today, this was thought most sinful and unnatural since it made man into an animal. Yet the evidence of the Penitentials on one hand and the *fabliaux* on the other suggest that anal sex was enjoyed by heterosexual couples. Committing sodomy with one's wife, however, was deemed as sinful as committing the act with a whore or a man. It was not so much the gender of the partner so much as what parts were put where that was labeled "against nature." The results of such "unnatural" sexual positions were thought to leave their mark on the infant, in diseases such as leprosy, marking the child's body with the stain of the parents' sexual sin.

134. Coitus, nature's smithy, from
Le Roman de la Rose, France, c. 1380. London,
British Library, MS Egerton 881, fol. 126r.

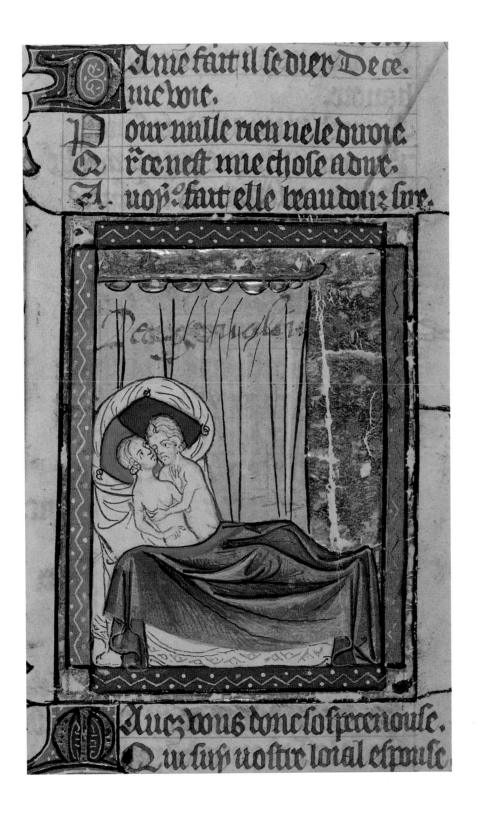

Using the proper orifice but having the woman on top was also viewed with horror by theologians and by medical practitioners, who thought that reversing the proper downward flow of semen could not only damage the fetus because the womb is "turned over," but may also cause harm to the man. Reversing the natural order in this way after all caused God to bring the biblical flood (Romans 1: 26–27), and its consequences were still thought dire for the bodies and souls of those seeking to gain pleasure from sexual experimentation. I have rarely seen the woman on top depicted in illuminations of copulation in manuscripts, which suggests just how taboo this simple inversion of gender roles was. It is alluded to nonetheless in the popular theme of Aristotle and Phyllis. The young girl riding the foolish old philosopher is the subject of a bronze aquamanile, or water-jug, which must have brought laughter to many a feast (see fig. 106). With a long spidery arm Phyllis pats her steed's behind and with the other pulls up a tuft of his hair into a horn to make him into a literal beast, ruled only by its lower body. But the philosopher still turns to us with a vaguely bemused smile. That such an image, in many ways parodying the ethos of courtly love, found its place on the noble table is an indication of how self-conscious and ironic people's views of the courtly system had become by this period. It also shows again how much more at ease the medieval viewer was with images that explicitly alluded to sexual acts rather than depicting the act itself, with the allegory rather than the reality of penetration.

Artists illuminating Jean de Meung's continuation of the *Roman de la Rose* faced the problem of reconciling the verbal allegory with the literal surface of the image. Earlier in the poem the author has Genius argue against clerical celibacy, urging those "who do not use their pens" and who let them get rusty and idle to get up and "plough!" The illustrators of this passage usually show what lies behind this allegorical surface of male writing – the act of carnal inscription (fig. 134). Jean de Meung's anxiety here is with procreation – the engendering of heirs; his primary concern is not with the joy of sex, but with its outcome, and artists tend simply to borrow the iconography from the medico-scientific tradition. The actual climax of the *Roman de la Rose*, when the lover finally gains possession of the virgin rose, is presented in a far more allusive, complex, and multiform allegorical way. Near the poem's end is a long mythological digression narrating the story of Pygmalion. Here was another important classical character who exemplified for the Middle Ages the problem of disordered desire, an artist who made his own girlfriend. The meaning of this manufacture is made explicit in the fourteenth-century illuminator of a Brussels manuscript who has the hammer and chisel re-enact the phallic desire of the artist, not just to create but to penetrate his beloved (fig. 135). Pygmalion then kneels before the finished ivory statue and falls in love with it, a scene represented in the late fifteenth-century manuscript by Robinet Testard, which focuses a whole narrative sequence on the artist's obsession (fig. 136). The carver's tools lying on the ground and in the kneeling suitor's apron emphasize the status of the artist. As a sculptor Pygmalion would have been considered more of a manual laborer than a painter in this period, making his groveling ado-

135. Pygmalion "making" his beloved, from *Le Roman de la Rose*, Paris, c. 1360.
Brussels Bibliothèque Royale Albert 1er KBR, MS 11.187, fol. 12r.

ration of the noble ivory statue even more comic. In the poem at this point Pygmalion compares himself to Narcissus who fell in love with an image: "But Narcissus could not possess what he saw in the fountain," whereas for this artist, that possession is possible.

Significantly, Pygmalion first dresses up his statue (fig. 137). He does this with all the care of a couturier:

> in many ways, in dresses made with great skill of white cloths of soft wool, of linsey-woolsey [mixed wool and flax], or of the stuffs in green, blue, and dark colors that were pure fresh and clean. Many of the fabrics were lined with fine furs, ermine, squirrel, and costly gray fur. Then he would undress her and try the effect on her of a dress of silk, of sendal [a fine rich silk], he puts a wimple on her but never covers her face "like the Saracens, who are so full of jealous rage that they veil the faces of their wives so that passers-by will not see them," ... to hold her collar he placed two golden clasps at her neck, and he put another in the middle of her chest and a girdle around her waist. At the girdle he hung a precious and expensive purse ... plus chaplets of flowers and gold rings on her fingers.

136. Robinet Testard
Pygmalion kneels before the statue he has made, from *Le Roman de la Rose*, western France, c. 1480. Oxford, Bodleian Library, MS Douce 195, fol. 149v.

This fetishistic fashioning of the object of desire by the artist is emblematic of the creation of so many images of women's bodies illustrated in this book, which were, as I have argued, mostly fashioned and elaborated by and for the male gaze. Only after dressing does Pygmalion try to have intercourse with his image, but he finds his beloved "as rigid as a post and so very cold that my mouth is chilled when I touch her to kiss her" (fig. 138). Robinet Testard shows her lying like a shrouded corpse on the bed in the miniature, his tools now sticking out of his apron as the signals of his uncontrolled desire for a dead image. Eventually Venus grants his wish and on his return from the temple Pygmalion finds his statue not only alive but able to say to him: "I am neither a demon nor a ghost, sweet lover, I am your beloved."

The story of Pygmalion comes as a long digression near the end of the *Roman de la Rose*, just before the proper climax of the poem. In

some manuscripts the image of Pygmalion fashioning the statue and not its coming to life is the final miniature of the pictorial cycle, suggesting both the sexual conclusion of the poem and the lover's continued captivation by illusion and artifice. But other manuscripts take the story to its actual climax, returning to the attack on the castle where his rose has been immured. An earlier fifteenth-century manuscript like that in Valencia, painted by a gifted Parisian illuminator, depicts the surface of the pseudo-sacred allegory which approximates sexual penetration to that of a pilgrim approaching a sacred sanctuary (fig. 140):

> I knelt without delay between the two pillars, for I was very hungry to worship the lovely adorable sanctuary with a devoted and pious heart ... I kissed the image very devoutly and then, to enter the sheath safely, wished to put my staff into the aperture, with the sack hanging behind. Indeed I

137. Robinet Testard
Pygmalion dresses the statue, from *Le Roman de la Rose*, western France, c. 1480. Oxford, Bodleian Library, MS Douce 195, fol. 150r.

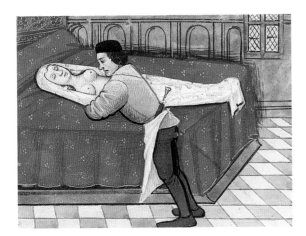

138. Robinet Testard
Pygmalion tries to have sex with the statue, from *Le Roman de la Rose*, western France, c. 1480. Oxford, Bodleian Library, MS Douce 195, fol. 151r.

thought that I could shoot it in at the first try, but it came back out. I replaced it, but to no avail; it still recoiled. By no effort could I enter there, for I found there a paling in front I felt but could not see. ... You shall know how I carried on until I took the bud at my pleasure. You, my young lords, shall know both the deed and the manner, so that if, when the sweet season returns, the need for you to go gathering roses, either open or closed, you may go so discreetly that you will not fail in your collecting ... Finally I scattered a little seed on the bud when I shook it.

Robinet Testard's version of this moment, painted in the later fifteenth century when the veil of allegory was becoming more and more transparent to the realities of "naturalistic" representation, is at the same time less physical (fig. 139). The lover is shown pulling aside the

bed curtains, his staff and sword ready to take the rose who has become a real flesh and blood person, just like Pygmalion's statue earlier. The next miniature, the very last in the manuscript, is truly anticlimactic and depicts the conventional, mostly hidden couple "doing it" fully clothed in bed.

Another wonderfully inventive illustrator who managed to escape from the tyranny of convention, partly by using a rapid pen-drawing technique unusual for its time, was an artist known as the Master of Jean de Wavrin, who worked in Lille around 1450–60. One of his most spirited works is the illustrations in the manuscript entitled *Le Livre du Trés Chevalereux Comte d'Artois et de Sa Femme, Fille du Comte de Boulogne*. This romance tells the story very much from a woman's perspective, that of the young countess, who in the title is named only as the wife of one man and the daughter of another. After her husband leaves her when she is unable

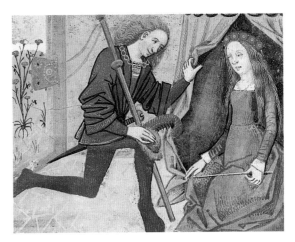

139. Robinet Testard
The lover finally approaches the sanctuary, from *Le Roman de la Rose*, western France, c. 1480. Oxford, Bodleian Library, MS Douce 195, fol. 155r.

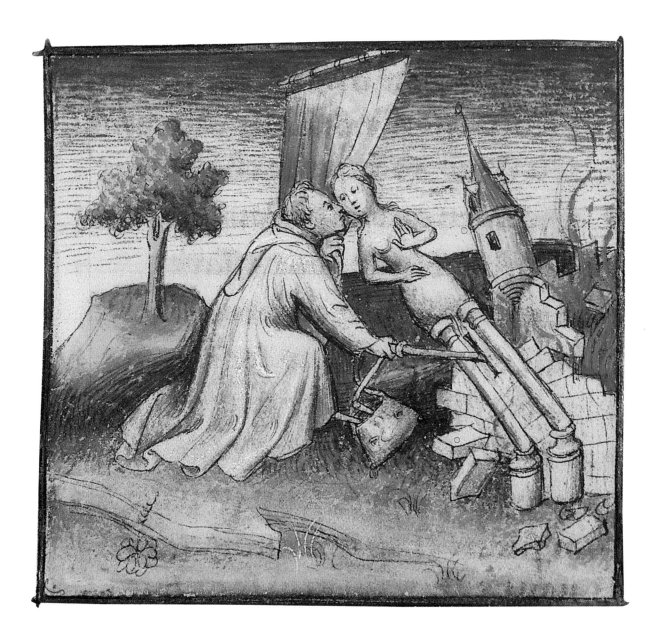

140. The lover finally penetrates the sanctuary, from *Le Roman de la Rose*, Parisian illuminator, c. 1410. Valencia University Library, MS 387, fol. 146v.

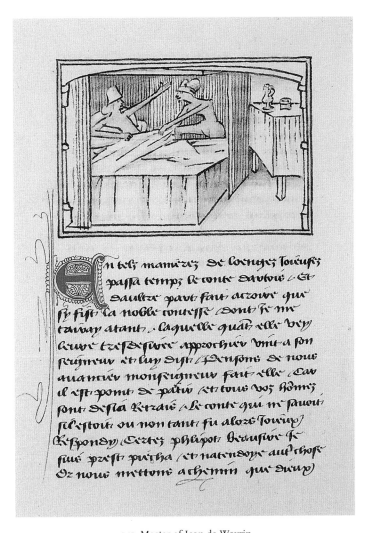

141. Master of Jean de Wavrin
The Countess of Artois finally triumphs, *Le Livre du Trés Chevalereux Comte d'Artois et de Sa Femme,*
Fille dui Comte de Boulogne, Lille, c. 1460, Paper. Paris, Bibliothèque Nationale, MS fr. 11610, fol. 87v.

to bear him children, she follows him to the court of Castile where, disguised as a man, she gets close to him by feigning a love-interest for the king's daughter, who has become her husband's mistress. In this way she is finally able to substitute herself for this girl in his bed and win him back (fig. 141). The rubric before this image reads: "Comment la contesse d'artois coucha avec sa mari ou lieu de sa fille de roy de Castile" ("How the Countess of Artois sleeps with her husband in the place of the daughter of the King of Castile"). Very few representations of this period are either so lively in feeling or manage to present an active female participant in the sexual encounter. Although this moment is when the count welcomes her back into his bed it is the

142. Martinus Opifex
"Achilles' scores," from *Historia Troiana*, c. 1450. Vienna,
Österreichische Nationalbibliothek, Cod. 2773, fol. 164r.

lady herself pulling back the sheets with all the bravado that she had used when "cross-dressing" as a man earlier that makes the reader sympathetic to her mounting excitement.

Another very personal but this time much more masculine perspective is provided by a contemporary of the Lille master, the illuminator known as Martinus Opifex, who worked at the court of the Emperor Frederick III and who died in 1456. Another very idiosyncratic artist, Martinus was fascinated by human sexuality, which he illustrated in a number of scholastic treatises on nature. In one of the miniatures in another, this time historical text, the *Historia Troiana*, Achilles, his back turned to the viewer, reaches his goal of love within a great tent whose labial lips spread open (fig. 142). This is the absolute erasure of the other, not a merging with the beloved object of desire but its total overlap, its obliteration. There is no reference to the woman in the process, except on the surface, which figures her genitals so blatantly. The painted space comes to stand for the act of penetrative desire itself as our eyes delve deeper and we lose ourselves in the flower-like folds. This is something the illuminators of the *Roman de la Rose* did not make use of, limited as they were to the surface of allegory. Martinus Opifex makes his image perform desire in a way that looks forward to art of later periods and in doing so goes some way to filling the emptiness that, for its anxious male subjects, came at the climax of the medieval art of love.

143. Master of the Housebook
The Uncourtly Lovers, southern Germany, c. 1484. Tempera on panel,
44³/₄ x 31¹/₂" (114 x 80 cm). Gotha Museum.

LOVE'S DECLINE &
LOVE'S RENAISSANCE

*Age is an obstacle, because after a man's sixtieth year
and a woman's fiftieth, one can admittedly have sexual intercourse
but one's sensual pleasure cannot lead to love.*
Andreas Capellanus

The three traditional enemies of love – marriage, old-age, and death – as well as their pictorial equivalent – the cold shiver of the real – permeates most images of the art of love created at the end of the Middle Ages. One of the few exceptions is a painting attributed to the Master of the Housebook, whose ill-defended Castle of Love we have already seen (fig. 143). This fashionable young couple painted around 1484 shows that many of the tropes we have traced in this book continue well into the period known as the Renaissance. During the fifteenth century art comes to treat erotic love more and more negatively, not because of any increasing pressure from the Church, which had always condemned it, but because of the expanding audience for images. Hardened by war, plague, and an urban reality that seemed ever more at odds with courtly fantasy, bourgeois patrons detested the old chivalric ideals as intensely as they aped them. Although marriage was seen as the antidote and opposite of love, many works of art celebrating love's myths were made in the Middle Ages to serve more practical means in rituals of betrothal, and this appears at first to be the context for this painting. The young man has his arm around the woman's waist and tenderly regards her while she looks demurely down. She stares not at him but at two things that she holds in her hands and which serve to symbolize their relationship. In her left hand she holds a wild rose, the same flower that forms a garland in the man's luxuriant locks. In her other

hand she fingers a finely decorated gold band, known as a *Schnürlin*, which is a ring holding together the tassel of the cap that lies over the young man's shoulder. In binding her love in a crown of flowers and presenting him with the gift of a luxurious hat jewel, this looks on the surface like a marriage portrait, representing the ideal of courtly love in late medieval German art.

But recently scholars have come to realize that what this panel represents is not the ideal of courtly but in fact uncourtly love. First it represents not even a bridal couple but it is a portrait made for Count Philip von Hanau-Munzenberg (1449–1500) and his concubine Margret Weiszkircher. The inscription on Philip's scroll, *Un-byllich het Sye es gedan*, suggests the illegal state of their union, it being done "against custom" or "unlawfully." His beloved's reply, *Sye hat üch nyt gantz veracht/Dye üch das schnürlin hat gemacht* assures him that "You have your own love/Who has made this *Schnürlin* for you." Documents reveal that the Count was unable to find a wife of his own class after the death of his first spouse in 1477 but lived openly with this woman of the burgher class with whom he had three children. It has been suggested that Philip had this double portrait made before setting out on a dangerous pilgrimage with his brother to the Holy Land in July 1484.

For all its flouting of social convention, at least this painting is sincere in its expression of love and indeed in showing love outside marriage it can be said to be one of the few medieval works that actually conforms to one of the precepts of the courtly ideal. The youth in the engraving of two lovers by Master ES is also shown wearing his fashionable *Schnürlin* but this awkward pair presents a far more pathetic spectacle (fig. 144). The old symbols are still there but rather than evoking erotic potential and pleasure they serve to underline the embarrassment of the scene. Leaving his falcon on the side the gangling boy is about to make a grab, only slightly repulsed by the lady's spidery fingers. One sword hangs down as his phallus, the other lies broken beneath his excessively elongated footwear. Her lapdog, hardly visible at first, winds like a weasel up against him. The symbol of the garden enclosed, of the girl's virginity, is a miniature tree in a pot; whether it represents Eden with its Tree of Good and Evil or the Garden of Pleasure of the *Roman de la Rose*, it has been reduced to the status of a house-plant. The nervous fragility of every line of the engraver's burin cruelly exposes these wasp-waisted wastrels of charlatan chivalry, whose erotic indeterminacy would have been laughed at by the God-fearing bourgeois mer-

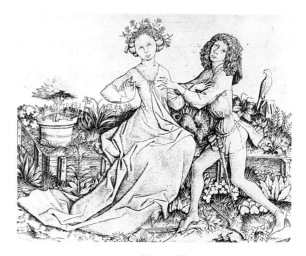

144. Master ES
A Pair of Lovers, c. 1460. Engraving, 5¼ x 6½"
(13.4 x 16.4 cm). London, British Museum.

chant class who would have bought such prints. They seem to have been caught in the act just as much as their twelfth-century counterparts with which this book began, except they are not caught under the gaze of God's judgment but that of a whole society.

The very medium of print, its bare black and whiteness, was crucial in constituting a new art-audience, the aspiring middle class. The spectacular warnings about the vices carved in stone on the thirteenth-century cathedral were now available at a cheaper price and could become part of the physical as well as the mental baggage of every householder. If chivalry had become decrepit so had lovers themselves. Part of the imagery of odd couples that permeates northern art of the fifteenth century is that of the unequal couple in which one of the partners is much older than the other. Andreas Capellanus had described old age as the enemy of love, but in an engraving by Israel van Meckenem love is linked to other vices such as avarice and vanity because the old woman here has to buy her young lover (fig. 145). The humanist Erasmus in his *Praise of Folly* written in 1509 describes this kind of union as a reality:

> nowadays any old dotard with one foot in
> the grave can marry a juicy young girl,
> even if she has no dowry ... But best of all
> is to see the old women almost dead and
> looking like skeletons who have crept out
> of their graves, still mumbling "Life is
> Sweet!" As old as they are they are still in
> heat, still seducing some young Phaon
> they have hired for large sums of money.
> Every day they plaster themselves with

145. Israel van Meckenem
An Old Woman and a Young Man, 1500. Engraving,
4¹³/₁₆ x 3³/₄" (12.1 x 9.53 cm). London, British Museum.

> makeup and tweeze their pubic hairs;
> they expose their sagging breasts and try
> to arouse desire with their thin voices.

In van Meckenem's engraving, unlike other versions of this subject in woodcuts and in paintings by Lucas Cranach, the two lovers are not that different, indeed they seem reflections of one another as though old age were seeing not only its sexual other in the mirror of lust, but its own past. The usual dynamic was the other way round – the beautiful and young should have the image of their future decay constantly before their minds. This macabre attitude is most clearly revealed in an anonymous painting that has now been split in

146. Standing Bridal Pair. Front panel showing a
young married couple, made in Germany, c. 1470. Oil on wood,
24¹/₂ x 14¹/₄" (62.2 x 36.5 cm). The Cleveland Museum of Art.

two but which once formed the front and back of
the same work, known as the *Standing Bridal Pair*.
The front of the panel shows the young couple
wearing jeweled chaplets and matching left
sleeves of damask becoming "one body" as the
youth presents his bride with a flower (fig. 146).
The reverse of the panel shows the two lovers
turned into corpses, their naked flesh rotting

from their exposed bones (fig. 147). Their posi-
tions are now reversed with the groom in the
"subject" position looking out in penance and
able to cover his genitals with his shroud. His
cadaverous bride stands silent and aghast, as
much a focus of horrible fascination in death as
she was of envy in life, horribly and totally naked,
still an object even in death compared with her

147. Standing Rotting Pair. The back of the previous
panel, made in Germany, c. 1470. Musée de l'Oeuvre
Notre-Dame de Strasbourg.

husband's gestures of self-reproach. Was reflection on the vanity of all things the only moral charge of this strange pair of paintings or was there a sense in which the future decay of this young couple made their youth and beauty all the more delectable? For the man who commissioned this strange *memento mori* would have watched as disease and decay ate away their firm flesh, not in secret like Dorian Gray in Oscar Wilde's famous story, but publicly in this expensive, commissioned image. For these lovers the joy of betrothal was the back rather than the front of the panel, since the focus of fascination for both artist and patron is not the side of love, youth, and beauty, which has an empty, conventional patina about it, but that of death, old age, and decay, which is a far

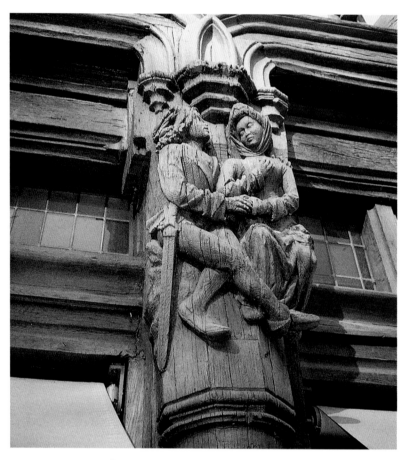

148. Lovers on the street. Wooden sculpture,
c. 1500. "Adam's House," Angers.

more vivid painting and which also provides more avenues for a public exploration of the self.

This more public aspect of love, visible also in the new medium of printing in the fifteenth century, meant that by the end of the century couples begin to appear in wider social contexts than that of the rarefied luxury art objects and manuscripts of the princely courts. On a late fifteenth-century merchant's house known as Adam's House at Angers not only were Adam and Eve, as the first bridal couple and the primal householders, carved on either side of the corner buttress, but a

pair of contemporary clothed lovers project out directly in the middle of the side facing the Place Sainte Croix (fig. 148). At this period *gens méchaniques* and manual workers were forbidden from carrying weapons in towns, so the lover's long sword is probably, like his hat, a sexual pun. He thrusts out a long leg, dangling his wooden clogs before his demure mistress, and grasps her by the hand. Like the shepherd and shepherdess who once appeared carved on the same façade and in contrast to a man who exposes his genitals to people passing by on the other side of the

house, the couple carved here represent urban nostalgia for an earlier, idealized courtly ideal that never actually existed.

In Italy the art of love was paraded through the streets on the occasion of a marriage in the form of the two *cassone* chests usually purchased by the bridegroom, or by his family. These were used to transport his bride's dowry to the bedroom of the couple's house and then remained in the nuptial bedroom. In fifteenth-century Florence these large chests were often adorned with scenes of romances and mythology on their exteriors but their interior lids sometimes depicted the bridal pair, the bride totally naked and asleep in one, and her more modestly dressed husband awake and staring wistfully (at her?) in the other (fig. 149). The emphasis upon male beauty in a well-preserved example of this type in Avignon has suggested to some historians that these interior nudes painted on the inner lids of the chests were meant to be displayed to the bride alone, for whom they served as some kind of fertility charm, ensuring beautiful offspring. This is hard to accept since the male, for all his elegance, is shown in the

traditional manner we have come to expect – as the subject not the object of desire, just as the poet Petrarch celebrates gazing on the lovely form of his sleeping beloved. The Renaissance casket, just like its medieval forebears, proclaimed possession of a bride by her husband along with her dowry, for all its imagery of Petrarchan longing. An even more public side to Petrarchan love is suggested by those cassone panels and birth-salvers depicting the *Triumphs of Love*, based upon six long poems that Petrarch began in 1340. Sometimes actually staged as civic festivals, the great chariots made love into a spectacle of pure visibility. Of course in Italy there existed another more profoundly personal and poetic side, represented best in the art and poetry of Michelangelo, in which Petrarchan ideas are developed into a highly idiosyncratic and lyrical expression of love, available to both men and women for objects of desire that could be of a different or the same gender, rooted in Renaissance Neo-Platonic texts that had been unavailable to the men of the Middle Ages. This tradition saw its ultimate refinement in the Renaissance portrait, which, as

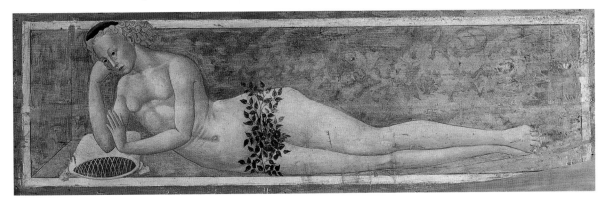

149. The Petrarchan look: the bridegroom painted on the inside lid of a *cassone*,
Florence, c. 1450. Tempera on wood. Avignon, Musée du Petit Palais.

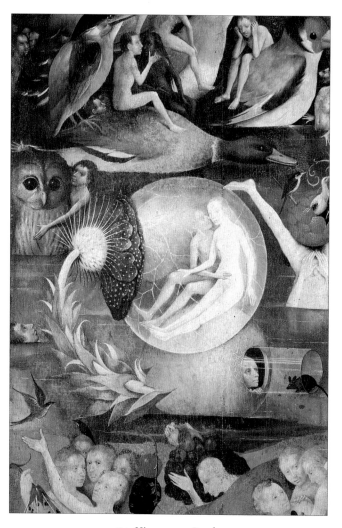

150. Hieronymus Bosch
Inside the Bubble of Love, detail of *The Garden of Earthly Delights*, c. 1510.
Central panel, 7'2¹/₂" x 6'4¹/₄" (2.2 x 1.95 m). Madrid, Prado.

Leonardo da Vinci described, could represent the lover to the beloved directly. The medieval art of love is, by contrast, less concerned with the portrayal of specific individuals and more with conventions, objects, and images through which individuals might play out and perform desire.

Hieronymus Bosch (1453–1516) paints the last courtly couple, or at least the latest in the chronology of this book, I believe as a conscious satire and critique of the whole tradition that I have traced. In the myriad marvelous details that make up the triptych known as the *Garden of Earthly Delights* painted toward the end of his life, this artist still reveals himself to be working very much in the medieval tradition. In the larger of the two ponds in the central panel, in which

men and women copulate with giant birds, plants ejaculate, and everything that can be polymorphously perverted through paint is, a man and woman appear in a bubble (fig. 150). Within this sphere of cracked crystal the two seem trapped, as if in a dream from some earlier age, along with a strawberry, a sign of gluttony and exquisite lechery, which lurks in the shadows by the man's knees. These two are on a line with Adam and Eve on the left, or "Paradise" panel as though representing their progeny, re-enacting the sin with even more forbidden fruits. In medieval elemental terms, crucial for understanding Bosch's medico-magico-political art, the ruddy hot young man still looks adoringly at the white wet woman from the left while she averts her gaze. The tyranny of the convention that elevates women to the specularity of the mirror, the "looked-at-look" or the object in this system, has trapped them both equally in the glass of misrecognition and distortion. This painting, the *Garden of Earthly Delights*, is full of ruptures and disturbing misalignments that make the symbols of earthly love even more unstable than they had been in the symbolic sets of the medieval imaginary. Bosch's couple is mismatched far more profoundly than the unequal couples in Northern art of the same period. We are approaching something closer to love in modernity with its Freudian fractures and Lacanian lack. For something is not quite right with this image, something does not quite join up properly beneath this membrane of painted desire. We are close to what Bosch's contemporary Leonardo da Vinci described when arguing for the superiority of painting over poetry: "And if the poet claims that he can inflame men to love ... the painter has the power to do the same, and indeed more so, for he places before the lover's eyes the very image of the beloved object, [and the lover] often engages with it, embracing it and talking to it." In Bosch's panel where the male hand penetrates the beloved's body within the bubble's membrane, or the crystal's cracked surface just where his right hand crosses over its object, the artist intentionally sets up an optical distortion so that her torso, like an object viewed under water, shifts over a few millimeters. Woman had always been a deformed man, an inferior, even monstrous creature in medieval misogynistic discourse, but here she is visibly presented as discontinuous – as the impossible object of desire, one that does not "line-up" properly, but wavers indeterminately as an optical illusion. Petrarch himself had described how love "often makes a healthy eye see crooked" and it is precisely this that Bosch enacts, making every viewer of this panel see crooked. The great painter refers to his own anxious practice, which embodies the myth, not of Pygmalion's statue, but of the ungraspability of a two-dimensional surface. The hand that makes the painted object is always unsure of the palpability of that which it has created. In this last detail of desire, still unfulfilled, still groped-for as a female object by a male subject, the art of love has actually become the art of painting.

BIBLIOGRAPHICAL REFERENCES

INTRODUCTION: LOVE'S LOST RELICS

All quotations from Andreas Capellanus's treatise are from the edition with parallel texts in Latin and English by P. G. Walsh, *Andreas Capellanus on Love* (London, 1982). There is no single survey of secular love themes in medieval art but useful general works include: Raimond van Marle, *Iconographie de l'Art Profane au Moyen-Age et à la Renaissance*, 2 vols (The Hague, 1931–32); D. D. R. Owen, *Noble Lovers* (New York, 1975); and, most recently, Markus Müller, *Minnebilder. Französische Minnendarstellungen des 13. und 14. Jahrhunderts* (Vienna, 1996), which has an excellent bibliography. Theories of the origins and history of "courtly love" are discussed in Roger Boase, *The Origins and Meaning of Courtly Love: A Critical Study of European Scholarship* (Manchester, 1977) and for the German context, Joachim Bumke, *Höfische Kultur, Literatur und Gesellschaft im hohen Mittelalter* (Munich, 1986; as *Courtly Culture, Literature, and Society in the High Middle Ages*, Berkeley, CA, 1991). For the twelfth-century context of the images discussed in this chapter, see John C. Moore, *Love in Twelfth-Century France* (Philadelphia, 1972) and Georges Duby, *Mâle Moyen Age* (Paris, 1988; as *Love and Marriage in the Middle Ages*, Chicago, 1994). For the troubadors, see René Nelli, *Troubadors et Trouvères* (Paris, 1979); Linda M. Patterson, *The World of the Troubadours* (Cambridge, 1993); and F. R. P. Akehurst and Judith M. Davis, eds, *A Handbook of the Troubadours* (Berkeley, CA, 1995). Important recent literary studies include Sarah Kay, "The Contradictions of Courtly Love and the Origins of Courtly Poetry: The Evidence of the *Lauzengiers*," *Journal of Medieval and Early Modern Studies*, vol. 26 (1996), pp. 209–55; Simon Gaunt, *Gender and Genre in Medieval French Literature* (Cambridge, 1995); and Michel Zink, "Un Nouvel Art d'Aimer," in *L'Art d'Aimer au Moyen Age* (Paris, 1997), pp. 9–70.

For an excellent introduction to some of the objects discussed in this chapter, see John Cherry, *Medieval Decorative Art* (London, 1991). The Limoges casket is discussed in Marie-Madeleine Gauthier, *Emaux Méridionaux. Catalogue International de l'Oeuvre de Limoges*, vol. 1: *L'Epoque Romane* (Paris, 1987), pp. 160–63, and Müller, *Minnebilder*, pp. 59–73. For the Vannes casket, see Gérard J. Brault, "Le Coffret de Vannes et la Légende de Tristan au XIIème Siècle," in *Mélanges Offerts à Rita Lejeune*, vol. 1 (Paris, 1969), pp. 653–68. For love imagery on seals, see the work of Brigitte Bedos Rezak, especially "Medieval Seals and the Structure of Medieval Society," in *The Study of Chivalry: Resources and Approaches*, ed. Howell Chickering and Thomas H. Seiler (Kalamazoo, MI, 1988), pp. 313–73. The "Forrer" casket and the Tristram legend are discussed in the classic study by Roger Sherman Loomis and Laura Hibbard Loomis, *Arthurian Legends in Medieval Art* (2nd ed., New York, 1975), pp. 43–44, and Michael Curschmann, "Images of Tristan," in *Gottfried von Strassburg and the Medieval Tristan Legend*, ed. Adrian Stevens and Roy Wisby (Rochester, NY, 1990). For a new interpretation of the erotic scene in the Bayeux Tapestry, see Gerald A. Bond, *The Loving Subject: Desire, Eloquence, and Power in Romanesque France* (Philadelphia, 1996), pp. 19–40. The Chelles purse is discussed in the exhibition catalog *Tissu et Vêtement: 5000 ans de savoir-faire*, Musée Archéologique Départmental du Val-d'Oise (Guiry-en-Vexin, 1986), pp. 153–55. For the Frankfurt mirror, see the exhibition catalog *The Year 1200* (The Metropolitan Museum of Art, New York, 1970), pp. 105–06, and Heinrich Kohlhausen, "Das paar vom Bussen," *Festschrift Friedrich Winkler* (Berlin, 1959), pp. 29–48. The exhibition catalog *The Bride in the Enclosed Garden* (National Gallery of Prague, 1996) is an excellent introduction to the Song of Songs. There is a facsimile of the *Carmina Burana*, ed. A. Hilka, O. Schumann, and B. Bischoff, 3 vols (1930–70).

CHAPTER ONE: LOVE'S LOOKS

He Looks at Her

For general theories of love and vision, see Ruth H. Kline, "Heart and Eyes," *Romance Philology*, vol. 25 (1972), pp. 263–97, and A. C. Spearing, *The Medieval Poet as Voyeur: Looking and Listening in*

Medieval Love-Narratives (Cambridge, 1993).
Machaut manuscripts are discussed in François
Avril, *Manuscript Painting at the Court of France: The
Fourteenth Century* (New York, 1978), pp. 22–23, and
gendered looks in manuscript illumination in
Brigitte Buettner, "Dressing and Undressing Bodies
in Late Medieval Images," in *Kunstlerischer
Austausch/Artistic Exchange: Akten des XXXVIII.
internationalen Kongresses für Kunstgeschichte* (Berlin,
1993), pp. 383–92. The Morgan *Chansonnier* is dis-
cussed in Sylvia Huot, "Visualization and Memory:
The Illustration of Troubador Lyric in a Thirteenth
Century Manuscript," *Gesta*, vol. 31 (1992), pp. 3–14.
For the mysterious Morgan model-book, see R. W.
Scheller, *Exemplum: Model-Book Drawings and the
Practice of Artistic Transmission in the Middle Ages, ca.
900–1470* (Amsterdam, 1995), and Albert Châtelet,
"Un Artiste à la Cour de Charles VI. A Propos d'un
Carnet d'Esquisses du 14ème Siècle Conservé à la
Pierpont Morgan Library," *L'Oeil*, 216 (1972), pp.
16–21. The Louvre birth tray is discussed in Eugene
B. Cantelupe, "The Anonymous *Triumph of Venus* in
the Louvre," *Art Bulletin*, vol. 44 (1963), pp. 61–65.

She Looks at Him

For a facsimile of the Berlin manuscript, see
Heinrich von Veldecke, *Eneide: Die Bilder der Berliner
Handschrift*, ed. Albert Boeckler (Leipzig, 1939).
For female spectatorship, see James A. Schultz,
"Bodies That Don't Matter: Heterosexuality
Before Heterosexuality in Gottfried's *Tristan*,"
in *Constructing Medieval Sexuality*, ed. Karma
Lochrie, Peggy McCracken, and James A. Schultz
(Minnesota, 1997), pp. 91–111, and Louise Olga
Fradenburg, *City, Marriage, Tournament: Arts of Rule
in Late Medieval Scotland* (Madison, WI, 1991). For
the Manesse Codex, see two important exhibition
catalogs: Elmar Mittler and Wilfred Werner, *Codex
Manesse: Texte. Bilder. Sachen* (Universitätsbibliothek
Heidelberg, 1988) and Claudia Brinkler and Dione
Flühler-Kreis, *Die Manessische Liederhandschrift in
Zürich* (Schweizerisches Landesmuseum, Zürich,
1991). For the bride's mystical love and its visual-
ization, see Jeffrey F. Hamburger, *The Rothschild
Canticles: Art and Mysticism in Flanders and the
Rhineland circa 1300* (New Haven and London, 1990).

Who Looks at Them?

The classic essay by Erwin Panofsky is "Blind
Cupid," in *Studies in Iconology: Humanistic
Themes in the Art of the Renaissance* (Oxford,
1939). Thibaud, Messire, *Le Roman de la Poire*,
ed. Christiane Marchello-Nizia (Paris, 1984). For
Narcissus, see Christelle L. Baskins, "Echoing
Narcissus in Alberti's *Della Pittura*," *Oxford Art
Journal*, vol. 16 (1993), pp. 25–33. For the lady
and the unicorn, see Margaret B. Freeman, *The
Unicorn Tapestries* (New York, 1976); A. Erlande
Brandenburg, *The Lady and the Unicorn* (Paris,
1989); Jean-Pierre Jossua, *La Licorne: Images d'un
Couple* (Paris, 1994); and Fabienne Joubert, *La
Tapisserie Médiévale au Musée de Cluny* (Paris,
1988), pp. 66–84.

CHAPTER TWO: LOVE'S GIFTS

The Mirror and the Comb

On the gendering of mirrors, see Françoise
Frontisi-Ducroix and Jean-Pierre Vernant, *Dans
l'Oeil du Miroir* (Paris, 1997); John B. Friedman,
"L'Iconographie de Vénus et de Son Miroir à la
fin du Moyen Age," *L'Érotisme au Moyen Age*, ed.
B. Roy (Montreal and Paris, 1971), pp. 51–81;
Ingeborg Krueger, "Glasspiegel im Mittelalter:
Fakten, Funde und Fragen," *Bonner Jahrbuch er
des Rheinischen Londesmuseums in Bonn*, 190
(1990), pp. 233–320; and Herbert Grabes,
Speculum, Mirror und Looking-Glass (Tübingen,
1973; as *The Mutable Glass: Mirror-Imagery in
Titles and Texts of the Middle Ages and the English
Renaissance*, Cambridge, 1982). For ivories, the
basic catalog is Raymond Koechlin, *Les Ivoires
Gothiques Français* (Paris, 1924, reprinted 1968),
but see the more recent exhibition catalog: Peter
Barnett, *Images in Ivory: Precious Objects of the
Gothic Age* (Detroit Institute of Arts, 1997). For
"His wyfe es whitte as walles bone," see Walter
Clyde Curry, *The Middle English Ideal of Personal
Beauty; As Found in the Metrical Romances,
Chronicles, and Legends of the XIII, XIV, and XV
Centuries* (Baltimore, 1916), but a more up-to-
date study of makeup is Christine Martineau-

Genieys, "Modèles, Maquillages et Misogynie à travers les Textes Littéraires Française du Moyen Age," in *Les Soins de Beauté: Actes du IIIe Colloque Internationale à Grasse* (Nice, 1987), pp. 31–50. Flower-chaplets are discussed in Alice Planche, "La Parure du Chef: Les Chapeaux de Fleurs," *Razo*, vol. 7 (Nice, 1987), pp. 133–44.

The Girdle and the Purse

For the best analysis of girdles, see Ronald W. Lightbown, *Mediaeval European Jewellery with a Catalogue of the Collection in the Victoria and Albert Museum* (London, 1992), pp. 306–40, but see also Ilse Fingerlin, *Gürtel des hohen und späten Mittelalters* (Munich, 1971), and Verena Kessel, "Studien zu Darstellungen von Taschen und Beuteln im 14. und 15. Jahrhundert," *Jahrbuch des Museums für Kunst und Gewerbe Hamburg*, vol. 3 (1984), pp. 63–78. For information on *aumonières* I am grateful to my student Nancy E. Gardner, who is preparing a doctoral dissertation on the subject. For the use of love-knots and letters, see Jean-Pierre Jourdain, "La Lettre et l'Etofe: Etude sur les Lettres dans le Dispositif Vestimentaires à la fin du Moyen Age," *Médiévales*, vol. 29 (1995), pp. 23–46. For a new approach to dress, see Odile Blanc, *Parades en Parures: L'Invention du Corps de Mode à la fin du Moyen Age* (Paris, 1996).

The Casket and the Key

For the British Museum ivory box, see *Les Fastes du Gothique. Le Siècle de Charles V*, Paris, Galeries nationales du Grandes Palais (Paris, 1981), no. 127. For the German boxes, see Heinrich Kohlhaussen, *Minnekästchen im Mittelalter* (Berlin, 1928); the exhibition catalog *The Secular Spirit: Life and Art at the End of the Middle Ages* (The Metropolitan Museum of Art, New York, 1975); and Timothy Husband, *The Wild Man: Medieval Myth and Symbolism*, The Metropolitan Museum of Art (New York, 1980), no. 16. The leather caskets are described in Günter Gall, *Leder im europäischen Kunsthandwerk* (Braunschweig, 1965), and John Cherry, "The Talbot Casket and Related Late Medieval Leather Caskets," *Archaeologia*, vol. 107 (1982), pp. 131–40. For an inter-

esting analysis of caskets in relation to gift-giving, see Susan L. Smith, *The Power of Women: A Topos in Medieval Art and Literature* (Philadelphia, 1995), pp. 137–91. An exemplary study of one problematic image is Donal Byrne's "A 14th-Century French Drawing in Berlin and the *Livre du Voir-Dit* of Guillaume de Machaut," *Zeitschrift für Kunstgeschichte*, vol. 47 (1984), pp. 70–81. For the enclosure of women, see Carla Cassagrande, "La Femme Gardée," in *Histoire des Femmes en Occident*, vol. 2: *Le Moyen Age*, ed. Georges Duby and Michelle Perrot (Paris, 1991).

CHAPTER THREE: LOVE'S PLACES

The Garden Enclosed

Paul F. Watson, *The Garden of Love in Tuscan Art of the Early Renaissance* (Philadelphia, 1979), but for a new dating of the Davanzati frescoes, see Maribel Königer, "Die Profanen Fresken des Palazzo Davanzati in Florenz. Private Repräsentationen zur Zeit der Internationalen Gotik," *Mitteilungen des Kunsthistorischen Institute in Florenz*, vol. 34 (1990); Marilyn Stokstad and Jerry Stannard, *Gardens of the Middle Ages* (Lawrence, KA, 1983); Elisabeth MacDougal, ed., *Medieval Gardens* (Dumbarton Oaks, Washington, DC, 1986); M. Carrol-Spillecke, ed., *Der Garten von der Antike bis zum Mittelalter* (Mainz, 1996); Renate Berger and Daniela Hammer-Tugendhat, eds, *Der Garten der Lüste: Zur Deutung des Erotischen und Sexuellen bei Künstlern und ihren Interpreten* (Cologne, 1985).

The Fountain of Youth

Anna Rapp, *Der Jungbrunnen in Literatur und bildener Kunst des Mittelalters* (Zürich, 1976); for the Castello di Manta, see Steffi Roettgen, *Fresques Italiennes de la Renaissance, 1400-1470* (Paris, 1996), pp. 42-60; Philippe Verdier, "Women in the Marginalia of Gothic Manuscripts and Related Works," in *The Role of Women in the Middle Ages*, ed. R. T. Morewedge (Binghampton, NY, 1975); Hana Hlaváčková, "Courtly Body in the Bible of Wenceslas," in *Kunstlerischer Austausch/Artistic Exchange: Akten des XXXVIII. internationalen Kongresses für Kunstgeschichte* (Berlin, 1993), pp. 371–79.

The Castle Besieged

Roger Sherman Loomis, "The Allegorical Siege in the Art of the Middle Ages," *Journal of the Archaeological Institute of America*, vol. 23 (1919), pp. 255–69; Heather Arden, "The Slings and Arrows of Outrageous Love in the *Roman de la Rose*," in *The Medieval City Under Siege*, ed. Ivy A. Corfis and Michael Wolfe (Woodbridge, Suffolk, 1996), pp. 191–205; and Suzanne Lewis, "Images of Opening, Penetration, and Closure in the *Roman de la Rose*," *Word and Image*, vol. 8 (1992), pp. 215–42. For the Housebook Master, see the exhibition catalog, *Livelier than Life: The Master of the Amsterdam Cabinet or the Housebook Master, ca. 1470-1500*, ed. J. P. Filedt Kok (Amsterdam, 1985).

CHAPTER FOUR: LOVE'S SIGNS

The Hunt

Mira Friedman, "The Falcon and the Hunt: Symbolic Love Imagery in Medieval and Renaissance Art," in *Poetics of Love in the Middle Ages: Texts and Contexts* (George Mason University, 1989), pp. 157–75; Marcelle Thiébaux, *The Stag of Love: The Chase in Medieval Literature* (London, 1974); Christian Antoine de Chamerlat, *Falconry and Art* (London, 1987), but for the most extensive study, see Baudouin van der Abeele, *La Fauconnerie dans les Lettres Françaises du XIIe au XIV Siècle* (Louvain, 1990). See also Malcolm Jones, "Folklore Motifs in Late Medieval Art iii: Erotic Animal Imagery," *Folklore*, 102 (1991), pp. 192–219. For love rings see John Cherry, "Medieval Rings," in *Rings Through the Ages*, ed. Anna Ward, Charlotte Gere, and Barbara Cartlidge (London, 1980), no. 198. Anna Rapp and Monica Stucky-Schürer, *Zahm und Wild: Basler und Strasburger Bildteppiche des 15. Jahrhunderts* (Mainz, 1990), pp. 156–57; Richard de Fournival, *Li Bestiaires d'Amours di Maistre Richart de Fornival e li Response du Bestiaire*, ed. Cesare Segre (Milan and Naples, 1957; as *Master Richard's Bestiary and Response*, Berkeley, CA, 1986); and Helen Solterer, "Letter Writing and Picture Reading: Medieval Textuality and the *Bestiaire d'Amour*," *Word and Image*, vol. 5 (1989), pp. 131–47.

The Rose

Jack Goody, *The Culture of Flowers* (Cambridge, 1993) and Bernhardt Heinz-Mohr, *Die Rose: Entfaltung eines Symboles* (Munich, 1986). The little love-book of Pierre Sala is discussed in *Renaissance Painting in Manuscripts: Treasures from the British Library* (New York, 1983), pp. 169–74, and in François Avril and Nicole Reynaud, *Les Manuscrits à Peintures en France, 1440–1520* (Paris, 1993), pp. 207–08. For the rose-plucking tapestry, see Adolfo Salvatore Cavallo, *Medieval Tapestries in the Metropolitan Museum of Art* (New York, 1995).

The Heart

F. Unterkircher, *King René's Book of Love: Le Cuer d'Amours Espris* (New York, 1975); Marie-Thérèse Gousset, Daniel Poirion, and Franz Unterkircher, *Reproduction Intégrale en Facsmile des Miniatures du Codex Vindobonensis 2597 de la Bibliothèque Nationale de Vienne* (Paris, 1981); Alcuin Blamires, "The 'Religion of Love' in Chaucer's *Troilus and Criseyde* and Medieval Visual Art," in *Word and Visual Imagination: Studies in the Interaction of English Literature and the Visual Arts*, ed. Karl Josef Höltgen, Peter M. Daly, and Wolfgang Lottes (Erlangen, 1988), pp. 11–31. A good collection of essays is *Le "Cuer" Au Moyen Age (Réalié et Senefiance)* (Aix-en-Provence, 1991). The Leipzig painting is well described in Brigitte Lymant, "Entflammen und Löschen: Zur Ikonographie des Liebezaubers vom Meister des Bonner Diptychons," *Zeitschrift für Kunstgeschichte*, vol. 57 (1994), pp. 111–22.

CHAPTER FIVE: LOVE'S GOAL

Touching

There is a great deal of literature on sacred gestures in medieval art but very little on courtly gestures, but see Jacques Le Goff, "Les Gestes Symboliques de la Vassallité," in *Pour un Autre Moyen Age: Temps, Travail et Culture en Occident* (Paris, 1977; as "The Symbolic Ritual of

Vassalage," in *Time, Work, and Culture in the Middle Ages*, Chicago, 1980) and Jean-Claude Schmitt, *La Raison des Gestes dans l'Occident Médiéval* (Paris, 1990). The Nuremberg tapestry is described in Betty Kurth, *Die deutschen Bildteppiche des Mittelalters*, 3 vols (Vienna, 1926), pls 108–9. For erotic scenes in the margins of Gothic manuscripts, see Lillian Randall, *Images in the Margins of Gothic Manuscripts* (Berkeley, CA, 1966) and Michael Camille, *Image on the Edge: The Margins of Medieval Art* (London, 1992).

Kissing

Nicholas James Perella, *The Kiss Sacred and Profane: An Interpretative History of Kiss Symbolism and Related Religo-Erotic Themes* (Los Angeles, 1969); Michael Camille, "Gothic Signs and the Surplus: The Kiss on the Cathedral," *Yale French Studies: Contexts: Style and Value in Medieval Literature* (New Haven, 1991), pp. 151–70; Yannick Carré, *Le Baiser sur la Bouche au Moyen Age: Rites, Symboles, Mentalités, à travers les Textes et les Images, XIe–XVe Siècles* (Paris, 1992); Alison Stones, "Illustrating Lancelot and Guinevere," in *Lancelot and Guinevere: A Casebook*, ed. Lori J. Walters (New York, 1996), pp. 125–57.

"Doing It"

James A. Brundage, "Let Me Count the Ways: Canonists and Theologians Contemplate Coital Positions," *Journal of Medieval History*, vol. 10 (1984), pp. 81–93; Michael Camille, "Manuscript Illumination and the Art of Copulation," in *Constructing Medieval Sexuality*, ed. J. Schultz, K. Lochrie, and Peggy McCracken (Minnesota, 1998), pp. 58–90; Malcolm Jones, "Sex and Sexuality in Late Medieval and Early Modern Art," *Frühneuzeit-Studien i: Privatisierung der Trieber* (Vienna, 1994), pp. 187–295. For the relation between love, sexuality, and medicine, see Danielle Jacquart and Claude Thomasset, *Sexualité et Savoir Médical au Moyen Age* (Paris, 1985; as *Sexuality and Medicine in the Middle Ages*, Princeton, 1988) and the excellent illustrated study by Mary Frances Wack, *Lovesickness in the Middle Ages: The Viaticum and Its Commentaries* (Philadelphia, 1990); Gabriele Bartz, Alfred Karnein, and Claudio Lange, *Liebesfreuden im Mittelalter: Kulturgeschichte des Erotik und Sexualität in Bildern und Dokumenten* (Stuttgart, 1994); James A. Brundage, *Law, Sex, and Christian Society in Medieval Europe* (Chicago, 1987); John W. Baldwin, *The Language of Sex: Five Voices from Northern France Around 1200* (Chicago, 1994); Vern L. Bullough and James A. Brundage, eds, *Handbook of Medieval Sexuality* (New York, 1996). For the fullest account of the theme of Aristotle and Phyllis, see Susan L. Smith, *The Power of Women: A Topos in Medieval Art and Literature* (Philadelphia, 1995); for homosexuality in medieval art, see John Boswell, *Christianity, Social Tolerance, and Homosexuality* (Chicago, 1980) and Silke Tammen, "Bilder der Sodomie in der Bible Moralisée," *Frauenkunstwissenschaft*, vol. 21 (1996), pp. 30–48. Master Jean de Wavrin is discussed in Avril and Raynaud, *Les Manuscrits à Peintures*, pp. 98–100. For Martinus Opifex, see Charlotte Ziegler, *Martinus Opifex: Ein Hofminiator Friedrichs III* (Vienna, 1984).

EPILOGUE: LOVE'S DECLINE & LOVE'S RENAISSANCE

I can only refer to a few studies that are crucial for the particular works briefly touched on here: Daniel Hess, *Das Gothaer Liebespaar: Ein ungleiches Paar im Gewand höfischer Minne* (Frankfurt am Main, 1996); Keith P. Moxey, "Master ES and the Folly of Love," *Simiolus*, vol. 11 (1980), pp. 125–48; the exhibition catalog *Images of Love and Death in Late Medieval and Renaissance Art* (University of Michigan Museum of Art, 1975); Alison G. Stewart, *Unequal Lovers: A Study of Unequal Couples in Northern Art* (New York, 1978); *Amour, Mariage et Transgressions au Moyen Age*, ed. D. Buschinger and A. Crépin (Göppingen, 1984); Linda Seidel, *Jan van Eyck's Arnolfini Portrait: Stories of an Icon* (Cambridge, 1993).

PICTURE CREDITS

Collections are given in the captions alongside the illustrations. Sources for illustrations not supplied by museums or collections, additional information, and copyright credits are given below. Numbers are figure numbers unless otherwise indicated.

page 6. © Museo del Prado, Madrid, all rights reserved

1. © British Museum, London
2. © Paul M.R. Maeyaert, Mont de l'Enclus-Orroir, Belgium
4. © British Museum, London
6. © Paul M.R. Maeyaert
7. © The British Museum, London # MLA 1947,7-6,1
9. © Musée de Chelles, photographers E. Mittard & N. Georgieff
10. Photo Stuart Michaels
12. Musée de Cambrai, photo Claude Therier
14. By permission of the Provost and Fellows of King's College, Cambridge
16. The Metropolitan Museum of Art, New York, The Cloisters Collection, Rogers Fund and Exchange, 1950. Photograph © 1990 The Metropolitan Museum of Art.
17, 18, 19, 20. Cliché Bibliothèque nationale de France, Paris
21, 22. The Pierpont Morgan Library/Art Resource, New York
23. Musée du Louvre # RF 2089, photo RMN, Paris/Gérard Blot
25. © The British Museum, London # MLA 56,6.23,166
28. Cliché Bibliothèque nationale de France, Paris
29. Musée du Moyen-Age – Cluny # 9191/ © RMN, Paris
30. INDEX/Pineider, Florence
31. Musée du Moyen-Age – Cluny # 17506/ © RMN, Paris
32. INDEX, Florence
33. © British Library, London
34. Charles Potter Kling Fund, courtesy The Museum of Fine Arts, Boston # 68.114
36. Musée du Moyen-Age – Cluny # 10836/ © RMN, Paris

40. © The British Museum, London # 1856, 6-23, 166
41, 42 V&A Picture Library, London # A.560-1910
43. Cliché Bibliothèque nationale de France, Paris
45. INDEX/Gonella, Florence
47. Musée du Louvre # OA 7505/ © RMN, Paris
48. Statens Historiska Museum, Stockholm n# 6849:81
49. © The Cleveland Museum of Art, Ohio. Gift of the John Huntington Art and Polytechnic Trust, 1930.742
50. © The British Museum, London # MLA 63,5.1,1
51. Cliché Bibliothèque nationale de France, Paris
54. Museum für Angewandte Kunst Cologne # A 318
55. The Metropolitan Museum of Art, Gift of George Blumenthal, 1941 # 41.100.194
56. Staatliche Museen Preußischer Kulturbesitz, Kupferstichkabinett, Berlin (West) # 3202, photo Jörg P. Anders
57. Musée du Moyen-Age – Cluny # 10834/ © RMN, Paris
58. Cliché Bibliothèque nationale de France, Paris
60. © British Library, London
61. Musée d'Archeologie du Morbihan, Vannes/ photo A. Percepied
62. Cliché Bibliothèque nationale de France, Paris
63. Studio Fotografico Quattrone, Florence
65, 66. © British Library, London
67. © The British Museum, London # MLA 1856,6-23,166
68. © Musée d'Unterlinden F 68000 Colmar, photo O.Zimmermann
69. Scala, Florence
74. V&A Picture Library, London # 218-1874
75. Cliché Bibliothèque nationale de France, Paris
76. Musée du Moyen-Age – Cluny # 19093/ © RMN, Paris – Gérard Blot
78. © British Library, London
79. Kunst und Kultur Schloß Wolfegg
80. Musée du Louvre # 3131/ © RMN, Paris
82. © The British Museum, London # MLA 1977,5-2,1
83. Staatliche Museen zu Berlin-Preußischer Kulturbesitz Kunstgewerbemuseum # F 1364
84. Lyon Musée des Tissus 30.020/1 + 2, photo

Studio Basset

87. © The British Museum, London # MLA 1892,8-1,47

88. © The British Museum, London # MLA 1856,7-1,1675

89. © The British Museum, London # AF 2683

90. The Metropolitan Museum, Gift of Irwin Untermeyer 1964 64. 101. 409

91. Staatliche Museen zu Berlin-Preußischer Kulturbesitz Kunstgewerbemuseum # K 6211

93. Swiss National Museum # 6957-4

94. The Metropolitan Museum of Art, New York, Rogers Fund, 1909 (09.137.2). Photograph © 1990 The Metropolitan Museum of Art

95. Atelier Hugel, Villingen

96. © British Library, London

97. V&A Picture Library, London # 217 1867

100. © The British Museum, London # MLA 1967,12.8,6

102. Historisches Museum, Basel # 1953, 407/Peter Portner

103. Cliché Bibliothèque nationale de France, Paris

104. AKG, London

106. The Metropolitan Museum, New York. Robert Lehman Collection, 1975 # 1975.I.141. Photograph © 1979 The Metropolitan Museum of Art

107. Courtesy H.J.E. van Beuningen, Cothen, The Netherlands, photo by Tom Haartsen

110. Musée du Louvre # OA 117, Photo RMN, Paris – Arnaudet

111. Index, Florence. Museo Nazionale del Bargello # 155

113. Staatliche Museen zu Berlin-Preußischer Kulturbesitz Skulpturengalerie # 7950

115. © Paul M.R. Maeyaert, Mont de l'Enclus-Orroir, Belgium

116. Musée du Moyen-Age – Cluny # 383/ © RMN, Paris

117. Cliché Bibliothèque nationale de France, Paris

119. Photo Stuart Michaels

120. © The British Museum, London

121. The National Library of the Czech Republic, Prague

122. Photo Angelo Hornak, London

123. The Pierpont Morgan Library/Art Resource, New York

124, 128, 129, 130. © British Library, London

133. © RMN, Paris

134. © British Library, London

144. © The British Museum, London # 1855-7-14-11

145. © The British Museum, London # E.1-134

146. © The Cleveland Museum of art, Delia E. and L.E. Holden Funds, 1932.179

147. Les Musées de la Ville de Strasbourg

148. Photo Stuart Morgan

149. Musée du Petit Palais, Avignon # MNR 320

150. © Museo del Prado, Madrid, all rights reserved

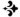

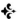

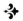

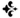